Sammlung
Ingrid & Thomas Jochheim
Collection

Christo and Jeanne-Claude
Projects 1963–2020

KERBER ART

Contents
Inhalt

Friedhelm Hütte
Global Head of Art
Deutsche Bank

On the Exhibition
Zur Ausstellung

"The story of each project is unique.
Our projects have no precedent."
„Die Geschichte eines jeden Projekts
ist einzigartig. Unsere Kunstprojekte
haben keine Vorläufer."

Christo

The second solo exhibition at the Palais-Populaire presents the world's most famous artistic duo of our time: Christo and Jeanne-Claude. They succeeded in breaking through the narrow boundaries of the art business and attracting a broad public, across all social classes, to their spectacular large-scale projects. Particularly impressive and unforgettable for many Berliners and visitors to this day is the wrapping of the Reichstag twenty-five years ago. Deutsche Bank is showing the exhibition *Christo and Jeanne-Claude: Projects 1963–2020* at the PalaisPopulaire not only to mark this anniversary, but also because of its long association with the artist couple.

Ingrid and Thomas Jochheim, who are presenting this part of their collection in such a comprehensive manner for the first time, kindly lent around seventy works for the show. Our great thanks go to both of them for having temporarily separated themselves from works that are otherwise an integral part of their lives. We also thank them sincerely for their trusting and inspiring cooperation.

Without Christo's consent and personal commitment, the exhibition would not have been possible in this form. We are extremely grateful to him and his team. With his advice and support in the preparation of the exhibition and catalog, Matthias Koddenberg also made a major contribution to the success of the project.

On display are works created between 1963 and 2019, including early objects, many large-format drawing tableaux, and several editions and prints. These exhibits are accompanied by photographs by Wolfgang Volz, a close confidante of the artist couple, who documented many projects and whose

Die zweite Einzelausstellung des Palais-Populaire präsentiert das weltweit wohl bekannteste künstlerische Duo unserer Zeit: Christo und Jeanne-Claude. Ihnen gelang es, die engen Grenzen des Kunstbetriebes zu durchbrechen und eine breite Öffentlichkeit, quer durch alle sozialen Schichten, für ihre spektakulären Großprojekte zu interessieren. Besonders eindrucksvoll und für viele Berliner und Besucher bis heute unvergesslich ist dabei die Verhüllung des Reichstags, die sich in jetzt zum fünfundzwanzigsten Mal jährt. Nicht nur aus diesem Anlass, sondern auch wegen der langen Verbundenheit mit dem Künstlerpaar, zeigt die Deutsche Bank im PalaisPopulaire die Ausstellung *Christo and Jeanne-Claude: Projects 1963–2020*.

Als Leihgeber von circa siebzig Werken konnten Ingrid und Thomas Jochheim gewonnen werden, die diesen Teil ihrer Sammlung zum ersten Mal so umfangreich präsentieren. Ihnen beiden gilt unser großer Dank, dass sie sich von den Werken, die ansonsten fester Teil ihrer Lebenswelt sind, auf Zeit getrennt haben. Auch für die vertrauensvolle und inspirierende Zusammenarbeit danken wir ihnen sehr.

Ohne Christos Zustimmung und sein persönliches Engagement wäre die Ausstellung in dieser Form nicht möglich gewesen. Dafür sind wir ihm und seinem Team überaus dankbar. Mit seiner Beratung und Unterstützung bei der Vorbereitung von Ausstellung und Katalog hat außerdem Matthias Koddenberg wesentlich zum Gelingen des Projektes beigetragen.

Zu sehen sind Arbeiten, die von 1963 bis 2019 entstanden sind, darunter frühe Objekte, viele großformatige Zeichnungstableaus sowie einige Editionen und Druckgrafiken. Diese Exponate werden begleitet von Fotografien von Wolfgang Volz, dem

photographs are an integral part of their artistic work.

After wrapping everyday objects in foil and with strings—from stacks of magazines to VW Beetles—Christo and Jeanne-Claude increasingly devoted themselves to artistic transformations and accentuations of entire landscapes or architectures, such as Rifle Gap in Colorado and Pont Neuf bridge in Paris. From 1962 to 2019, twenty-three projects were realized on various continents. Since the death of his wife in 2009, Christo has continued the projects he planned with her.

All of the projects are exclusively supported by the sale of preliminary studies, original lithographs, and editions. Christo and Jeanne-Claude never let big companies sponsor them. One could describe their actions as a "grassroots movement," in which a stable base of activists and supporters developed, continuously committed to the cause.

Ingrid and Thomas Jochheim have been such supporters. They have been amicably connected to the two artists for over twenty years, not only as collectors.

But as great as their temporary art is, their drawings are an essential part of their work. They are much more than just sketches of ideas, drafts, or construction instructions. They display an unmistakable signature in their stroke, hatchings, light, and color. In addition, the collaged plans, materials, fabrics, and photographs and their always-identical acrylic glass wrapping make them unmistakable, even unique, testifying to what a great artist Christo is. In the run-up to the often decades-long planning phases of projects, there were enthusiastic supporters as well as bitter opponents. The veiling of the Reichstag even required a debate in the

engen Vertrauten des Künstlerpaares, der viele Projekte dokumentiert hat und dessen Fotografien fester Bestandteil des künstlerischen Werkes sind.

Nach in Folien verpackten und mit Schnüren umwickelten Alltagsgegenständen – vom Zeitschriftenstapel bis zum VW-Käfer – widmeten sich Christo und Jeanne-Claude zunehmend künstlerischen Transformationen und Akzentuierungen von ganzen Landschaften oder Architekturen wie der Rifle-Schlucht in Colorado oder der Brücke Pont-Neuf in Paris. Von 1962 bis 2019 konnten dreiundzwanzig Projekte auf verschiedenen Kontinenten realisiert werden. Seit dem Tod seiner Frau im Jahre 2009 führt Christo die mit ihr geplanten Projekte weiter fort.

Sämtliche Projekte werden ausschließlich durch den Verkauf von Vorstudien, Originallithografien und Editionen getragen. Christo und Jeanne-Claude ließen sich nie von großen Unternehmen sponsern. Man könnte ihre Aktionen als „Graswurzel-Bewegung" beschreiben, bei denen ein fester Stamm von Aktivisten und Unterstützern heranwächst, die sich kontinuierlich für die Sache einsetzen.

Ingrid und Thomas Jochheim sind solche Unterstützer und den beiden Künstlern seit über zwanzig Jahren nicht nur als Sammler freundschaftlich verbunden gewesen.

Doch so großartig auch die Kunst auf Zeit ist, die Zeichnungen sind ein essenzieller Bestandteil des Werkes. Sie sind viel mehr als nur Ideenskizzen, Entwürfe oder Konstruktionsanleitungen. Sie zeigen in ihrer Strichführung, Schraffur, Lichtführung und Farbigkeit eine unverwechselbare Handschrift. Zudem sind sie auch durch die collagierten Pläne, Materialien, Stoffe oder Fotografien und ihre immer gleiche

Cover and pp. 8/9
Titel und S. 8/9

Christo and Jeanne-Claude during the installation of *Wrapped Reichstag*, Berlin 1995
© Wolfgang Volz

Christo und Jeanne-Claude während der Installation des *Verhüllten Reichstags*, Berlin 1995

Bundestag, the German federal parliament. As soon as a project is realized, however, the aesthetic experience of the sight of the fabrics shimmering in the light puts visitors in a good mood. With the wrapping, Christo and Jeanne-Claude's projects also aim to make people aware of social and historical processes. In 1995, the transformation of the parliament building in reunited Berlin captured the spirit of the times. Over five million visitors came from all over the world. And, as always, the project had a peaceful, cheerful, almost euphoric effect on spectators.

The art of Christo and Jeanne-Claude has no claim to permanence. Rather, it thrives on the charm of unrepeatable eventfulness. "The fourteen or sixteen days in which the work is accessible to the public are not the period in which the work exists," says Christo. "The realization of a project releases a great deal of energy— you feel the enormous dynamism when you're confronted with something that has taken so many years to come into being." This other part of their work is now on view at the PalaisPopulaire—not only for dyed-in-the-wool aficionados of Christo and Jeanne-Claude, but for anyone who wants to experience the art of this extraordinary couple, who were born on the same day and worked together all their lives.

Acrylglas-Umhüllung unverwechselbar, ja einzigartig. Und ein Zeugnis dafür, welch ein großartiger Zeichner Christo ist. Im Vorfeld der oft jahrzehntelangen Planungsphasen der Projekte gibt es ebenso begeisterte Befürworter wie erbitterte Gegner. Die Verhüllung des Reichstags hat sogar einer Bundestagsdebatte bedurft. Sobald ein Projekt jedoch verwirklicht ist, versetzt das ästhetische Erlebnis des Anblickes der im Licht schimmernden Stoffe die Besucher in eine Hochstimmung. Auch die Bewusstmachung sozialer und historischer Prozesse durch die Verhüllung ist in den Projekten von Christo und Jeanne-Claude intendiert. 1995 trifft die Verwandlung des Parlamentsbaus im wiedervereinten Berlin den Nerv der Zeit. Über fünf Millionen Besucher aus aller Welt kommen. Und wie immer ist die Wirkung auf das Publikum auch bei diesem Projekt friedvoll, heiter, geradezu euphorisierend.

Die Kunst von Christo und Jeanne-Claude ist eine Kunst ohne Anspruch auf Dauerhaftigkeit. Sie lebt vielmehr von dem Reiz unwiederholbarer Ereignishaftigkeit. „Die vierzehn oder sechzehn Tage, in denen das Werk dem Publikum zugänglich ist, sind nicht der Zeitraum, in dem das Werk existiert", sagt Christo. „Bei der Realisierung eines Projektes wird eine große Energie freigesetzt – man spürt die enorme Dynamik, wenn man vor etwas steht, das so viele Jahre für seine Entstehung gebraucht hat." Im PalaisPopulaire ist nun dieser andere Teil des Werkes zu sehen – nicht nur für ausgemachte Kenner von Christo und Jeanne-Claude, sondern für alle, die die Kunst dieses außergewöhnlichen Paares erleben möchte, das am selben Tag auf die Welt kam und ein Leben lang zusammengearbeitet hat.

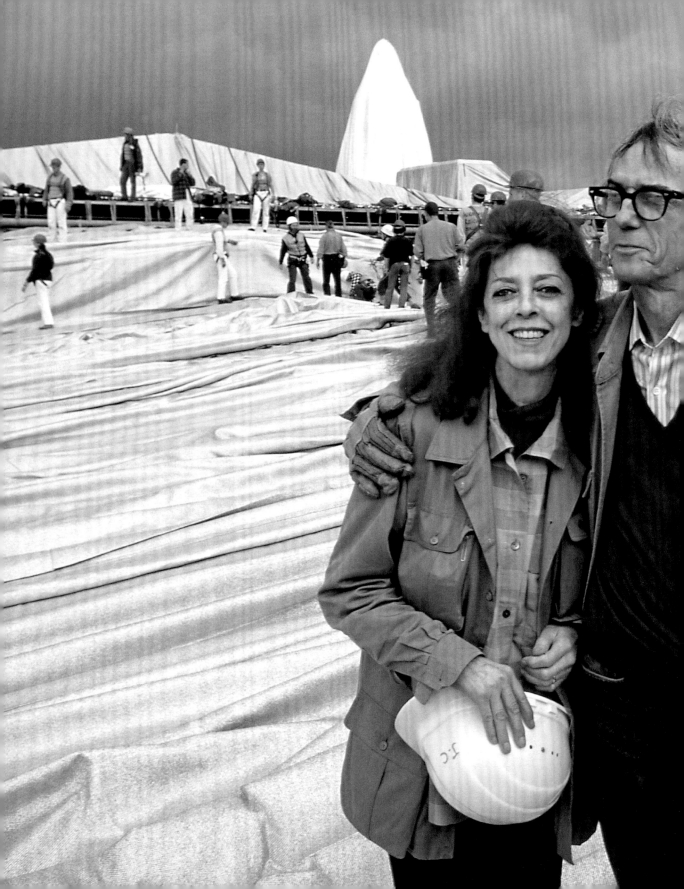

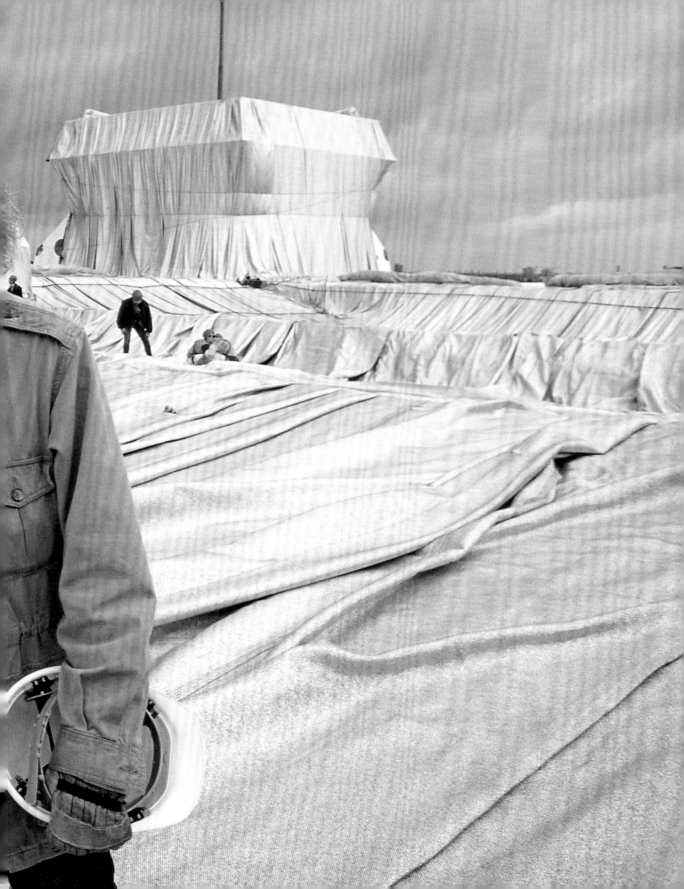

Salute from Christo …
Christo grüßt …

August 15, 2019

Dear Ingrid and Thomas,

In addition to being devoted fans and collec-
tors of our work, you have been great
friends to Jeanne-Claude and me since the
1990s. I have fond memories from visiting
your home many times over the years and
seeing beautiful works of art everywhere.
Your love and enthusiasm for art gives me
joy and I look forward to seeing this pas-
sion for art in your faces at my exhibitions
and projects, which you seldom miss.

It gives me great pleasure to know that
many works by me, from your collection,
will be exhibited at the Deutsche Bank's
PalaisPopulaire in Berlin next March.

I offer my sincere congratulations to you
both on this important exhibition.

Warm regards,

15. August 2019

Liebe Ingrid, lieber Thomas,

ihr seid treue Freunde und Sammler unse-
res Werks und darüber hinaus seit den
1990er-Jahren großartige Freunde von
Jeanne-Claude und mir. Ich habe liebe-
volle Erinnerungen an die vielen Besuche
in eurem Zuhause über all die Jahre und
an die wunderschönen Kunstwerke über-
all dort. Eure Liebe und euer Enthusiasmus
für die Kunst erfreut mich und ich bin im-
mer gespannt darauf, diese Leidenschaft
für die Kunst in euren Gesichtern bei
meinen Ausstellungen und Projekten zu
sehen – Gelegenheiten, die ihr nur selten
verpasst.

Es ist mir eine große Freude, dass viele
meiner Werke aus eurer Sammlung im
PalaisPopulaire der Deutschen Bank in
Berlin im kommenden März gezeigt werden.

Meine besten Glückwünsche an euch
beide zu dieser wichtigen Ausstellung.

Herzliche Grüße,

Matthias
Koddenberg

Christo's Drawings from Vision to Document

Christos Zeichnungen zwischen Vision und Dokumentation

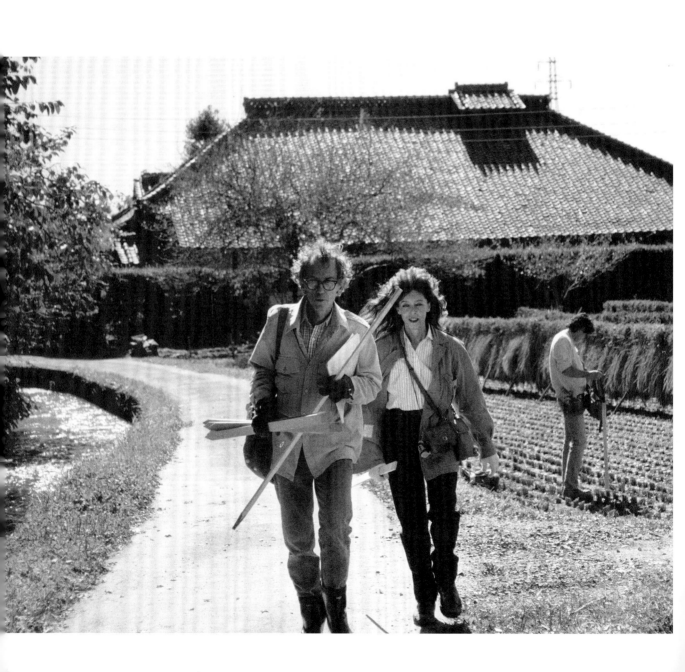

Before Christo fled to the West in January 1957 at the age of 21, he threatened to suffocate in a world of indoctrination. Frustrated by the courses on offer at the art academy in Sofia, where he had spent three years studying under the ideology of Socialist Realism, in the autumn of 1956 he left Bulgaria and headed for Prague. Shortly thereafter, he bribed a railway employee, fled to Vienna in a sealed freight wagon and applied for political asylum—a biography that continues to shape Christo's free thinking and acting to this day.

On his arrival in Paris in March 1958, Christo's art initially consisted of a wild jumble of styles. His tiny studio was home to works of all kinds: from Cubist or Fauvist-inspired still lifes and landscapes to abstract drawings, paintings, reliefs and sculptures. He ignored with almost stoic imperturbability the circumstance that hardly anyone wanted to buy his works. To make a living, he engaged in what he later called "prostitution": he painted portraits of rich society ladies. As for Jeanne-Claude, whom Christo met when he painted her mother's portrait in October 1958, there was first friendship, then love, and finally an artistic partnership. For three decades, Jeanne-Claude played the role, assigned to her by society, of Christo's wife and right hand, before the two declared in 1994, to the horror of an art scene bogged down in clichés, that from now there would only be "Christo and Jeanne-Claude" as equal partners.

It is not surprising that despite his lack of language skills, Christo quickly settled down in the city. After all, Paris was still at the centre of the international art scene at that time, even though New York was increasingly outstripping it. In Paris (and on several trips to Germany) Christo also met the protagonists of the European and American avantgarde, including Karlheinz Stockhausen, John Cage, Joseph Beuys, and Nam June Paik. Under the influence of a progressive art scene that was busily

Bis Christo im Januar 1957, im Alter von 21 Jahren, in den Westen floh, drohte er in einer Welt der Indoktrination zu ersticken. Frustriert vom Angebot der Kunstakademie in Sofia, wo er zuvor drei Jahre lang unter der Ideologie des Sozialistischen Realismus studiert hatte, verließ Christo im Herbst 1956 Bulgarien in Richtung Prag. Kurz darauf bestach er einen Bahnangestellten, floh in einem verplombten Güterwaggon nach Wien und bat um politisches Asyl – eine Biografie, die Christos freiheitliches Denken und Handeln bis heute prägt.

Nach seiner Ankunft in Paris im März 1958 bestand Christos Kunst zunächst aus einem wilden Durcheinander an Stilen. In seinem winzigen Atelier türmten sich Arbeiten jeglicher Couleur: angefangen bei kubistisch oder fauvistisch angehauchten Stillleben und Landschaften bis hin zu abstrakten Zeichnungen, Gemälden, Reliefs und Skulpturen. Dass kaum jemand seine Werke kaufen wollte, ignorierte Christo mit fast stoischer Gelassenheit. Um seinen Lebensunterhalt zu bestreiten, machte er das, was er später als „Prostitution" bezeichnen sollte: Er malte Porträts von den reichen Damen der Gesellschaft. Im Falle von Jeanne-Claude, die Christo kennenlernte, als er im Oktober 1958 ihre Mutter porträtierte, wurde daraus erst Freundschaft, dann Liebe und schließlich auch eine künstlerische Partnerschaft. Drei Jahrzehnte lang spielte Jeanne-Claude die ihr gesellschaftlich zugeschriebene Rolle als Christos Ehefrau und rechte Hand, bevor die beiden 1994, zum Entsetzen einer in Rollenklischees verhafteten Kunstszene, erklärten, ab sofort heiße es gleichberechtigt nur noch „Christo und Jeanne-Claude".

Es ist nicht verwunderlich, dass sich Christo trotz mangelnder Sprachkenntnisse schnell in der Stadt einlebte, schließlich war Paris damals noch immer Zentrum der internationalen Kunstszene, auch wenn New York ihr zunehmend den Rang ablief.

Christo and Jeanne-Claude working on *The Umbrellas*, Ibaraki, 1988
Photo: Wolfgang Volz

Christo und Jeanne-Claude bei der Arbeit an *The Umbrellas*, Ibaraki, 1988

1 Jan van der Marck, "Christo: The Making of an Artist," in: *Christo: Collection on Loan from the Rothschild Bank AG, Zurich*, Cat. La Jolla Museum of Contemporary Art, La Jolla 1981, p. 84.

exploding all conventions, Christo began to "appropriate" everyday objects, to deprive them of their function, and, by putting them under wraps, to preserve them permanently for posterity. Even if the first works had been created as random artistic experiments, Christo soon realized that this was the beginning of an artistic career in which the transformation of everyday objects and places would become the central theme. His approach was direct, immediate, radical. While he covered the first "wrapped" objects—mostly empty paint cans and glass bottles—with a layer of glue, sand and gloss paint to create an encrusted, haptic surface, he soon began to let the material "breathe," so that the work was subject to constant change. Christo's passion was primarily directed towards the objects as physical things and not as bearers of meaning. He was concerned above all with the texture, the form, and not so much with the content. Wherever he could, he rummaged around to find new objects. He confiscated his landlord's chair, Jeanne-Claude's shoes, their son's stroller. In the following years he was to wrap objects with the obsession of a fetishist: magazines, bicycles, telephones (pp. 32–35).

These early objects all arose in direct involvement with the real, physical object, spontaneously, without the need for any particular planning or preparation. That was soon to change. Christo was no longer satisfied with small-scale objects. His works became bigger, more complex and extended further and further into the surrounding space. He took a decisive step towards the later large-scale projects conceptually in the early 1960s, but especially after the couple's move to New York in 1964. The production of his works became so complex that he began to prepare them with sketches and drawings (fig. 1). The importance of this step can hardly be overestimated. Anyone who has ever heard Christo talk about his passion realizes how

In Paris (und bei mehreren Reisen nach Deutschland) lernte Christo auch die Protagonisten der europäischen und amerikanischen Avantgarde kennen, darunter Karlheinz Stockhausen, John Cage, Joseph Beuys und Nam June Paik. Unter dem Einfluss einer progressiven, alle Konventionen sprengenden Kunstszene begann Christo, sich Alltagsgegenstände „anzueignen", sie ihrer Funktion zu entreißen und sie durch Verhüllen für die Nachwelt dauerhaft zu konservieren. Auch wenn die ersten Arbeiten als zufällige künstlerische Experimente entstanden waren, erkannte Christo darin bald den Beginn einer künstlerischen Laufbahn, in der die Umgestaltung alltäglicher Objekte und Orte das zentrale Thema werden sollte. Sein Ansatz war direkt, unmittelbar, radikal. Während Christo die ersten verhüllten Objekte – meist leere Farbdosen und Glasflaschen – mit einer Schicht aus Leim, Sand und Lackfarbe bedeckte, um so eine verkrustete, haptische Oberfläche zu schaffen, begann er wenig später, den Stoff „atmen" zu lassen, so dass das Werk einer ständigen Veränderung unterworfen war. Christos Leidenschaft galt den Objekten vorrangig als physikalischen Gegenständen und nicht als Bedeutungsträgern. Es ging ihm vor allem um die Textur, die Gestalt, weniger um die inhaltliche Ebene. Wo immer er konnte, stöberte er herum, um neue Objekte aufzutreiben. Er konfiszierte die Stühle seines Vermieters, Jeanne-Claudes Schuhe, den Kinderwagen seines Sohnes. In den Folgejahren sollte er Gegenstände mit der Obsession eines Fetischisten verpacken: Magazine, Fahrräder, Telefone (S. 32–35).

Christos frühe Objekte entstanden allesamt in direkter Auseinandersetzung mit dem realen, physischen Gegenstand, spontan, ohne dass es einer besonderen planerischen Vorbereitung bedurft hätte. Das sollte sich schon bald ändern. Schnell begnügte sich Christo nicht mehr mit kleinformatigen Objekten. Seine Arbeiten

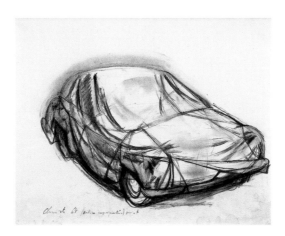

1
Wrapped Car (Project), 1964
Charcoal on paper, 36 × 43.5 cm
Private collection, New York, USA
Photo: André Grossmann

Kohle auf Papier, 36 × 43,5 cm
Privatsammlung, New York, USA

deep is his need to express himself in this medium, how deep drawing is inscribed in his DNA. Already as a child, he had begun to draw passionately, so that his parents were soon induced to hire a private drawing teacher for their son. Although drawing had become an elixir of life for Christo, he had stopped abruptly after fleeing to the West. On the one hand, the return to paper and pencil satisfied a deep, inner need; on the other, it enabled him to visualize his ideas in advance. To this day, Christo describes his drawings and collages as "preparatory works," sketches in the classical sense. For this reason, Jan van der Marck once aptly described their function in the work of Christo and Jeanne-Claude as "vision-leading-to-action." [1] An idea is to be implemented, is to become reality. Each drawing is an independent work of art in its own right, but at the same time the drawings do not become pure ends in themselves. They fulfil a specific function within the work process. In this sense, it is doubtless wrong to speak of "sketches" in relation to Christo's works. Rather, these are technical drawings: on a two-dimensional path, so to speak, the desired end-product takes on its "definitive" form, a template from which the work can then be realized as a craft object.

wurden größer, komplexer und griffen mehr und mehr in den Raum ein. Einen entscheidenden Schritt hin zu den späteren Großprojekten vollzog Christo in konzeptioneller Hinsicht Anfang der 1960er-Jahre, vor allem aber nach Christo und Jeanne-Claudes Umzug nach New York 1964. Die Herstellung seiner Arbeiten wurde nun so komplex, dass Christo begann, sie durch Skizzen und Zeichnungen vorzubereiten (Abb. 1). Man kann diesen Umstand kaum hoch genug einschätzen. Wer Christo einmal über seine Leidenschaft zu zeichnen hat sprechen hören, erkennt, wie tief sein Bedürfnis ist, sich in diesem Medium auszudrücken, wie tief das Zeichnen in seine DNA eingeschrieben ist. Bereits im Kindesalter hatte Christo begonnen, leidenschaftlich zu zeichnen, so dass sich seine Eltern bald veranlasst sahen, einen privaten Zeichenlehrer für ihren Sohn zu engagieren. Obwohl das Zeichnen für Christo zum Lebenselixier geworden war, hatte er nach seiner Flucht in den Westen abrupt damit aufgehört. Die Rückkehr zu Papier und Stift befriedigte also einerseits ein tiefes, inneres Bedürfnis; zum anderen versetze sie Christo in die Lage, seine Ideen vorab zu visualisieren. Bis heute bezeichnet Christo seine Zeichnungen und Collagen als „preparatory works", also als im klassischen Sinne werkvorbereitende Skizzen. Jan van der Marck hat ihre Funktion

1 Jan van der Marck,
„Christo: The Making
of an Artist", in:
*Christo: Collection on
Loan from the
Rothschild Bank AG,
Zurich*, Ausst.-Kat.
La Jolla Museum of
Contemporary Art,
La Jolla 1981, S. 84.

2
Packed Building (20 Exchange Place), 1964
Pencil and wash on paper, 71 × 56 cm
Collection Mr. and Mrs. Robert Kardon,
New York, USA
Photo: André Grossmann

Bleistift und Lavur auf Papier, 71 × 56 cm
Sammlung Mr. und Mrs. Robert Kardon,
New York, USA

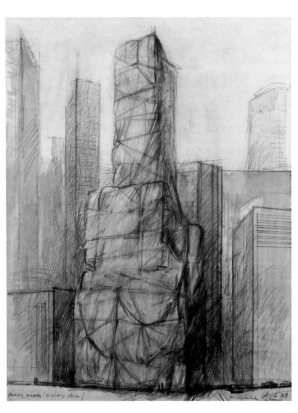

im Werk von Christo und Jeanne-Claude deshalb einmal treffend auf die Formel „vision-leading-to-action" [1] gebracht. Ein Gedanke soll umgesetzt, soll Realität werden. Jede Zeichnung ist für sich ein eigenständiges Kunstwerk, zugleich aber entstehen die Zeichnungen nicht zum reinen Selbstzweck. Sie erfüllen eine spezifische Funktion innerhalb des Werkprozesses. In diesem Sinne ist es sicherlich falsch, in Bezug auf Christos Arbeiten von Skizzen zu sprechen. Eher handelt es sich um technische Werkzeichnungen: Das angestrebte Endprodukt nimmt auf zweidimensionalem Wege sozusagen die „endgültige" Form an, nach deren Vorbild das Werk dann handwerklich realisiert werden kann.

Bestes Beispiel hierfür sind Christos ab 1964 entstandene *Store Fronts* – Repliken realer Ladenfronten, deren Fenster und Türen Christo mit Stoff oder Packpapier verhängte (S. 36/37). Die lebensgroßen Skulpturen überführten das Prinzip seiner verhüllten Objekte in architektonische Maßstäbe. Die *Store Fronts* warfen auch eine bemerkenswerte Reihe von Zeichnungen und Collagen ab, die Christo bei der Umsetzung der Skulpturen als Baupläne dienten, wovon die zahlreichen Maßangaben und Messlinien auf den Blättern noch heute zeugen. Dazu übertrug Christo die mit Hilfe der Zeichnungen entwickelten Proportionen zunächst mit Kreide maßstabsgerecht auf den Boden seines Ateliers, um anschließend auf dem Grundriss die eigentliche Ladenfront zu errichten. Die Arbeiten gehören sicherlich zu den technisch-konstruktivsten im Werk Christos; der funktionale Aspekt tritt hier in jedem Fall erstmals deutlich zu Tage.

Auch was seine künstlerischen Techniken betrifft, vollzog Christo mit den *Store Fronts* einen entscheidenden Schritt. Seine Zeichnungen wiesen nun immer häufiger Collage-Elemente auf. Dabei benutzte Christo für die vorbereitenden Studien die gleichen Materialien, die später

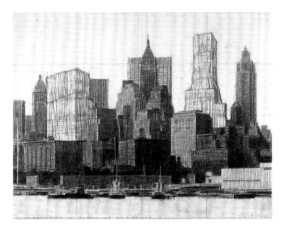

3
*Two Lower Manhattan Packed Buildings
(No. 2 Broadway and No. 20 Exchange
Place) Project*, 1964–66
Pencil, charcoal, wax crayon, and
gray wash on paper, 56 × 71 cm
Property of the artist
Photo: Eeva-Inkeri

Bleistift, Kohle, Wachskreide und
graue Lavur auf Papier, 56 × 71 cm
Besitz des Künstlers

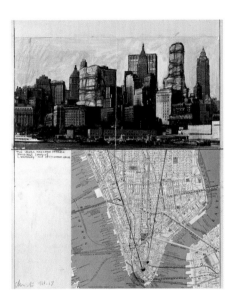

4
*Packed Buildings (Project) 2 Broadway
and 20 Exchange Place*, 1964–67
Pencil, ballpoint pen, enamel paint,
wax crayon, photograph and map on
board, 71.1 × 55.9 cm
Property of the artist
Photo: Harry Shunk

Bleistift, Kugelschreiber, Emailfarbe,
Wachskreide, Fotografie und Karte
auf Karton, 71,1 × 55,9 cm
Besitz des Künstlers

5
*Lower Manhattan Packed Buildings
(Project) 2 Broadway and 20 Exchange
Place*, 1964–66 (Detail)
Pencil, charcoal, photographs by
Raymond de Seynes, tracing paper,
and tape on board, 52 × 75 cm
Whereabouts unknown
Photo: Raymond de Seynes

Bleistift, Kohle, Fotografien von
Raymond de Seynes, Transparentpapier
und Klebeband auf Karton, 52 × 75 cm
Verbleib unbekannt

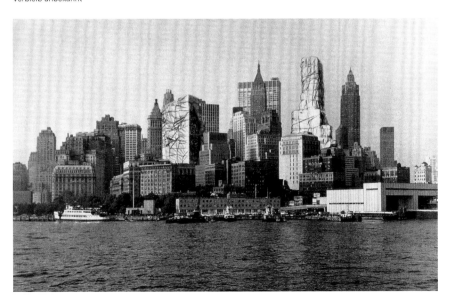

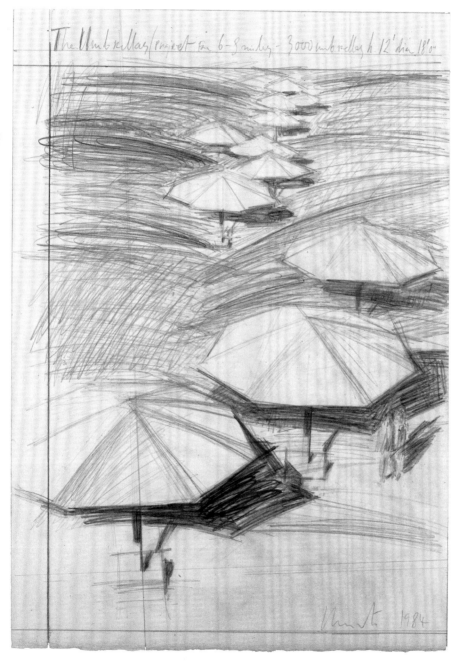

6
*The Umbrellas (Project for 6–8 Miles—
3,000 Umbrellas)*, 1984
Pencil on paper, 42.6 × 29.9 cm
National Gallery of Art, Washington, USA
(Dorothy and Herbert Vogel Collection)
Photo: André Grossmann

Bleistift auf Papier, 42,6 × 29,9 cm
National Gallery of Art, Washington, USA
(Dorothy and Herbert Vogel Collection)

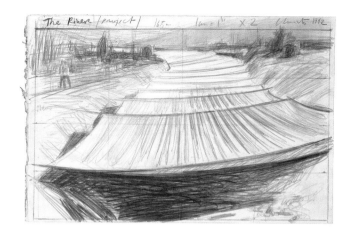

7
The River (Project), 1992
Pencil and pastel on paper,
22.8 × 34 cm
Property of the artist
Photo: André Grossmann

Bleistift und Pastellkreide auf Papier,
22,8 × 34 cm
Besitz des Künstlers

The best examples of this are Christo's *Store Fronts* dating from 1964 onwards—replicas of real shop fronts, their windows and doors hung with fabric or wrapping paper (pp. 36/37). These life-size sculptures transferred the principle of his wrapped objects on to an architectural scale. The *Store Fronts* also gave rise to a remarkable array of drawings and collages that served their creator as blueprints for the implementation of the sculptures, as evidenced by the numerous reference lines and indications of size on the works even today. Christo first transferred the proportions developed with the aid of the drawings to the floor of his studio in chalk, then went on to erect the actual shop front on the floor plan. The works are certainly among the most technically-constructive in Christo's oeuvre; the functional aspect is in any case clearly evident here for the first time.

As far as his artistic techniques are concerned, Christo took a decisive step with the *Store Fronts*. His drawings now had more and more collage elements. For the preparatory studies he used the same materials that were later to be used in the life-sized sculpture: wood for the frames and doors, zinc sheeting for the cladding, acrylic glass for the windows, fabric for the covered panes. Christo is still quite a draughtsman-sculptor here.

auch in der lebensgroßen Skulptur Verwendung finden sollten: Holz für die Rahmen und Türen, Zinkblech für die Verschalung, Plexiglas für die Fenster, Stoff für die verhängten Scheiben. Christo ist hier noch ganz zeichnender Bildhauer. Das zu gestaltende Objekt wird als plastische Einzelerscheinung dargestellt, ohne Bezug zur Umgebung. Auch wenn Christo einzelne *Store Fronts* ursprünglich für konkrete (Ausstellungs-)Räume konzipierte, so blieben es doch immer eigenständige, für sich funktionierende Skulpturen.

Als Christo und Jeanne-Claude 1964 die Idee entwickelten, zwei Hochhäuser der New Yorker Skyline zu verhüllen, übertrug Christo seinen „plastischen" Zeichenstil zunächst unverändert in die architektonische Dimension. Es schien für Christo keinen Unterschied zu machen, ob er ein Auto oder ein Gebäude verhüllte (Abb. 2). Die expressive, gestische Strichführung wirkt fast malerisch, in jedem Fall skizzenhaft und deutlich weniger technisch als bei den *Store Fronts*. Es hat fast den Anschein, als hätte Christo die vergrößerte Version eines seiner Packages in den Stadtraum verlegt und keine reale Architektur verhüllt. Die Umgebung ist nur schemenhaft dargestellt und wenig konkret. Das änderte sich erst, als Christo begann, Fotografien als Vorlage für seine Zeichnungen zu verwenden. Durch Zufall

8
Christo in his studio
working on a prepa-
ratory drawing for
The Gates, New York,
December 2004
Photo: Wolfgang Volz

8
Christo in seinem Atelier
bei der Arbeit an einer
Zeichnung zum Projekt
The Gates, New York,
Dezember 2004

The object to be designed is presented as a sculptural standalone, without reference to the environment. Although Christo originally designed individual *Store Fronts* for specific (exhibition) spaces, they always remained independent sculptures, functioning for and as themselves.

When Christo and Jeanne-Claude came up with the idea of covering two skyscrapers of the New York skyline in 1964, Christo initially transferred his "plastic" style of drawing to the architectural dimension unchanged. It did not seem to matter to Christo whether he was covering a car or a building (fig. 2). The expressive, gestural strokes are almost painterly, in any case sketch-like and much less technical than the *Store Fronts*. It almost seems as if Christo has moved the enlarged version of one of his packages into the urban space and has not covered any real architecture. The environment is only sketchy and not very concrete. This did not change until he started using photographs as a template for his drawings. By chance, shortly after arriving in New York, Christo and Jeanne-Claude ran into Raymond de Seynes, a French photographer who had already documented some of Christo's work in Paris. Christo asked de Seynes to take a trip together on the Staten Island Ferry to take pictures of the skyline. In the studio, Christo then transferred the motif to paper using a grid—a method that he has kept unchanged to this day (figs. 3, 8).

In order to enhance the realistic impression of his drawings, Christo—as he had already done with the *Store Fronts*—began to work with "real" materials, that is, no longer to depict the material as a drawing, but to collage it on the page so as to represent the throw of the folds as plastically as possible. From here on, it was basically just a small step—without detouring so to speak through the medium of drawing —to working directly with photography, which Christo either collaged with cloth or

liefen Christo und Jeanne-Claude kurz nach ihrer Ankunft in New York Raymond de Seynes in die Arme, einem französischen Fotografen, der bereits in Paris einige Arbeiten von Christo dokumentiert hatte. Christo bat de Seynes, gemeinsam eine Fahrt mit der Staten Island Ferry zu unternehmen, um Aufnahmen von der Skyline zu machen. Im Studio übertrug Christo dann das Motiv mithilfe eines Rasters auf Papier – eine Methode, die er bis heute unverändert beibehalten hat (Abb. 3, 8).

Um den realistischen Eindruck seiner Zeichnungen noch zu steigern, begann Christo – wie er es bei den *Store Fronts* bereits getan hatte – mit „realen" Materialien zu arbeiten, das heißt, den Stoff nicht länger zeichnerisch darzustellen, sondern auf das Blatt zu collagieren, um so den Faltenwurf möglichst plastisch darzustellen. Von hier war es im Grunde nur noch ein kleiner Schritt – sozusagen ohne Umweg über das Medium der Zeichnung – direkt mit der Fotografie zu arbeiten, die Christo nun entweder mit Stoff collagierte oder zeichnerisch überarbeitete (Abb. 4). Die so „manipulierte" Fotografie bot Christo die beste Möglichkeit, die geplante Projektausführung relativ spontan zu visualisieren. Die fotografisch fixierte Topografie lieferte dabei einen deutlich größeren Realitätsbezug. Anfangs schuf Christo noch Arbeiten, in denen er zwei oder mehrere Fotografien kombinierte, indem er die Fotos maßstabsgetreuer Modelle auf die Aufnahme einer Stadtansicht klebte (Abb. 5) oder in der Dunkelkammer die Negative zu einer Fotomontage ausbelichten ließ. Beide Techniken wurden von Christo alsbald aufgegeben. Sie waren zu perfekt, und es fehlte ihnen an künstlerisch-handwerklichem Zutun. Wozu das Projekt noch realisieren, wenn doch die Fotografie die Ausführung in der Realität bereits perfekt vortäuscht? „Heute gibt es Computer und die Menschen nutzen den Computer, um zu zeichnen. Das tue ich nicht. Ich zeichne

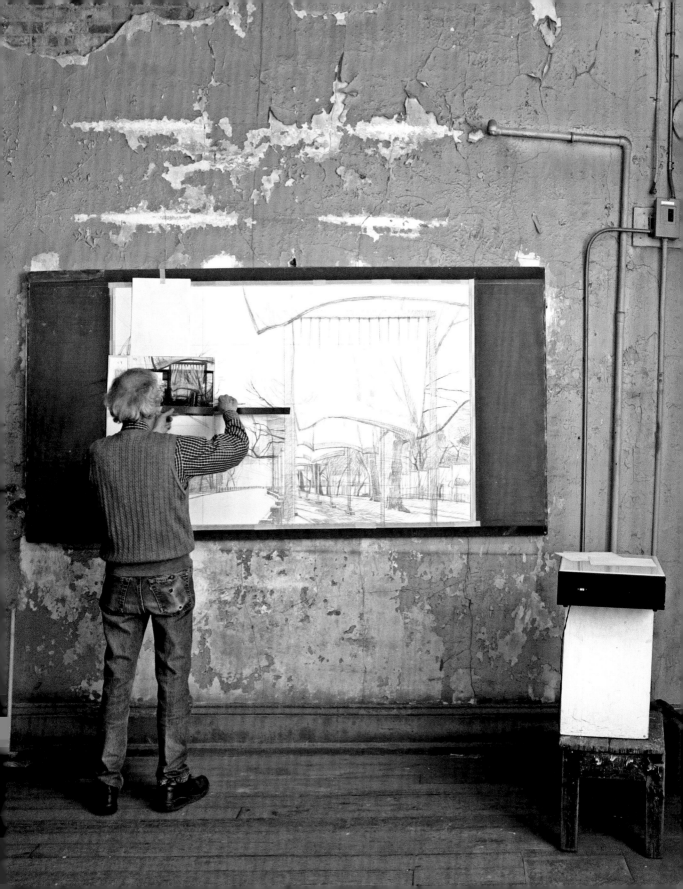

2 Christo, in: Olivier Kaeppelin, "Interview with Christo," in: *Christo and Jeanne-Claude: Barrels*, ex. cat./ Ausst.-Kat. Fondation Maeght, Saint-Paul de Vence 2016, p. / S. 98.

3 Ibid.

3 Ebd.

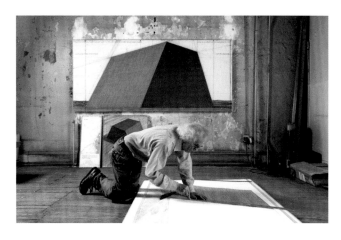

added to by drawing (fig. 4). The "manip-ulated" photograph thus provided Christo with the best opportunity to visualize the planned project relatively spontaneously. The photographically captured topogra-phy provided a much clearer reference to reality. Initially, Christo still created works in which he combined two or more photo-graphs by pasting the photos of scale models onto a photograph of a city view (fig. 5) or exposing the negatives to create a photomontage in the darkroom. Both techniques were soon abandoned. They were too perfect, and they lacked artistry and craftsmanship. Why bother to realize the actual project if the photograph already perfectly simulates the execution in reality? "Today there are computers and people use the computer to draw that's not the case with me. I draw physically with pencils. I like that my hand draws, it allows me to develop my thinking." [2]

This process of thinking is also evident in Christo's constant change between different techniques, perspectives and ma-terials, and testifies to the fact that with his preparatory studies he always pursues the goal of solving formal problems. The drawings and collages are thus always the result of previous intellectual and creative design work. "The drawings reflect the aesthetic evolution of the project. It doesn't emerge from my thoughts 'fully equipped.'

physisch mit dem Stift in der Hand. Ich liebe das und es hilft mir, meine Gedanken zu entwickeln." [2]

Dieser Denkprozess zeigt sich auch in Christos stetigem Wechsel zwischen unterschiedlichen Techniken, Blickwinkeln und Materialien und zeugt davon, dass Christo mit seinen vorbereitenden Studien immer auch das Ziel verfolgt, formale Probleme zu lösen. Die Zeichnungen und Collagen sind also stets das Ergebnis vorausgegangener geistiger und kreativer gestalterischer Arbeit. „Die Zeichnungen sind Ausdruck der ästhetischen Entwick-lung des Projektes. Wenn mir eine Idee kommt, ist diese schließlich nicht ausge-reift. Die ersten Zeichnungen sind immer vage, unspezifisch und unentschieden, sie liefern keinerlei Vorstellung davon, wie das Projekt umzusetzen ist, es fehlt schlicht an technischen Informationen. Die Zeich-nungen zeigen die Entstehung und Ent-wicklung des Projektes. In ihnen offenba-ren sich viele Dinge: Farben, Formen ..." [3]

Christos Zeichnungen und Collagen unterscheiden sich untereinander also vor allem durch den Entstehungszeitpunkt innerhalb des Entwicklungsprozesses, von der geistigen Initialzündung bis zur letzten Zeichnung, die kurz vor der Realisierung entsteht und der Ausführung in der Reali-tät am nächsten kommt. Ein Charakte-ristikum der Sammlung Jochheim besteht

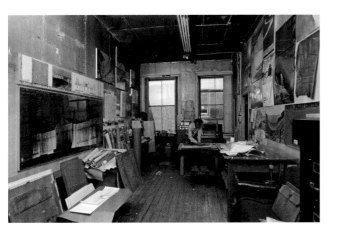

9, 10
Christo in his studio
working on preparatory
drawings and collages
for The Mastaba (left,
2012) and Wrapped
Reichstag (right, 1994)
Photos: Wolfgang Volz

9, 10
Christo in seinem Atelier
bei der Arbeit an
Zeichnungen und
Collagen zu den
Projekten The Mastaba
(links, 2012) und
Wrapped Reichstag
(rechts, 1994)

The first drawings are always skeletal, un-clear, very problematic because they don't yet give an understanding of how to go about the work, there's not enough technical information. The drawings reflect the birth and evolution of the project. They decide many things: colors, structures …" [3]

Christo's drawings and collages thus differ from each other above all through the time of their origin within the development process, from the intellectual initial spark to the final drawing, which is made shortly before the realization and comes closest to what is executed in reality. One characteristic of the Jochheim Collection is certainly that it focuses more on those "mature" works that are already relatively close to the intended final product. This aspect becomes clear in a comparison with the earliest sketches Christo made for the various projects, which are mostly no more than fleeting notes of an abstract idea (figs. 6–7). These sketches do not contain any technical information, only provisional or vague information as to title, location or dimensions, but above all no visual details, in most cases not even indications of the texture or colour of the material to be used. In fact, these decisions are taken gradually, in the course of a long process, after numerous site visits, after consultations with engineers, after testing different materials and proportions.

sicherlich darin, dass sie sich eher auf jene „reifen" Arbeiten konzentriert, die dem angestrebten Endprodukt bereits relativ nahe kommen. Deutlich wird dieser Aspekt bei einem Vergleich mit den frühesten Skizzen, die Christo zu den unterschiedlichen Projekten angefertigt hat und die zumeist nicht mehr sind als flüchtige Notizen einer noch abstrakten Idee (Abb. 6–7). Diese Skizzen enthalten keine technischen Informationen, nur vorläufige oder vage Titel-, Orts- oder Maßangaben, vor allem aber keine visuellen Details, in den meisten Fällen nicht einmal Hinweise auf die Beschaffenheit oder Farbe des zu verwendenden Stoffes. Tatsächlich fallen diese Entscheidungen sukzessive, im Zuge eines langen Prozesses, nach zahlreichen Ortsbegehungen, nach Beratungen mit Ingenieuren, nach dem Austesten unterschiedlicher Materialien und Proportionen. Vor der Realisierung eines jeden Großprojekts führen Christo und Jeanne-Claude – an einem abgelegenen Ort, versteckt vor der Öffentlichkeit – einen Test in Lebensgröße durch. Hier entscheidet sich unter realen Bedingungen, wie das Projekt später aussehen soll, welcher Stoff, welche Kabel, welche Verankerungen zum Einsatz kommen. Die dabei gesammelten Erkenntnisse fließen in Christos Zeichnungen ein, ebenso wie die formalen und ästhetischen Lösungen, die Christo zuvor auf dem

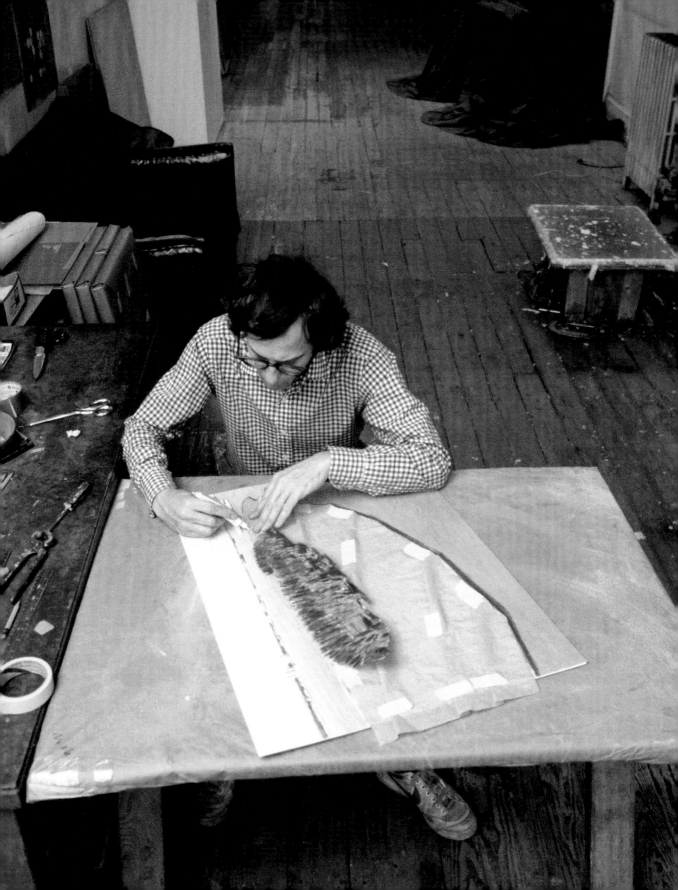

Before realizing each major project, Christo and Jeanne-Claude—in a remote location, hidden from the public—carried out a life-size test. Here, under real conditions, it was decided how the project should look, using what material, what cables, what anchors. The insights gained were incorporated into Christo's drawings, along with the formal and aesthetic solutions that he had previously developed on paper, which either proved themselves in the real situation, or, if necessary, had to be adapted.

In particular those drawings conceived as diptychs demonstrate Christo's interest in revealing his own thought process to the beholder. The integration of maps, aerial photographs, historical plans, documentary photographs, technical engineering drawings or fabric samples conveys a sort of archival character, a kind of "making of" the adjacent drawing (pp. 50/51, 61, 85, 96/97). In the effects they create, the works go far beyond a mere draft. They are a creative vision and at the same time a document of the creative development process. And once the project has been realized, they once again assume a documentary function as a testimony to what has been—because Christo's drawings outlast the concrete realization of the project. And because of their function as preparatory drawings, they have an artistically higher level of intellectual and creative authenticity than the photographic or cinematic documentation.

In his studio Christo always works on several projects at the same time, switching between different workplaces and formats (figs. 9–11). The overpainted photographs form the basis for the large-format drawings. For the multitude of motifs, he selects individual works, which he transfers to paper using a grid (fig. 8), but not every collage is necessarily transferred to large format. The Jochheim Collection contains several of these studies, all of which are clearly covered with corresponding reference lines (pp. 74/75, 79, 88/89, 110/111, 114/115).

Papier entwickelt hat, sich in der Realität bewähren oder gegebenenfalls angepasst werden müssen.

Vor allem die als Diptychon konzipierten Zeichnungen belegen Christos Interesse, dem Betrachter den eigenen Denkprozess vor Augen zu führen. Die Integration von Karten, Luftaufnahmen, historischen Plänen, dokumentarischen Fotografien, technischen Ingenieurszeichnungen oder Stoffmustern vermitteln eine Art Archivcharakter, eine Art „making of" der nebenstehenden Zeichnung (S. 50/51, 61, 85, 96/97). Die Arbeiten gehen hier in ihrer Wirkung weit über die Aufgabe eines Entwurfs hinaus. Sie sind gestalterische Vision und zugleich Dokument des kreativen Entwicklungsprozesses. Und ist das Projekt einmal realisiert, übernehmen sie als Zeugnis des einst Gewesenen erneut eine dokumentarische Funktion. Denn Christos Zeichnungen überdauern die eigentliche Projektrealisierung. Und aufgrund ihrer Funktion als werkvorbereitende Zeichnungen besitzen sie einen künstlerisch höheren geistigen und kreativen Authentizitätsgrad als die fotografischen oder filmischen Dokumentationen.

In seinem Studio arbeitet Christo stets an mehreren Werken gleichzeitig, wechselt zwischen verschiedenen Arbeitsplätzen und Formaten hin und her (Abb. 9–11). Dabei bilden die übermalten Fotografien die Vorlage für die großformatigen Zeichnungen. Aus der Vielzahl der Motive wählt er dafür einzelne Arbeiten aus, die er mithilfe eines Rasters auf Papier überträgt (Abb. 8), wobei nicht jede Collage zwangsläufig auf das Großformat übertragen wird. In der Sammlung Jochheim befinden sich mehrere dieser Studien, die alle deutlich mit entsprechenden Messlinien überzogen sind (S. 74/75, 79, 88/89, 110/111, 114/115). Das Arbeitsmaterial für diese Collagen liefert seit nunmehr über 40 Jahren Jahren der Fotograf Wolfgang Volz, der bereits seit den 1970er-Jahren exklusiv die Projekte von

The photographer Wolfgang Volz, who exclusively documented the projects of Christo and Jeanne-Claude with his camera from the 1970s, has provided the material for these collages for over forty years now.

The photographs that Volz takes of the future locations of the projects serve Christo as the basis for his collages. Using contact sheets, he selects the photos he needs for his work. After they have been painted over and collaged in the studio, Christo then cuts up the prints, duplicates them with the photocopier or enlarges them to the format needed. For several years, Christo has increasingly used color photographs for his collages. Previously, they were almost exclusively black-and-white shots, which he occasionally hand-colored with crayons, as was the practice in the nineteenth century (pp. 74/75). Astonishingly, Christo also transfers the principle to his drawings by sketching the cityscape or landscape expressively in color (pp. 46/47), then developing it in filigree lines and monochrome with the pencil, as if the background were a black-and-white photograph (p. 84). This shows how much each individual piece of work is not just a construction drawing, but always an independent work of art. In every work, Christo makes innumerable aesthetic decisions—not with regard to the future project, but with reference to the drawing itself. With in enamel paint, Christo accentuates certain lines or letters here and there (pp. 79, 88/89), achieving painterly effects by blurring charcoal or pastel (p. 104). These interventions are not necessary in the technical sense, they are basically superfluous, and yet decisive for the character of the work. The reference lines with which Christo finally covers the largeformat drawings also have no function, except that they make the actual grid hidden beneath the motif visible to the beholder once more and

Christo und Jeanne-Claude mit der Kamera dokumentiert.

Die Aufnahmen, die Volz von den zukünftigen Standorten der Projekte macht, dienen Christo als Grundlage für seine Collagen. Mithilfe von Kontaktbögen wählt er jene Fotos aus, die er für seine Arbeit benötigt. Im Studio übermalt, collagiert, zerschneidet Christo dann die Abzüge, vervielfältigt sie mit dem Fotokopierer oder vergrößert sie auf das gerade nötige Format. Seit einigen Jahren verwendet Christo zunehmend Farbfotos für seine Collagen, zuvor waren es fast ausschließlich Schwarz-Weiß-Aufnahmen, die er in einzelnen Fällen mit Wachsstiften wie die Koloristen des 19. Jahrhunderts einfärbte (S. 74/75). Erstaunlicherweise überträgt Christo das Prinzip auch auf seine Zeichnungen, indem er die (Stadt-)Landschaft mal farbig, ausdrucksstark und expressiv skizziert (S. 46/47), dann wieder filigran und monochrom mit dem Bleistift ausarbeitet, so als wäre der Hintergrund eine Schwarz-Weiß-Fotografie (S. 84). Hier zeigt sich, wie sehr jede einzelne Arbeit nicht nur Konstruktionszeichnung, sondern in gleicher Weise immer auch eigenständiges Kunstwerk ist. Bei jedem Werk trifft Christo unzählige ästhetische Entscheidungen – nicht in Bezug auf das spätere Projekt, sondern bezogen auf die Zeichnung selbst. Mit Emailfarbe werden von Christo hier und dort bestimmte Linien oder Buchstaben akzentuiert (S. 79, 88/89), mit dem Verwischen der Kohle oder Pastellkreide malerische Effekte erzielt (S. 104). Diese Eingriffe sind im technischen Sinne nicht nötig, sie sind im Grunde ein Zuviel und doch entscheidend für den Charakter des Werkes. Auch die Messlinien, mit denen Christo abschließend die großformatigen Zeichnungen überzieht, sind ohne Funktion, außer dass sie das eigentliche, unter dem Motiv verborgene Raster für den Betrachter wieder sichtbar machen und so Zeugnis von der Entstehung des Werkes ablegen (S. 55, 65, 70/71, 93, 94, 103).

thus testify to the genesis of the work (pp. 55, 65, 70/71, 93, 94, 103).

Museums and collectors learnt early on to appreciate Christo's outstanding drawing talent and not only the material value of his works. (The sale of the work finances the construction of the projects and secured Christo and Jeanne-Claude their artistic independence.) For ephemeral as their works are, the drawings and collages remain, and they are a part of the artwork just as the documents, photographs and films document the process and the realization. Christo and Jeanne-Claude's projects can hardly be overlooked in their dimensions, and yet they are intangible. They have no material value, belong to no one, exist only for a brief moment. Christo and Jeanne-Claude's landscape or city projects do not fit into any museum, or any gallery. With them they confront an audience to most of whom art is foreign. This is not a consequence of their work, it is their primary motivation.

Museen und Sammler haben Christos herausragendes zeichnerisches Talent und den nicht nur materiellen Wert seiner Arbeiten früh schätzen gelernt. (Der Verkauf der Arbeiten finanziert den Bau der Projekte und sichert Christo und Jeanne-Claude ihre künstlerische Unabhängigkeit.) Denn so ephemer ihre Werke sind, die Zeichnungen und Collagen bleiben bestehen und sind ebenso Teil des Kunstwerkes wie die Dokumente, Fotografien und Filme, die den Prozess und die Realisierung dokumentieren. Christo und Jeanne-Claudes Projekte sind in ihren Ausmaßen kaum zu übersehen, und doch sind sie nicht zu greifen. Sie haben keinen Wert, gehören niemandem, existieren nur für einen kurzen Augenblick. Christo und Jeanne-Claudes Landschafts- oder Stadtprojekte passen in kein Museum, keine Galerie. Mit ihnen konfrontieren sie ein Publikum, dem Kunst normalerweise fremd ist. Das ist keine Folge ihrer Arbeiten, es ist ihre primäre Motivation.

WRAPPED MAGAZINE,
1963
Magazines, polyethylene,
and twine, mounted
on burlapcovered board,
63 × 22 cm

Zeitschriften, Polyethylen
und Schnur, montiert
auf mit Sackleinen be-
spannter Holzplatte,
63 × 22 cm

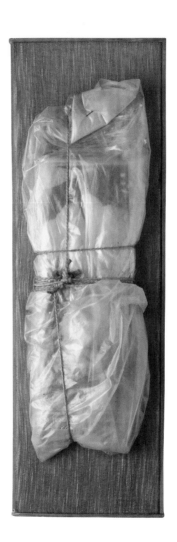

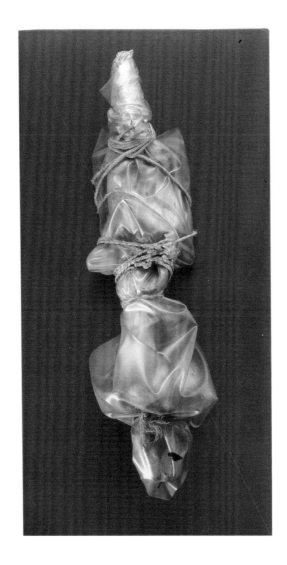

WRAPPED APPLIQUÉS,
1963
Appliqués, polyethylene,
and twine, mounted on
painted board, 46 × 24 cm

Applikationen, Polyethylen
und Schnur, montiert
auf bemalter Holzplatte,
46 × 24 cm

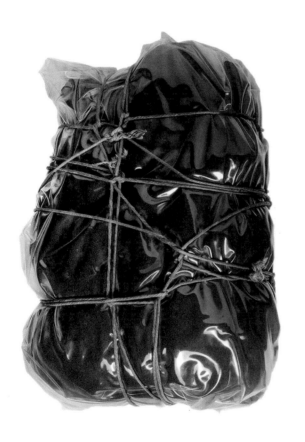
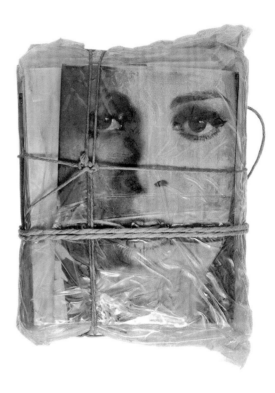

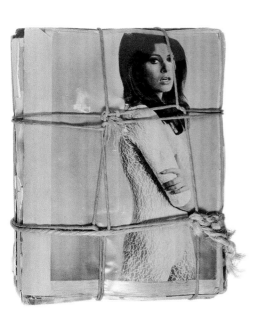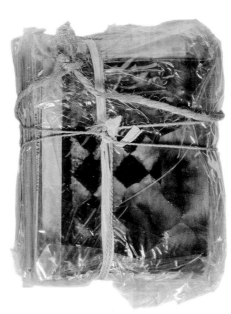

WRAPPED MAGAZINES
(IN FOUR PARTS), 1967
Magazines, polyethylene,
twine, rope; fabric, poly-
ethylene, twine,
4 parts, 45 × 30 × 22,
33 × 26 × 15, 33 × 27 ×
17.36 × 29 × 18 cm

Zeitschriften, Polyethylen,
Schnur, Seil; Stoff, Poly-
ethylen, Schnur,
4-teilig, 45 × 30 × 22,
33 × 26 × 15, 33 × 27 ×
17,36 × 29 × 18 cm

Store Fronts
1964–68

ORANGE STORE FRONT,
1965
Pencil, wood, fabric,
staples, enamel paint,
and galvanized metal,
82 × 67 cm

Bleistift, Holz, Stoff, Me-
tallklammern, Emailfarbe
und verzinktes Metall,
82 × 67 cm

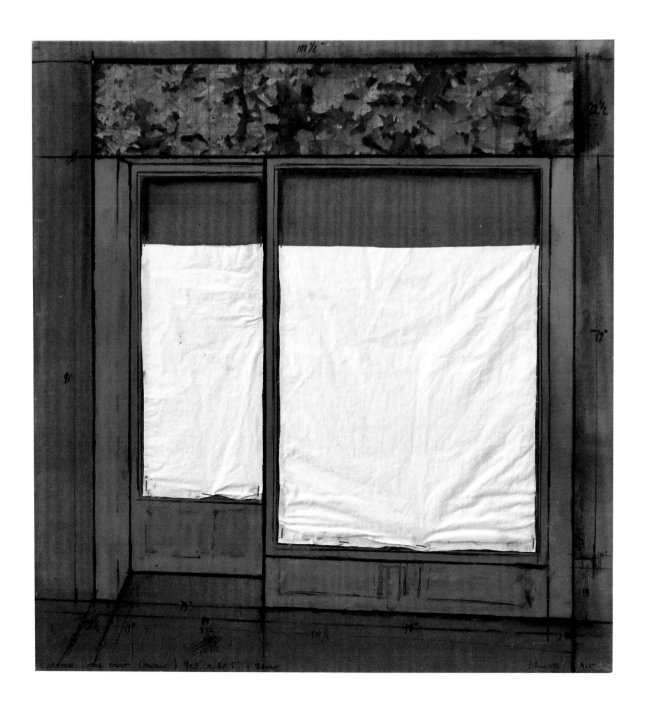

In 1964, Christo became entranced with the notion of *Store Fronts*, and produced a large number of works resembling full-size shop fronts with conventional architectural details. Made out of materials found in scrap heaps and the abandoned buildings in New York City and in France, the first *Store Fronts* exuded an elegant archaic appearance. They had paneled fronts, large, projecting display windows and inset doors, and they were painted in colors—deep green, burgundy red, yellow, orange, and pink—that purposefully brought to mind the façade of an old shop. By partially covering the inside of the glass windows with a white fabric cloth, Christo turned the function of the store fronts around. Christo further perverted this situation by illuminating the inside of the *Store Fronts* with a light bulb.

The *Store Fronts* were an attempt to expand the mystery of the *Packages* and the small, wrapped pieces to architectural scale. Christo's *Store Fronts* have elements that have been carried throughout the artists' career. The curtains of fabric draped on the inside of the windows can be seen as forerunners of such projects as the *Valley Curtain*, the *Running Fence* or *The Gates*.

Christo further explored the idea of obstruction in architecture in a second series of *Store Fronts* executed on monumental scales. Beginning in 1965, Christo had decisively changed the design and size of the series. He put aside the old-fashioned shop front design in favor of an all-glass

1964 begann Christo, sich mit der Form und Funktion herkömmlicher Ladenfronten zu beschäftigen. Mit seinen *Store Fronts* schuf er in der Folge eine Reihe von Arbeiten, die reale Ladenfronten mit all ihren architektonischen Details nachbildeten. Die ersten *Store Fronts* fertigte Christo aus vorgefundenen Materialien, die er auf dem Schrottplatz oder in Abrisshäusern in New York und Frankreich fand, so dass diese Arbeiten ein meist gefälliges, nostalgisches Aussehen aufweisen. Mit ihren getäfelten Fronten, den ausladenden, vorspringenden Fenstern und innenliegenden Türen sowie ihrem bunten Farbanstrich in dunklem Grün, Burgunderrot, Gelb, Orange und Rosa erinnern sie an die Fassaden vergangener Zeiten. Christo verhängte die Glasscheiben von innen mit weißem Stoff und verkehrte so ihre Funktion ins Gegenteil. Er steigerte diesen Effekt noch, indem er das Innere seiner *Store Fronts* mit einer Glühbirne ausleuchtete.

Die *Store Fronts* waren Christos Versuch, das Geheimnisvolle seiner *Packages* und der kleinen verhüllten Gegenstände in eine architektonische Dimension zu übertragen. Dabei finden sich die in den *Store Fronts* entwickelten Motive in späteren Arbeiten von Christo und Jeanne-Claude wieder. So können die Stoffvorhänge als Vorläufer des *Valley Curtain,* des *Running Fence* oder des Projektes *The Gates* verstanden werden.

In einer zweiten Serie von *Store Fronts* erkundete Christo die Möglichkeit archi-

and metal *Store Front*. The charm of the handcrafted gave way to an industrial formality, the colors to a clinically polished surface, vaguely reminiscent of modernization schemes from the 1940s and 1950s, and recalling the gigantic dimensions of New York architecture.

While rather smaller objects were prevalent in the early 1960s, from the mid-1960s Christo and Jeanne-Claude's interest turned into altering whole rooms and environments, which actively engaged the spectators.

tektonischer Eingriffe in noch größerem Format. Ab 1965 änderte er das Aussehen der *Store Fronts* radikal, indem er das nostalgische Aussehen zugunsten einer modernen Stahl-Glas-Konstruktion aufgab. Der handwerkliche Charme machte einer industriellen Gleichförmigkeit Platz, die Farben wichen einer klinisch polierten Oberfläche, die vage an modernistische Tendenzen der 1940er- und 1950er-Jahre erinnerte. In ihren Ausmaßen griffen die *Store Fronts* die gigantischen Dimensionen der New Yorker Architektur auf.

Während in den frühen 1960er-Jahren vor allem kleinformatige Arbeiten entstanden waren, so wandelte sich Christo und Jeanne-Claudes Interesse ab Mitte der 1960er-Jahre dahingehend, ganze Räume und Landschaften zu verändern, in denen der Betrachter eine zunehmend aktive Rolle spielte.

Wrapped Coast
1968 – 69

WRAPPED COAST
(Project for Little Bay New
South Wales, Australia),
1969
Drawing; pencil, wax crayon,
ball point pen, and topo-
graphic map, 71 × 56 cm
Photo: Eeva-Inkeri

Bleistift, Wachskreide,
Kugelschreiber und Land-
karte, 71 × 56 cm

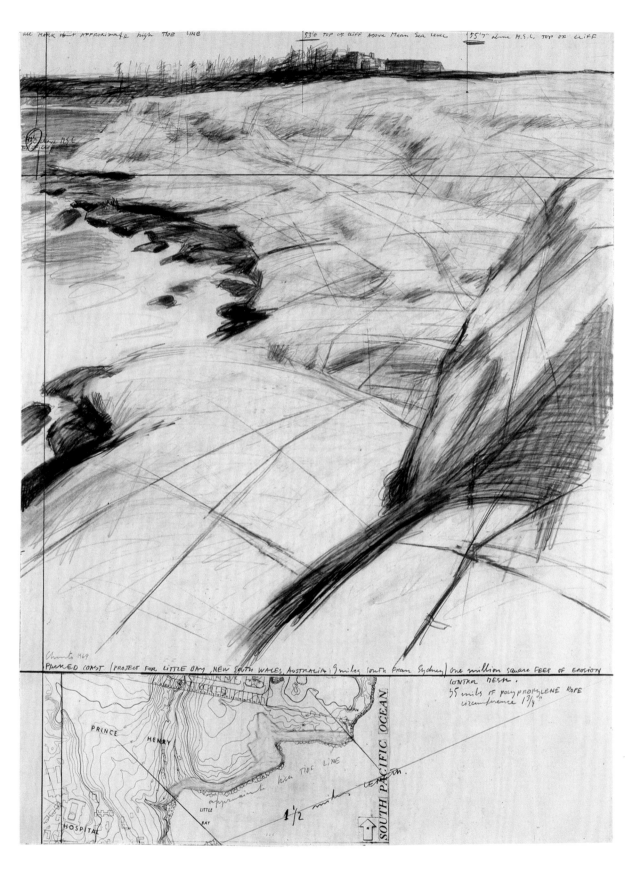

WRAPPED COAST
One Million Square Feet,
Little Bay, Sydney,
Australia, 1968–69

92.900 Quadratmeter,
Little Bay, Sydney,
Australien, 1968–69

Little Bay, property of Prince Henry Hospital, is located 14.5 kilometers (9 miles) southeast of the center of Sydney. The cliff-lined South Pacific Ocean shore area that was wrapped is approximately 2.4 kilometers (1.5 miles) long, 46 to 244 meters (150 to 800 feet) wide, 26 meters (85 feet) high at the northern cliffs and was at sea level at the southern sandy beach.

92,900 square meters (one million square feet) of erosion-control fabric (synthetic woven fiber usually manufactured for agricultural purposes) were used for the wrapping. 56.3 kilometers (35 miles) of polypropylene rope, 1.5 centimeters (0.6 inches) in diameter, tied the fabric to the rocks. Ramset guns fired 25,000 charges of fasteners, threaded studs and clips to secure the rope to the rocks.

Major Ninian Melville, retired from the Army Corps of Engineers, was in charge of the climbers and workers at the site. 17,000 manpower hours, over a period of four weeks, were expended by fifteen professional mountain climbers, 110 workers (architecture and art students from the University of Sydney and East Sydney Technical College), as well as a number of Australian artists and teachers. All climbers and workers were paid, with the exception of eleven architecture students who refused payment.

Die Little Bay, ehemals im Besitz des Prince-Henry-Hospitals, liegt 14,5 Kilometer südöstlich vom Zentrum Sydneys. Das felsige Küstengebiet des Südpazifiks, das verhüllt wurde, ist etwa 2,4 Kilometer lang und zwischen 46 und 244 Meter breit. Die nördlichen Klippen erreichen eine Höhe von 26 Metern, während sie im Süden auf einen Sandstrand auslaufen.

92.900 Quadratmeter synthetisches Erosionsschutzgewebe, normalerweise hergestellt für landwirtschaftliche Zwecke, wurde für die Verhüllung verwendet. 56,3 Kilometer Polypropylenseil mit einem Durchmesser von 1,5 Zentimetern hielten das Gewebe an den Felsen fest. Mit Bolzenschussapparaten wurden 25.000 Ladungen Bolzen, Gewindeschrauben und Klammern in den Felsen geschossen, um das Seil daran zu befestigen.

Ninian Melville, ein Major des Armeekorps der Ingenieure im Ruhestand, beaufsichtigte die Bergsteiger und Arbeiter vor Ort. 15 ausgebildete Bergsteiger und 110 Hilfskräfte, darunter Kunst- und Architekturstudenten von der Universität Sydney und von der Technischen Hochschule in Ost-Sydney, sowie zahlreiche australische Künstler und Lehrer, arbeiteten in vier Wochen insgesamt 17.000 Stunden an dem Projekt. Mit Ausnahme von elf Architekturstudenten, die keine Bezahlung annehmen wollten, wurden alle Bergsteiger und Arbeiter bezahlt.

The project was financed entirely by Christo and Jeanne-Claude through the sale of Christo's original preparatory drawings, collages, scale models, early *Packages* and *Wrapped Objects* of the 1950s and 1960s and lithographs. The artists do not accept sponsorships of any kind.

The coast remained wrapped for a period of ten weeks from October 28, 1969. Then all materials were removed and recycled and the site was returned to its original condition.

Das Projekt wurde von Christo und Jeanne-Claude durch den Verkauf von Vorstudien, Zeichnungen, Collagen, Modellen, frühen *Packages* und verhüllten Objekten sowie Originallithografien aus den 1950er- und 1960er-Jahren finanziert. Die Künstler akzeptieren keine Sponsorengelder jedweder Art.

Die Küste blieb vom 28. Oktober 1969 an für zehn Wochen verhüllt. Anschließend wurden alle Materialien entfernt, und die Küste erhielt ihr natürliches Aussehen zurück.

Wrapped Coast
1968–69

Valley Curtain
1970–72

VALLEY CURTAIN
(Project for Colorado),
1971
Collage; fabric, photostat,
pencil, color pencil, and
surveyor's map, 71 × 56 cm
Photo: Eeva-Inkeri

Collage; Stoff, Fotokopie,
Bleistift, Buntstift
und Übersichtskarte,
71 × 56 cm

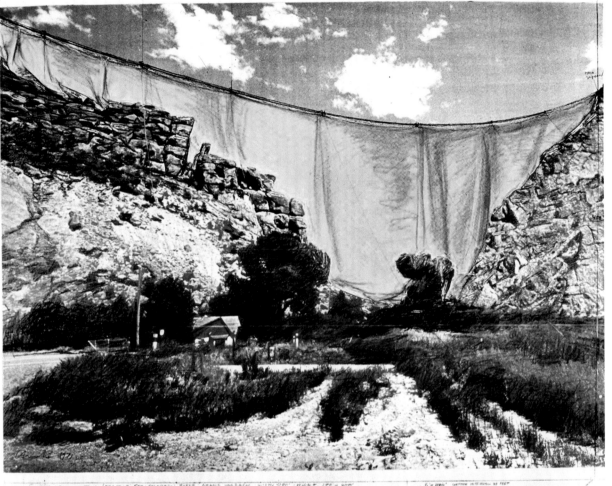

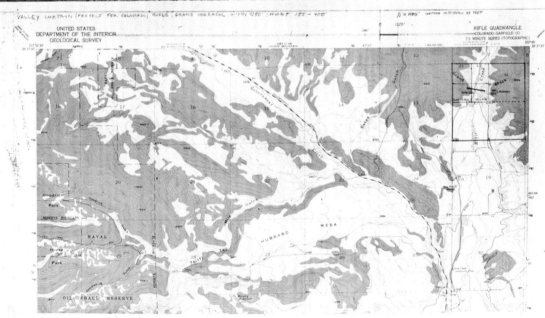

VALLEY CURTAIN (PROJECT FOR COLORADO) RIFLE, GRAND HOGBACK, WIDTH 1250', HIGHT 350 - 400'

UNITED STATES
DEPARTMENT OF THE INTERIOR
GEOLOGICAL SURVEY

RIFLE QUADRANGLE
COLORADO-GARFIELD CO.
7.5 MINUTE SERIES (TOPOGRAPHIC)

VALLEY CURTAIN
(Project for Colorado),
1972
Drawing; pencil, wax
crayon and charcoal on
paper, 93 × 154 cm

Zeichnung; Bleistift,
Wachskreide und Kohle
auf Papier, 93 × 154 cm

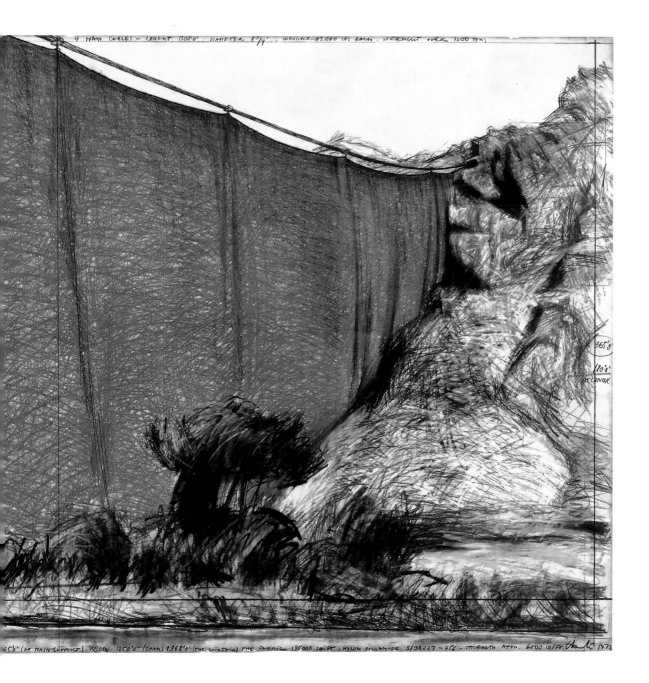

4 MAIN CABLES — LENGHT 1300'0" . DIAMETER 2³/₄" , WEIGHT 97.000 LBS EACH . STRENGHT OVER 1200 TONS)

365'0"

110's"
AT CENTER

65'0" (AT MAIN SUPPORT) WIDTH 1250'0" (SPAN) 1368'0" (THE CURTAIN) THE FABRIC . 180'000 SQ FT , NYLON POLYAMIDE S/38227 - 456 - STRENGTH APPR. 6000 LB/FT Christo 1972

VALLEY CURTAIN
Rifle, Colorado,
1970–72

On August 10, 1972, in Rifle, Colorado, between Grand Junction and Glenwood Springs in the Grand Hogback Mountain Range, at 11 am a group of 35 construction workers and 64 temporary helpers, art-school and college students, and itinerant art workers tied down the last of 27 ropes that secured the 18,600 square meters (200,200 square feet) of woven nylon fabric orange curtain to its moorings at Rifle Gap, 11.3 km (7 miles) north of Rifle, on Highway 325.

Valley Curtain was designed by Dimiter Zagoroff and John Thomson of Unipolycon of Lynn, Massachusetts, and Dr. Ernest C. Harris of Ken R. White Company, Denver, Colorado. It was built by A and H Builders, Inc. of Boulder, Colorado, President Theodore Dougherty, under the site supervision of Henry B. Leininger.

Because the curtain was suspended at a width of 381 meters (1,250 feet) and a height curving from 111 meters (365 feet) at each end to 55.5 meters (182 feet) at the center, the curtain remained clear of the slopes and the valley bottom. A 3-meter (10-foot) skirt attached to the lower part of the curtain visually completed the area between the thimbles and the ground.

Am 10. August 1972 um 11 Uhr morgens zog eine Gruppe von 35 Bauarbeitern und 64 Helfern (Kunstschüler, Studenten, Hilfsarbeiter) in Rifle, Colorado, das letzte von insgesamt 27 Seilen auf, die den Vorhang aus 18.600 Quadratmeter orangefarbenem Nylongewebe an seiner Verankerung hielten. Der Vorhang hing zwischen Grand Junction und Glenwood Springs in der Rifle-Schlucht, 11,3 Kilometer nördlich von Rifle über dem Highway 325.

Der *Valley Curtain* wurde von Dimiter Zagoroff, John Thomson von der Firma Unipolycon aus Lynn, Massachusetts, und von Dr. Ernest C. Harris von der Ken R. White Gesellschaft in Denver, Colorado, entworfen. Er wurde von der A and H Builders, Inc. (Vorsitzender: Theodore Dougherty) aus Boulder, Colorado, unter der Aufsicht von Henry B. Leininger erbaut.

Der Vorhang, mit einer Breite von 381 Metern sowie einer Höhe von 111 Metern an den Enden und 55,5 Metern in der Mitte, hing leicht durchgebogen über dem Tal und ließ so die seitlichen Böschungen und den Boden des Tales frei. Ein drei Meter langer Saum, der am unteren Teil des Vorhangs angebracht war, vervollständigte optisch den Raum zwischen der eigentlichen Vertäuung und dem Boden.

An outer cocoon enclosed the fully fitted curtain for protection during transit and at the time of its raising into position and securing to the eleven cable-clamps connections at the four main upper cables. The cables spanned 417 meters (1,368 feet), weighed 61 tons and were anchored to 864 tons of concrete foundations.

An inner cocoon, integral to the curtain, provided added insurance. The bottom of the curtain was laced to a 7.6-centimeter-(3-inch)-diameter Dacron rope from which the control and tie-down lines ran to the 27 anchors. The *Valley Curtain* project took 28 months to complete.

Christo and Jeanne-Claude's temporary work of art was financed by the Valley Curtain Corporation (Jeanne-Claude Christo-Javacheff, President) through the sale of the studies, preparatory drawings and collages, scale models, early works and original lithographs. The artists do not accept sponsorship of any kind.

On August 11, 1972, 28 hours after completion of the *Valley Curtain*, a gale estimated in excess of 96.6 kph (60 mph) made it necessary to start the removal.

Der maßgeschneiderte Vorhang befand sich beim Transport und während er in Position gebracht und mit Hilfe der elf Kabelklemmen an den vier oberen Hauptseilen befestigt wurde in einer Schutzhülle. Die Kabel überspannten das Tal auf einer Breite von 417 Metern, wogen 61 Tonnen und waren an 864 Tonnen Betonfundamenten verankert.

Ein innerer, in den Vorhang integrierter, Schutzkokon verlieh zusätzliche Sicherheit. Am unteren Ende des Vorhangs war ein 7,6 Zentimeter starkes Dacronseil befestigt, von dem aus die Kontroll- und Zugleinen zu den 27 Verankerungen liefen. Das Projekt *Valley Curtain* brauchte 28 Monate bis zu seiner Vollendung.

Das temporäre Kunstwerk wurde von der Valley Curtain Corporation durch den Verkauf von Studien, vorbereitenden Zeichnungen, Collagen, Modellen, frühen Werken und Originallithografien finanziert. Die Künstler akzeptieren keinerlei Fördermittel aus öffentlicher oder privater Hand.

Am 11. August 1972, 28 Stunden nach seiner Vollendung, musste der *Valley Curtain* wegen eines Sturms, der sich mit einer Geschwindigkeit von fast 100 Stundenkilometern näherte, wieder abgebaut werden.

Running Fence
1972–76

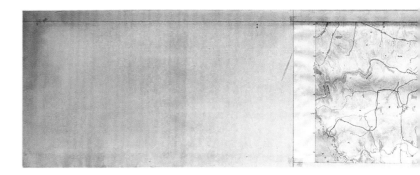

RUNNING FENCE
(Project for Sonoma and
Marin Counties), 1975
Drawing; pencil, charcoal,
colored pencil, ball point
pen, photographs, and
map on paper
Two parts, 35.5 × 244 cm
and 106.6 × 244 cm
Photo: Eeva-Inkeri

Zeichnung; Bleistift, Kohle,
Buntstift, Kugelschreiber,
Fotografien und Landkarte
auf Papier
Zweiteilig, 35,5 × 244 cm
und 106,6 × 244 cm

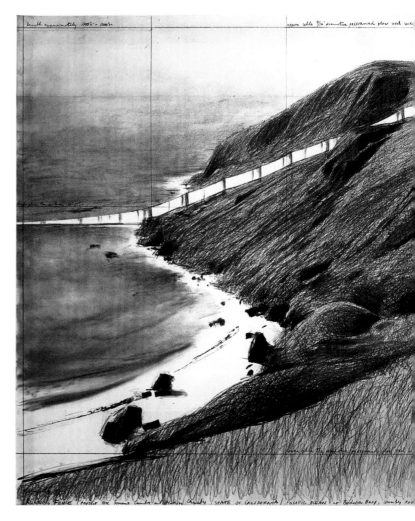

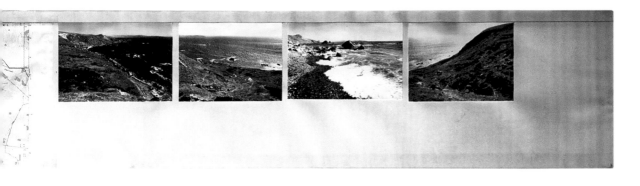

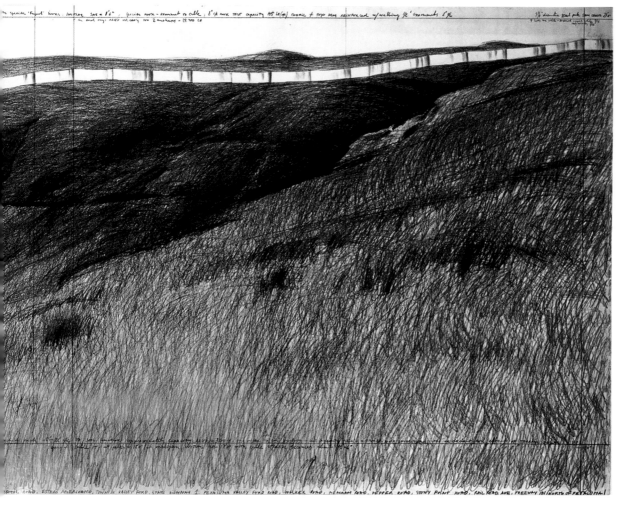

RUNNING FENCE
Sonoma and Marin
Counties, California,
1972–76

Sonoma und Marin
Counties, Kalifornien,
1972–76

Running Fence: 5.5 meters (18 feet) high, 39.4 kilometers (24.5 miles) long, extending east-west near Freeway 101, north of San Francisco, on the private properties of 59 ranchers, following the rolling hills and dropping down to the Pacific Ocean at Bodega Bay. The *Running Fence* was completed on September 10, 1976.

The art project consisted of 42 months of collaborative efforts, the ranchers' participation, eighteen public hearings, three sessions at the Superior Courts of California, the drafting of a 450-page Environmental Impact Report and the temporary use of the hills, the sky and the ocean.

All expenses for the temporary work of art were paid by Christo and Jeanne-Claude through the sale of studies, preparatory drawings and collages, scale models and original lithographs. The artists do not accept sponsorship of any kind.

Running Fence was made of 200,000 square meters (2.15 million square feet) of heavy woven white nylon fabric, hung from a steel cable strung between 2,050 steel poles (each 6.4 meters/21 feet long, 8.9 centimeters/3.5 inches in diameter) embedded 91 centimeters (3 feet) into the ground, using no concrete and braced laterally with guy wires (145 kilometers/90 miles of steel cable) and 14,000 earth anchors. The top and bottom edges of the 2,050 fabric panels were secured to the upper and lower cables by 350,000 hooks.

All parts of *Running Fence's* structure were designed for complete removal and

Running Fence: 5,5 Meter hoch, 39,4 Kilometer lang, erstreckt er sich von Ost nach West, nahe der Autostraße 101, beginnend im Norden von San Francisco, quer über den Besitz von 59 Ranchern laufend, dem Verlauf der Hügel folgend und im Pazifischen Ozean in der Bodega-Bucht endend. Der *Running Fence* wurde am 10. September 1976 vollendet.

Das Kunstprojekt bestand aus 42 Monaten gemeinsamer Anstrengungen und Bemühungen, aus der Teilnahme der Rancher, aus 18 öffentlichen Anhörungen, drei Sitzungen am obersten Gericht von Kalifornien, aus der Abfassung eines 450 Seiten starken Berichtes über Umweltauswirkungen des Projektes und der temporären Nutzung der Hügel und Berge, des Himmels und des Meeres.

Alle Ausgaben für dieses temporäre Kunstwerk wurden von Christo und Jeanne-Claude durch den Verkauf von Vorstudien, Zeichnungen, Collagen, Modellen und Originallithografien bezahlt. Die Künstler akzeptieren keine Sponsorengelder jedweder Art.

Der *Running Fence* bestand aus 200.000 Quadratmetern schwerem weißen Nylongewebe, das von einem Stahlkabel herabhing. Das Kabel war zwischen 2.050 Stahlpfähle (jeder davon 6,4 Meter hoch und 9 Zentimeter im Durchmesser) gespannt, die einen Meter tief in den Boden eingegraben waren. Dabei wurde kein Beton benutzt, die Pfähle wurden stattdessen durch Drähte mit insgesamt 145 Kilometern Länge seitlich abgespannt.

no visible evidence of Running Fence remains on the hills of Sonoma and Marin Counties.

As had been agreed with the ranchers and with county, state and federal agencies, the removal of *Running Fence* started 14 days after its completion and all materials were given to the ranchers.

Running Fence crossed fourteen roads and the town of Valley Ford, leaving passage for cars, cattle and wildlife. It was designed to be viewed by following 64 kilometers (40 miles) of public roads, in Sonoma and Marin.

Diese waren mit 14.000 Ankern in der Erde befestigt. Die Enden der 2.050 Gewebesegmente wurden mit 350.000 Haken an den oberen und unteren Kabeln gesichert.

Alle Teile des *Running Fence* waren für den späteren vollständigen Abbau konzipiert worden, und es gibt keine Anzeichen mehr dafür, dass er je auf den Hügeln der Bezirke Sonoma und Marin gestanden hat.

Entsprechend der mit den Ranchern, dem Bezirk, den staatlichen und bundesstaatlichen Behörden getroffenen Vereinbarungen begann 14 Tage nach seiner Vollendung der Abbau des *Running Fence,* und alle verwendeten Materialien wurden den Ranchern überlassen.

Der *Running Fence* kreuzte 14 Straßen und die Stadt Valley Ford, wobei für Autos, Vieh und wilde Tiere Durchgangsmöglichkeiten blieben. Der *Running Fence* war so ausgerichtet, dass man auf den öffentlichen Straßen der Bezirke Sonoma und Marin über 64 Kilometer an ihm entlangfahren und ihn so in seiner ganzen Ausdehnung erleben konnte.

Running Fence
1972–76

Surrounded Islands
1980–83

SURROUNDED ISLANDS
(Project for Biscayne Bay,
Greater Miami, Florida),
1983
Collage; pencil, fabric,
pastel, charcoal, wax
crayon, enamel paint,
and photostat
Two parts, 71 × 56 cm
and 71 × 28 cm
Photo: Eeva-Inkeri

Collage; Bleistift, Stoff,
Pastell, Kohle, Wachskreide,
Emailfarbe und Fotokopie
Zweiteilig, 71 × 56 cm und
71 × 28 cm

200 Feet extending into the Bay, covering the Surface of the Water, woven propropylene Fabric
875 Feet length Island #1 - 250 Feet width

Surrounded Islands (project for Biscayne Bay
Greater Miami, Florida)

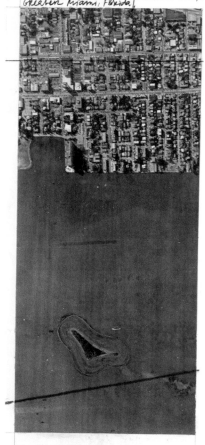

anchor 4.1
Boom 3.9

the Floating Fabric attached to a long Boom (in sections 100 Feet diameter 12")

Christo 1983
Fabric construction (7×7 per inch, Gr. 0.48)

SURROUNDED ISLANDS
Biscayne Bay, Greater
Miami, Florida, 1980–83

Biscayne Bay, Greater
Miami, Florida, 1980–83

On May 7, 1983, the installation of *Surrounded Islands* was completed in Biscayne Bay, between the city of Miami, North Miami, the village of Miami Shores and Miami Beach. Eleven of the islands situated in the area of Bakers Haulover Cut, Broad Causeway, 79th Street Causeway, Julia Tuttle Causeway, and Venetian Causeway were surrounded with 603,870 square meters (6.5 million square feet) of floating pink woven polypropylene fabric covering the surface of the water and extending out 61 meters (200 feet) from each island into the bay. The fabric was sewn into 79 patterns to follow the contours of the eleven islands.

For two weeks, *Surrounded Islands*, spreading over 11.3 kilometers (7 miles), was seen, approached and enjoyed by the public, from the causeways, the land, the water and the air. The luminous pink color of the shiny fabric was in harmony with the tropical vegetation of the uninhabited verdant islands, the light of the Miami sky and the colors of the shallow waters of Biscayne Bay.

Am 7. Mai 1983 war die Installation der *Surrounded Islands* in der Biscayne Bay zwischen der Stadt Miami, North Miami, den Siedlungen Miami Shores und Miami Beach vollendet. Elf Inseln im Gebiet von Bakers Haulover Cut, Broad Causeway, 79th Street Causeway, Julia Tuttle Causeway und Venetian Causeway wurden mit 603.870 Quadratmetern pinkfarbenem Polypropylengewebe umsäumt. Auf der Wasseroberfläche schwimmend ragte es 61 Meter von den Inseln in die Bucht hinein. Das Gewebe war in 79 einzelnen Teilen genäht worden, um sich den Konturen der elf Inseln genau anpassen zu können.

Für die Dauer von zwei Wochen waren die *Surrounded Islands* auf einer Länge von 11,3 Kilometern zu sehen, die Zuschauer konnten sich an ihnen erfreuen und über Verbindungsbrücken, über das Wasser, vom Land oder aus der Luft in ihre Nähe gelangen. Das leuchtende Pink des glänzenden Gewebes harmonierte mit der tropischen Vegetation der unbewohnten grünen Inseln, dem Licht des Himmels von Miami und den Farben der seichten Gewässer der Biscayne Bay.

Since April 1981, attorneys Joseph Z. Fleming, Joseph W. Landers, marine biologist Anitra Thorhaug, ornithologists Oscar Owre and Meri Cummings, mammal expert Daniel Odell, marine engineer John Michel, four consulting engineers, and builder-contractor, Ted Dougherty of A and H Builders, Inc. had been working on the preparation of the *Surrounded Islands*. The marine and land crews picked up debris from the eleven islands, putting refuse in bags and carting it away after they had removed some forty tons of varied garbage: refrigerator doors, tires, kitchen sinks, mattresses and an abandoned boat.

Permits were obtained from the following governmental agencies: The Governor of Florida and the Cabinet; the Dade County Commission; the Department of Environmental Regulation; the City of Miami Commission; the City of North Miami; the Village of Miami Shores; the U.S. Army Corps of Engineers; the Dade County Department of Environmental Resources Management.

Ab April 1981 arbeiteten die Rechtsanwälte Joseph Z. Fleming und Joseph W. Landers, die Meeresbiologin Anitra Thorhaug, die Vogelkundler Oscar Owre und Meri Cummings, der Zoologe Daniel Odell, der Ozeanograf John Michel, vier beratende Ingenieure und der Bauunternehmer Ted Dougherty von der A and H Builders, Inc. an den Vorbereitungen für die *Surrounded Islands*. Die Hilfskräfte auf dem Meer und an Land räumten Schutt und Müll von den elf Inseln, steckten alles in Säcke und transportierten diese ab, nachdem sie bereits etwa 40 Tonnen verschiedenste Abfälle wie Kühlschranktüren, Reifen, Küchenspülen, Matten und ein verlassenes Boot eingesammelt hatten.

Genehmigungen mussten von folgenden Regierungsbehörden eingeholt werden: vom Gouverneur von Florida und seinem Kabinett, vom Rat der Gemeinde Dade, vom Department für Umweltbelange, vom Rat der Stadt Miami, von der Stadt North Miami, von der Gemeinde Miami Shores, vom Ingenieurkorps der amerikanischen Armee und vom Department für Umweltressourcen-Management der Gemeinde Dade.

The outer edge of the floating fabric was attached to a 30.5 centimeter (12 inch) diameter octagonal boom, in sections, of the same color as the fabric. The boom was connected to the radial anchor lines which extended from the anchors at the island to the 610 specially made anchors, spaced at 15.2 meter (50 foot) intervals, 76.2 meters (250 feet) beyond the perimeter of each island, driven into the limestone at the bottom of the bay. Earth anchors were driven into the land, near the foot of the trees, to secure the inland edge of the fabric, covering the surface of the beach and disappearing under the vegetation. The floating rafts of fabric and booms, varying from 3.7 to 6.7 meters (12 to 22 feet) in width and from 122 to 183 meters (400 to 600 feet) in length were towed through the bay to each island. There were eleven islands, but on two occasions, two islands were surrounded together as one configuration.

Der äußere Rand des schwimmenden Gewebes war an einem achtkantigen segmentierten Schwimmbaum von 30,5 Zentimetern Durchmesser befestigt, der dieselbe Farbe wie der Stoff hatte. Der Schwimmbaum war mit den strahlenförmig um die Inseln gespannten Seilen verbunden, die sich von den Verankerungen auf der Insel bis zu den 610 speziell angefertigten Ankern erstreckten, die in Abständen von 15,2 Metern in einem Umkreis von 76,2 Metern um die Inseln herum in den Kalksteinboden der Bucht getrieben wurden. Auf der Landseite wurden Erdanker nahe den Baumwurzeln im Boden fixiert, um die Seite des Gewebes, die den Strand der Insel bedeckte und unter der Vegetation verschwand, zu befestigen. Gebündelt zu Flößen, die zwischen 3,7 und 6,7 Meter breit und 122 bis 183 Meter lang waren, wurden das Gewebe und die Schwimmbäume per Schiff durch die Bucht zu den einzelnen Inseln geschleppt. Es gab insgesamt elf Inseln, in zwei Fällen wurden zwei Inseln gemeinsam umsäumt.

As with Christo and Jeanne-Claude's previous art projects, *Surrounded Islands* was entirely financed by the artists, through the sale of preparatory drawings, collages, and early works. The artists do not accept sponsorship of any kind.

On May 4, 1983, out of a total work force of 430, the unfurling crew began to blossom the pink fabric. *Surrounded Islands* was tended day and night by 120 monitors in inflatable boats. *Surrounded Islands* was a work of art underlining the various elements and ways in which the people of Miami live, between land and water.

Wie alle vorangegangenen Kunstprojekte, wurde auch *Surrounded Islands* ausschließlich von Christo und Jeanne-Claude durch den Verkauf von vorbereitenden Zeichnungen, Collagen und frühen Werken finanziert. Die Künstler nehmen keinerlei Förderung jedweder Art an.

Am 4. Mai 1983 begann das 430-köpfige Team mit dem Entfalten des Gewebes und zauberte so pinkfarbene Blüten auf das Wasser. 120 Mitarbeiter in Schlauchbooten kümmerten sich Tag und Nacht um das Projekt. *Surrounded Islands* war ein Kunstwerk, das die verschiedenen Bereiche und Lebensstile der zwischen Land und Wasser lebenden Einwohner von Miami unterstrich.

Surrounded Islands
1980–83

The Pont Neuf Wrapped
1975–85

THE PONT NEUF
WRAPPED
(Project for Paris—
Length 270 m), 1980
Collage; pencil, fabric,
twine, pastel, wax crayon,
technical data, and aerial
photograph
Two parts, 71 × 28 cm
and 71 × 56 cm
Photo: Eeva-Inkeri

Collage; Bleistift, Stoff,
Bindfaden, Pastell, Wachs-
kreide, technische An-
gaben und Luftaufnahme
Zweiteilig, 71 × 28 cm
und 71 × 56 cm

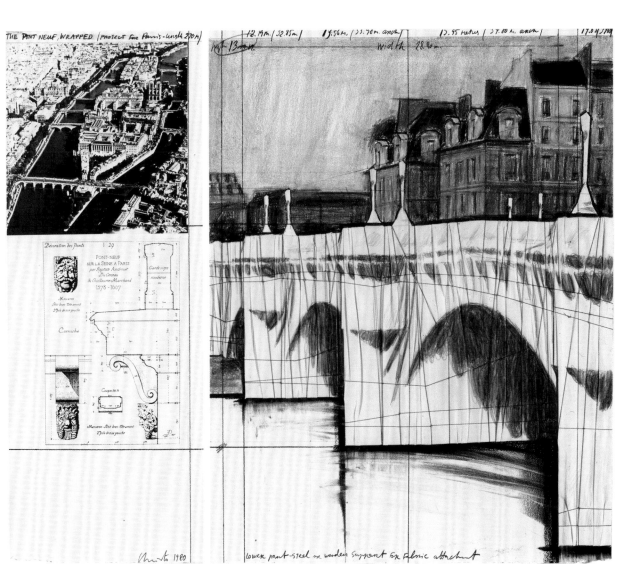

THE PONT NEUF, WRAPPED (PROJECT FOR PARIS—length 290 M)

Décoration des Ponts

PONT-NEUF
SUR LA SEINE A PARIS
par Baptiste Androuet
Du Cerceau
& Guillaume Marchand
1578 - 1607

Corniche

12.19 m. / 32.85 m. / 19.56 m. / 33.70 m. arch / 19.45 metres / 37.00 m. arch / 17.04 1980

hgt 13 m m. width 28.86 m.

Christo 1980 lower part-steel or wooden support for fabric attachment

On September 22, 1985, a group of 300 professional workers completed the temporary work of art *The Pont Neuf Wrapped*. They had deployed 41,800 square meters (450,000 square feet) of woven polyamide fabric, silky in appearance and golden sandstone in color, covering:

· The sides and vaults of the twelve arches, without hindering river traffic.
· The parapets down to the ground.
· The sidewalks and curbs (pedestrians walked on the fabric).
· All the street lamps on both sides of the bridge.
· The vertical part of the embankment of the western tip of the Île de la Cité.
· The Esplanade of the Vert-Galant.

The fabric was restrained by 13 kilometers (8 miles) of rope and secured by 12.1 tons of steel chains encircling the base of each tower, one meter (3.3 feet) underwater.

The "Charpentiers de Paris" headed by Gérard Moulin, with French sub-contractors, were assisted by the USA engineers who have worked on Christo and Jeanne-Claude's previous projects, under the direction of Theodore Dougherty: Vahé Aprahamian, August L. Huber, James Fuller, John Thomson and Dimiter Zagoroff. Johannes Schaub, the project's director, had submitted the work method and detailed plans and received approval for the project from the authorities of the City of Paris, the Department of the Seine and the State. 600 monitors, in crews of 40, led by Simon Chaput, were working around the clock maintaining the project

Am 22. September 1985 vollendete eine Gruppe von 300 professionellen Arbeitern das temporäre Kunstwerk *Der verhüllte Pont Neuf*. Sie entfalteten 41.800 Quadratmeter eines eines seidenartigen Polyamidgewebes in der Farbe goldenen Sandsteins. Das Gewebe bedeckte:

· die Seiten und die Wölbungen der zwölf Brückenbögen, ohne dabei den Verkehr auf dem Fluss zu behindern.
· die Brückengeländer bis zum Boden.
· die Gehwege und die Bordsteine (Fußgänger liefen über das Gewebe).
· alle Straßenlampen an beiden Seiten der Brücke.
· den vertikalen Teil des Anlegers an der westlichen Spitze der Île de la Cité.
· die Esplanade du Vert-Galant.

Das Gewebe wurde von 13 Kilometern Seil gehalten und mit 12,1 Tonnen Stahlketten gesichert, die rund um das Fundament jedes Brückenpfeilers einen Meter unter der Wasseroberfläche lagen.

Die „Charpentiers de Paris", geleitet von Gérard Moulin, und französische Nebenvertragspartner wurden von amerikanischen Ingenieuren unterstützt, die unter der Leitung von Theodore Dougherty bereits an früheren Projekten von Christo und Jeanne-Claude mitgearbeitet hatten: Vahé Aprahamian, August L. Huber, James Fuller, John Thomson und Dimiter Zagoroff. Der Projektleiter Johannes Schaub hatte den zuständigen Stellen der Stadt Paris, des Departements Seine und des französischen Staates die Methoden und detaillierte Pläne des Werkes vorgelegt und deren Zustim-

and giving information, until the removal of the project on October 7.

All expenses for The *Pont Neuf Wrapped* were borne by the artists as in their other projects through the sale of preparatory drawings and collages as well as earlier works. The artists do not accept sponsorship of any kind.

Begun under Henri III, the Pont Neuf was completed in July 1606, during the reign of Henry IV. No other bridge in Paris offers such topographical and visual variety, today as in the past. From 1578 to 1890, the Pont Neuf underwent continual changes and additions of the most extravagant sort, such as the construction of shops on the bridge under Soufflot, the building, demolition, rebuilding and once again demolition of the massive rococo structure which housed the Samaritaine's water pump.

Wrapping the Pont Neuf continued this tradition of successive metamorphoses by a new sculptural dimension and transformed it, for 14 days, into a work of art. Ropes held down the fabric to the bridge's surface and maintained the principal shapes, accentuating relief while emphasizing proportions and details of the Pont Neuf, which has joined the left and right banks and the Île de la Cité, the heart of Paris, for over 400 years.

mung erhalten. Bis zum Abbau am 7. Oktober waren unter der Leitung von Simon Chaput 600 Mitarbeiter, in Gruppen zu je 40, rund um die Uhr damit beschäftigt, das Projekt zu bewachen, instand zu halten und Auskünfte zu geben.

Alle Ausgaben für den *Verhüllten Pont Neuf* wurden von Christo und Jeanne-Claude getragen und wie bei ihren anderen Projekten durch den Verkauf vorbereitender Zeichnungen und Collagen sowie früherer Werke finanziert. Die Künstler nehmen keinerlei Förderung jedweder Art an.

Unter Henri III. begonnen, wurde der Pont Neuf im Juli 1606 unter Henri IV. fertiggestellt. Bis heute bietet keine andere Brücke in Paris eine solche topografische und visuelle Vielfalt. Von 1578 bis 1890 unterlag der Pont Neuf Änderungen, wie z. B. Läden auf der Brücke unter Soufflot oder der Bau, Abriss, Wiederaufbau und nochmalige Abriss der massiven Rokoko-Strukturen, in denen sich die Wasserpumpe des Kaufhauses La Samaritaine befand.

Die Verhüllung des Pont Neuf setzte diese Tradition der sukzessiven Metamorphose durch eine neue skulpturale Dimension fort und verwandelte ihn für 14 Tage in ein Kunstwerk. Seile hielten das Gewebe dicht an der Oberfläche der Brücke, sodass wesentliche Umrisse erkennbar blieben. Durch die Betonung der Proportionen und Details wurde das Relief des Pont Neuf, der seit über 400 Jahren das rechte und das linke Seine-Ufer mit der Île de la Cité, dem Herzen der Stadt, verbindet, besonders hervorgehoben.

The Umbrellas
1984–91

THE UMBRELLAS
(Joint Project for Japan
and USA), 1988
Drawing; pencil, charcoal,
wax crayon, pastel, ena-
mel paint, and map
Two parts, 165 × 38 cm
and 165 × 106.6 cm
Photo: André Grossmann

Zeichnung; Bleistift,
Kohle, Wachskreide,
Pastell, Emailfarbe, Karte
Zweiteilig, 165 × 38 cm
und 165 × 106,6 cm

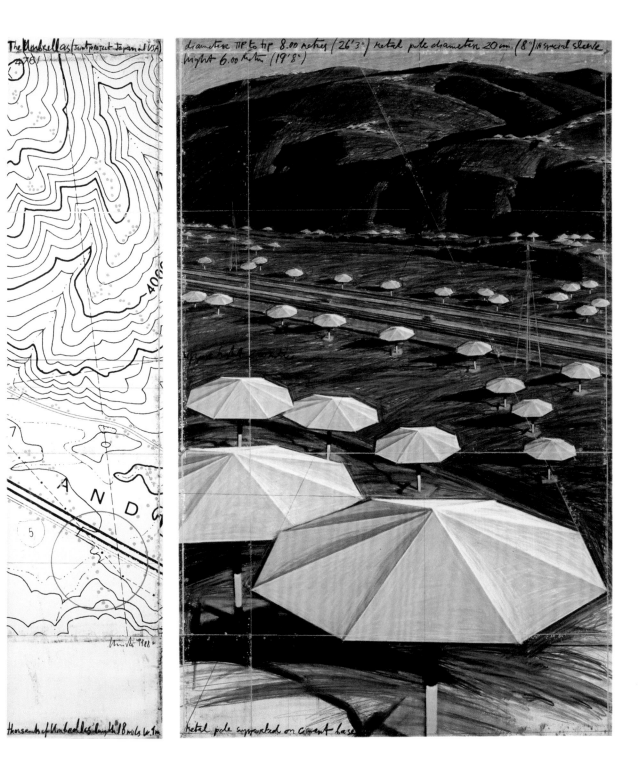

The Umbrellas (Joint project Japan and USA)
2478/

diameter TIP to tip 8.00 metres (26'3") metal pole diameter 20 cm. (8") IN special sleeve
height 6.00 metres (19'8")

4000

7

A N D G

5

Christo 1988

thousands of Umbrellas length 18 miles W. 1m

metal pole supported on cement base

At sunrise, on October 9, 1991, Christo and Jeanne-Claude's 1,880 workers began to open the 3,100 umbrellas in Ibaraki and California, in the presence of the artists at both sites. This Japan-USA temporary work of art reflected the similarities and differences in the ways of life and the use of the land in two inland valleys, one 19 kilometers (12 miles) long in Japan, and the other 29 kilometers (18 miles) long in the USA.

In Japan, the valley is located north of Hitachiota and south of Satomi, 120 kilometers (75 miles) north of Tokyo, around Route 349 and the Sato River, in the Prefecture of Ibaraki, on the properties of 459 private landowners and governmental agencies. In the USA, the valley is located 96.5 kilometers (60 miles) north of Los Angeles, along Interstate 5 and the Tejon Pass, between south of Gorman and Grapevine, on the properties of Tejon Ranch, 25 private landowners as well as governmental agencies.

Eleven manufacturers in Japan, USA, Germany and Canada prepared the various elements of the umbrellas: fabric, aluminum super-structure, steel frame bases, anchors, wooden base supports, bags and molded base covers. All 3,100 umbrellas were assembled in Bakersfield, California, from where the 1,340 blue umbrellas were shipped to Japan.

Am 9. Oktober 1991 bei Sonnenaufgang begannen 1.880 Arbeiter damit, in Anwesenheit von Christo und Jeanne-Claude, die 3.100 Schirme in Ibaraki und Kalifornien zu öffnen. Dieses temporäre, japanisch-amerikanische Kunstwerk zeigte die Gemeinsamkeiten und Unterschiede der Lebensstile und der Landnutzung in den beiden im Landesinneren liegenden Tälern, das eine 19 Kilometer lang in Japan, das andere 29 Kilometer lang in den USA.

Das Tal in Japan liegt zwischen Hitachiota im Norden und Satomi im Süden, 120 Kilometer nördlich von Tokio, in der Umgebung der Schnellstraße 349 und des Sato-Flusses in der Präfektur Ibaraki und umfasst Land von 459 Privatbesitzern und Behörden. Das Tal in den USA liegt 96,5 Kilometer nördlich von Los Angeles, längs der Interstate-Autobahn 5 und dem Tejon-Pass, zwischen dem Süden von Gorman und Grapevine, auf dem Gebiet der Tejon-Ranch sowie auf dem Land von 25 privaten Landeignern und Behörden.

Elf Unternehmen in Japan, den USA, Deutschland und Kanada bereiteten die verschiedenen Bestandteile der Schirme vor: das Gewebe, die Aluminiumaufbauten, die Stahlrahmen der Sockel, die Verankerungen, die hölzernen Sockelunterbauten, die Schutzhüllen und die Sockelabdeckungen. Alle 3.100 Schirme wurden in Bakersfield in Kalifornien montiert, von wo aus die 1.340 blauen Schirme nach Japan verschifft wurden.

Starting in December 1990, with a total work force of 500, Muto Construction Co. Ltd. in Ibaraki, and A. L. Huber & Son in California installed the earth anchors and steel bases under the supervision of Site Managers Akira Kato in Japan and Vince Davenport in the USA. The sitting platform-base covers were placed during August and September 1991.

From September 19 to October 7, 1991, an additional construction work force began transporting the umbrellas to their assigned bases, bolted them to the receiving sleeves, and elevated the umbrellas to an upright closed position.

On October 4, students, agricultural workers, and friends, 960 in USA and 920 in Japan, joined the work force to complete the installation of *The Umbrellas*. Each umbrella was 6 meters (19 feet 8 inch) high and 8.66 meters (26 feet 5 inch) in diameter.

Im Dezember 1990 begannen 500 Arbeiter der Baugesellschaft Muto in Ibaraki und von A. L. Huber & Son in Kalifornien damit, unter Aufsicht von Akira Kato in Japan und Vince Davenport in den USA, die Erdverankerungen und die Stahlsockel zu installieren. Die Sockelabdeckungen für die Schirme wurden zwischen August und September 1991 angebracht.

Vom 19. September bis zum 7. Oktober 1991 brachte eine zusätzliche Mannschaft die Schirme zu den für sie vorgesehenen Standorten, verschraubte sie mit den Sockelzylindern und brachte sie in eine aufrechte Position. Die Schirme blieben dabei noch geschlossen.

Am 4. Oktober 1991 stießen Studenten, Landarbeiter und Freunde, 960 in den USA und 920 in Japan, zu den Arbeitern, um die Installation der Schirme zu vervollständigen. Jeder Schirm war sechs Meter hoch und hatte einen Durchmesser von 8,66 Meter.

Christo and Jeanne-Claude's 26 million dollar temporary work of art was entirely financed by the artists through their "The Umbrellas, Joint Project for Japan and U.S.A. Corporation" (Jeanne-Claude Christo-Javacheff, President). The artists do not accept sponsorship.

The removal started on October 27 and the land was restored to its original condition. The umbrellas were taken apart and most of the elements were recycled.

The Umbrellas, free standing dynamic modules, reflected the availability of the land in each valley, creating an invitational inner space, as houses without walls, or temporary settlements and related to the ephemeral character of the work of art.

In the precious and limited space of Japan, the umbrellas were positioned intimately, close together and sometimes following the geometry of the rice fields. In the luxuriant vegetation enriched by water year round, the umbrellas were blue. In the California vastness of uncultivated grazing land, the configuration of the umbrellas was whimsical and spreading in every direction. The brown hills are covered by blond grass. In that dry landscape, the umbrellas were yellow.

Das 26 Millionen Dollar teure temporäre Kunstwerk wurde voll und ganz von den Künstlern mithilfe ihrer Gesellschaft „The Umbrellas, Joint Project for Japan and U.S.A." (Vorsitzende: Jeanne-Claude Christo-Javacheff) finanziert. Die Künstler akzeptieren keine Form der Sponsorenfinanzierung.

Der Abbau begann am 27. Oktober und der Landschaft wurde ihr ursprüngliches Aussehen zurückgegeben. Die Schirme wurden auseinandergenommen und wiederverwertet.

The Umbrellas, frei stehende dynamische Einheiten, spiegelten die Verfügbarkeit des Landes in den beiden Tälern und schufen einen einladenden Innenraum, wie Häuser ohne Wände oder eine vorübergehende Ansiedlung. Sie bezogen sich auf den vergänglichen Charakter dieses Kunstwerkes.

In dem kostbaren, weil begrenzten Raum in Japan wurden die Schirme in intimer Nähe, teilweise der Geometrie der Reisfelder folgend, aufgestellt. In der wegen der ganzjährigen Regenzeit üppigen Vegetation waren die Schirme blau. In der kalifornischen Weite unkultivierten Graslandes war die Verteilung der Schirme willkürlich und erstreckte sich in alle Richtungen. Die braunen Hügel waren mit goldgelbem Gras bewachsen, und in dieser trockenen Landschaft waren die Schirme gelb.

From October 9, 1991 for a period of 18 days, *The Umbrellas* were seen, approached, and enjoyed by the public, either by car from a distance and closer as they bordered the roads, or by walking under *The Umbrellas* in their luminous shadows.

Vom 9. Oktober 1991 an war das Projekt *The Umbrellas* für einen Zeitraum von 18 Tagen zu sehen, die Zuschauer konnten die Schirme entweder mit dem Auto aus einiger Entfernung, oder, dort wo sie an der Straße standen, von Nahem betrachten oder auch zu Fuß zwischen ihnen und in ihren leuchtenden Schatten spazieren gehen.

The Umbrellas
1984–91

Wrapped Reichstag
1971–95

WRAPPED REICHSTAG
(Project for Berlin), 1987
Drawing; pencil, charcoal,
wax crayon, and map
Two parts, 38 × 165 cm
and 106.6 × 165 cm
Photo: Eeva-Inkeri

Zeichnung; Bleistift, Kohle,
Wachskreide und Karte
Zweiteilig, 38 × 165 cm
und 106,6 × 165 cm

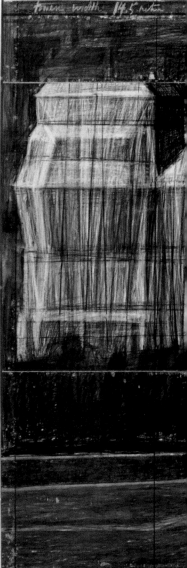

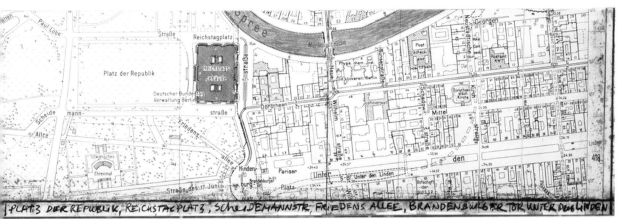

PLATZ DER REPUBLIK, REICHSTAGPLATZ, SCHEIDEMANNSTR, FRIEDENS ALLEE, BRANDENBURGER TOR UNTER DEN LINDEN

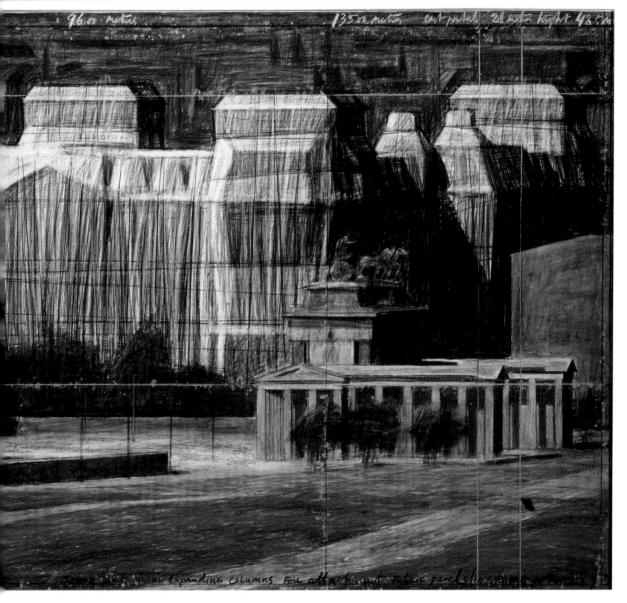

WRAPPED REICHSTAG
Berlin, 1971–95

After a struggle spanning the seventies, eighties and nineties, the wrapping of the Reichstag was completed on June 24, 1995 by a work force of 90 professional climbers and 120 installation workers. The Reichstag remained wrapped for 14 days and all materials were recycled.

100,000 square meters (1,076,390 square feet) of thick woven polypropylene fabric with an aluminum surface and 15,6 kilometers (9.7 miles) of blue polypropylene rope, diameter 3.2 cm (1.26 inch), were used for the wrapping of the Reichstag. The facades, the towers and the roof were covered by 70 tailor-made fabric panels, twice as much fabric as the surface of the building.

The work of art was entirely financed by the artists, as have all their projects, through the sale of preparatory studies, drawings, collages, scale models as well as early works and original lithographs. The artists do not accept sponsorship of any kind.

The *Wrapped Reichstag* represents not only 24 years of efforts in the lives of the artists but also years of team work by its leading members Michael S. Cullen, Wolfgang and Sylvia Volz, and Roland Specker.

Nach langem Ringen, welches sich durch die 1970er-, 1980er- und 1990er-Jahre zog, wurde die Verhüllung des Reichstagsgebäudes am 24. Juni 1995 von einer Mannschaft, bestehend aus 90 professionellen Kletterern und 120 Montagearbeitern, vollendet. Der Reichstag blieb 14 Tage lang verhüllt, und alle Materialien wurden recycelt.

100.000 Quadratmeter dickes Polypropylengewebe mit einer aluminisierten Oberfläche und 15,6 Kilometer blaues Polypropylenseil mit einem Durchmesser von 3,2 Zentimetern wurden für die Verhüllung des Reichstags benutzt. Die Fassaden, die Türme und das Dach wurden mit 70 speziell dafür zugeschnittenen Gewebebahnen bedeckt, der doppelten Menge der Oberfläche des Gebäudes. Das Kunstwerk wurde wie alle anderen Projekte der Künstler ausschließlich aus eigenen Mitteln finanziert, durch den Verkauf von Vorstudien, Zeichnungen, Collagen, maßstabsgerechten Modellen, frühen Arbeiten und Originallithografien. Die Künstler akzeptieren keinerlei Fördermittel aus öffentlicher oder privater Hand. Der *Verhüllte Reichstag* steht nicht nur für die 24-jährigen Bemühungen im Leben der Künstler, sondern auch für viele Jahre Teamarbeit der leitenden Mitglieder Michael S. Cullen, Wolfgang und Sylvia Volz und Roland Specker.

The Reichstag stands in an open, strangely metaphysical area. The building has experienced its own continual changes and perturbations: built in 1894, burned in 1933, almost destroyed in 1945, it was restored in the sixties, but the Reichstag always remained the symbol of democracy.

Throughout the history of art, the use of fabric has been a fascination for artists. From the most ancient times to the present, fabric forming folds, pleats and draperies is a significant part of paintings, frescoes, reliefs and sculptures made of wood, stone and bronze. The use of fabric on the Reichstag followed the classical tradition. Fabric, like clothing or skin, is fragile, it translates the unique quality of impermanence.

For a period of two weeks, the richness of the silvery fabric, shaped by the blue ropes, created a sumptuous flow of vertical folds highlighting the features and proportions of the imposing structure, revealing the essence of the Reichstag.

Der Reichstag steht auf einem weithin offenen Gelände, das geradezu metaphysische Assoziationen weckt. Das Gebäude hat ständige Wechsel und Erschütterungen erlebt. Fertiggestellt im Jahr 1894, wurde es 1933 in Brand gesteckt, 1945 fast völlig zerstört und in den 1960er-Jahren wieder aufgebaut. Doch immer blieb der Reichstag ein Symbol für die Demokratie.

Die ganze Kunstgeschichte hindurch haben Stoffe und Gewebe Künstler fasziniert. Von der frühesten Zeit bis zur Gegenwart ist die Struktur von Stoffen – Faltenwürfe, Plissees, Draperien – ein bedeutender Bestandteil von Gemälden, Fresken, Reliefs und Skulpturen aus Holz, Stein und Bronze. Die Verhüllung des Reichstags folgte dieser klassischen Tradition. Stoff ist – ähnlich wie Kleidung oder Haut – zart und empfindlich und steht hier für die einzigartige Qualität des Vergänglichen.

Für einen Zeitraum von zwei Wochen ergab die verschwenderische Fülle des silbrig glänzenden, mit blauen Seilen vertäuten Gewebes einen üppigen Fluss vertikaler Falten, die die wesentlichen Merkmale und Proportionen des imposanten Baus hervorhoben und die Besonderheit des Reichstagsgebäudes vor Augen führten.

Wrapped Reichstag
1971–95

Wrapped Trees
1997–98

WRAPPED TREES
(Project for Fondation
Beyeler and Berower Park,
Riehen), 1998
Collage; pencil, enamel
paint, photograph by
Wolfgang Volz, wax cray-
on, topographic map,
fabric sample, and tape,
21.5 × 28 cm
Photo: Wolfgang Volz

Collage; Bleistift, Email-
farbe, Fotografie von
Wolfgang Volz, Wachs-
kreide, topografische
Karte, Stoffmuster und
Klebeband, 21,5 × 28 cm

3 WRAPPED TREES
(Project for the Fondation
Marguerite et Aimé Maeght,
St. Paul de Vence, France),
1967
Drawing; pencil, wax cray-
on, charcoal, and wash on
paper, 71 × 55 cm

Zeichnung; Bleistift, Wachs-
kreide, Kohle und Tusche
auf Papier, 71 × 55 cm

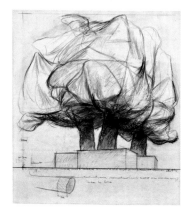

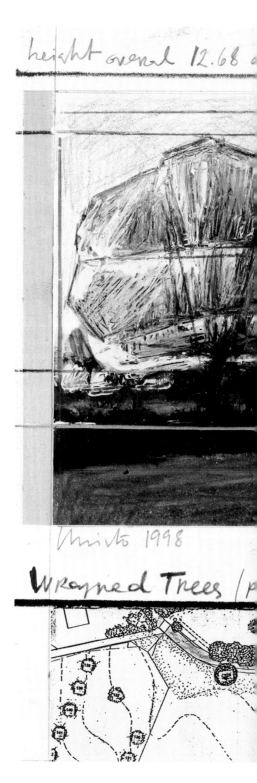

height overal 12.68

Christo 1998

Wrapped Trees /p

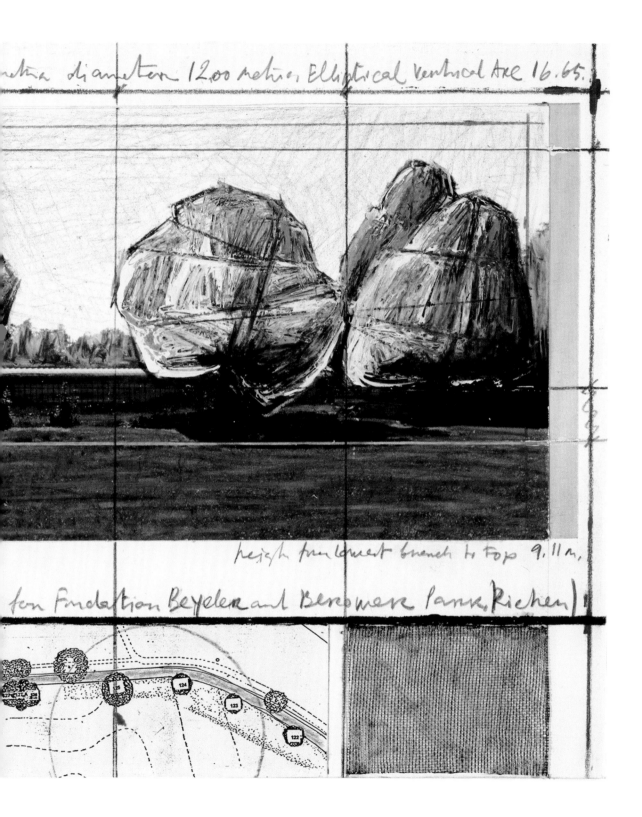

WRAPPED TREES
Fondation Beyeler and
Berower Park
Riehen, Switzerland,
1997–98

Fondation Beyeler und
Berower Park
Riehen, Schweiz,
1997–98

Starting on Friday, November 13, 1998, 178 trees were wrapped with 55,000 square meters (592,015 square feet) of woven polyester fabric (used every winter in Japan to protect trees from frost and heavy snow) and 23 kilometers (14.3 miles) of rope. The wrapping was completed on November 22.

The trees are located in the park around the Fondation Beyeler and in the adjacent meadow as well as along the creek of Berower Park, northeast of Basel, at the German border. The height of the trees varied between two meters (6.5 feet) and 25 meters (82 feet) with a diameter from one meter (3.3 feet) to 14.5 meters (47.5 feet).

The project was organized by Josy Kraft, project director, and by Wolfgang and Sylvia Volz, project managers, who also surveyed the trees and designed the sewing patterns for each tree. J. Schilgen GmbH & Co. KG, Emsdetten, Germany, wove the fabric. Günter Heckmann, Emsdetten, Germany, cut and sewed the fabric. Meister & Cie AG, Hasle-Rüegsau, Switzerland, manufactured the ropes. Field manager Frank Seltenheim of Seilpartner, Berlin, Germany, directed eight teams working simultaneously: ten climbers, three tree pruners and twenty workers.

Ab Freitag, den 13. November 1998, wurden 178 Bäume mit 55.000 Quadratmetern Polyestergewebe und 23 Kilometer Seil verhüllt. Diese Art von Gewebe wird in Japan benutzt, um Bäume im Winter vor Frost und schwerem Schnee zu schützen. Am 22. November war die Verhüllung vollendet.

Die Bäume stehen im Park um die Fondation Beyeler und auf dem benachbarten Feld sowie entlang des Bachtals im Berower Park nordöstlich von Basel an der Grenze zu Deutschland. Die Höhe der Bäume variiert zwischen zwei und 25 Metern mit einem Durchmesser von einem bis 14,5 Metern.

Das Projekt wurde organisiert von Josy Kraft, Projektdirektor, und Wolfgang und Sylvia Volz, Projektmanager, die auch die Bäume vermessen und die Schnittmuster für jeden Baum erstellt haben. Die J. Schilgen GmbH & Co. KG, Emsdetten, webte den Stoff, Günter Heckmann, Emsdetten, hat das Gewebe zugeschnitten und alle Baumhüllen genäht. Die Herstellung der Seile erfolgte durch die Meister & Cie AG, Hasle-Rüegsau, Schweiz. Frank Seltenheim, von Seilpartner GbR, Berlin, leitete die acht gleichzeitig arbeitenden Teams: zehn Kletterer, drei Baumpfleger und zwanzig Arbeiter.

As they have always done, Christo and Jeanne-Claude paid the expenses of the project themselves through the sale of original works to museums, private collectors and galleries. The artists do not accept any sponsorship.

The wrapping was removed on December 14, 1998 and the materials were recycled.

Christo and Jeanne-Claude have worked with trees for many years: In 1966, *Wrapped Trees* was proposed for the park adjacent to the Saint Louis Art Museum, Missouri, and the permission was denied. In 1969, the artists requested permission for *Wrapped Trees, Project for 330 Trees, Avenue des Champs-Élysées, Paris.* This was denied by Maurice Papon, Prefect of Paris. The *Wrapped Trees* in Riehen were the outcome of 32 years of effort.

The branches of the *Wrapped Trees* pushing the translucent fabric outward created dynamic volumes of light and shadow, moving in the wind with new forms and surfaces shaped by the ropes on the fabric.

Wie immer wurden die Kosten des Projekts von Christo und Jeanne-Claude durch den Verkauf von Originalkunstwerken an Museen, Privatsammler und Galerien selbst getragen. Die Künstler nehmen keinerlei Förderung jedweder Art an.

Am 14. Dezember wurden die Verhüllungen entfernt und alle Materialien wiederverwertet.

Christo und Jeanne-Claude arbeiten schon seit vielen Jahren mit Bäumen. Bereits im Jahr 1966 für den an das Saint Louis Art Museum in Missouri angrenzenden Park vorgeschlagen, wurde das Projekt *Wrapped Trees* damals nicht bewilligt. 1969 versuchten die Künstler, die Genehmigung für *Wrapped Trees, Project for 330 Trees, Avenue des Champs-Élysées, Paris*, zu erhalten. Das Vorhaben wurde jedoch von Maurice Papon, dem damaligen Präfekten von Paris, abgelehnt. Das Projekt *Verhüllte Bäume* in Riehen war das Ergebnis von 32 Jahren Anstrengung.

Die Äste der *Verhüllten Bäume* drückten das durchsichtige Gewebe nach außen und schufen so, geformt durch die Seile auf dem Stoff, neue Formen und Oberflächen sowie dynamische Volumina mit Licht und Schatten, die sich im Wind mit bewegten.

The Wall
1998–99

THE WALL
(Project for 13,600 oil
barrels, Gasometer Ober-
hausen, Germany), 1999,
Collage; pencil, enamel
paint, photograph by
Wolfgang Volz, wax crayon,
technical data, and tape,
35.5 × 28 cm
Photo: Wolfgang Volz

Collage; Bleistift, Email-
farbe, Fotografie von
Wolfgang Volz, Wachs-
kreide, technische
Angaben und Klebeband,
35,5 × 28 cm

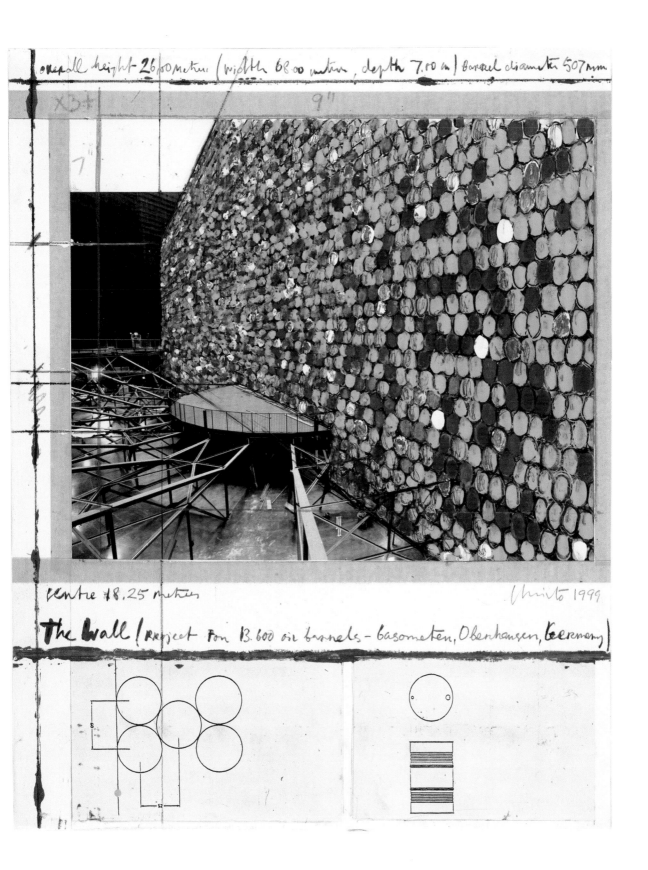

overall height 26,00 metres (width 68,00 metres, depth 7,00 m) Barrel diameter 507 mm

x3+

9"

7"

Centre +8.25 metres Christo 1999

The Wall (Project for 13.600 oil barrels - Gasometer, Oberhausen, Germany)

The indoor installation was completed on April 6, 1999 in the Gasometer Oberhausen and remained until mid-October 1999.

The Gasometer, one of the largest gas tanks in the world, 117 meters (384 feet) high by 68 meters (223 feet) in diameter, was built in 1928/29 to store the blast furnace gas (a by-product of the industrial processing of iron ore). Christo and Jeanne-Claude were invited by IBA Emscher Park Organization (founded by the state of North Rhine-Westphalia in 1989 to improve the infrastructure of the Ruhr region), to exhibit in the Gasometer Oberhausen.

The 13,000 oil barrel wall was 26 meters (85 feet) tall and 68 meters (223 feet) wide with a depth of 7.23 meters (23.7 feet), and spanned the distance from wall to wall of the Gasometer. The barrels (208 liter/ 55 gallon capacity each) were connected to a structural core made of steel scaffolding structure to which they were bolted. The entire wall of barrels was supported by steel pillars resting on the foundation of the Gasometer, and not connected to the steel structure of the Gasometer.

Die Inneninstallation im Gasometer Oberhausen war am 6. April 1999 vollendet und blieb bis Mitte 1999 bestehen.

Mit einer Höhe von 117 und einem Durchmesser von 68 Metern ist der Gasometer einer der größten der Welt. Er wurde 1928/29 zur Zwischenlagerung von Gas erbaut, das bei der Eisenverhüttung entsteht. Christo und Jeanne-Claude wurden von der IBA Emscher Park (1989 vom Land Nordrhein-Westfalen ins Leben gerufen, um die Infrastruktur des Ruhrgebietes zu verbessern) eingeladen, im Gasometer Oberhausen auszustellen.

Die Wand aus 13.000 Ölfässern war 26 Meter hoch und 68 Meter breit mit einer Tiefe von 7,23 Metern und füllte den Gasometer von Wand zu Wand. Die Fässer mit einem Fassungsvermögen von jeweils 208 Litern waren mit einer Unterkonstruktion aus Gerüstbauelementen verschraubt, die mit Hilfe von Schwerlaststützen auf dem Fundament des Gasometers ruhte. Dadurch stand die Fässerwand frei und ohne Verbindung zur Stahlkonstruktion des Gasometers.

The barrels had been specially painted in bright industrial yellow, deep orange, ultramarine blue, sky blue, rock gray, light ivory, and grass green. The barrels were stacked following a predetermined pattern. 45% of the barrels were yellow, 30% deep orange, and the remaining were painted in the other colors. The total weight of the wall was 300 tons. After the exhibition, *The Wall* was removed and all materials went back to their usual industrial uses.

The artists' friend and exclusive photographer, Wolfgang Volz, was the project director in charge of the planning and construction of *The Wall*.

Within the dark enclosure of the gas container the multicolored mosaic of 13,000 oil barrels stood out with luminosity.

Die Ölfässer hatten eine Speziallackierung in Signalgelb, Blutorange, Ultramarinblau, Himmelblau, Steingrau, Hellelfenbein und Grasgrün erhalten und wurden nach einem vordefinierten Muster gestapelt. 45% der Fässer waren signalgelb, 30% blutorange, und die übrigen waren in anderen Farben lackiert. Die Fässerwand mitsamt ihrer Unterkonstruktion wog 300 Tonnen. Nach dem Abbau wurden sämtliche Materialien in der Industrie wiederverwendet.

Der Freund und Exklusivfotograf der Künstler, Wolfgang Volz, war zugleich Projektleiter für die Planung und den Bau von *The Wall*.

In der dunklen Abgeschlossenheit des Gasbehälters stach das bunte Farbmosaik der 13.000 Ölfässer leuchtend hervor.

The Wall
1998–99

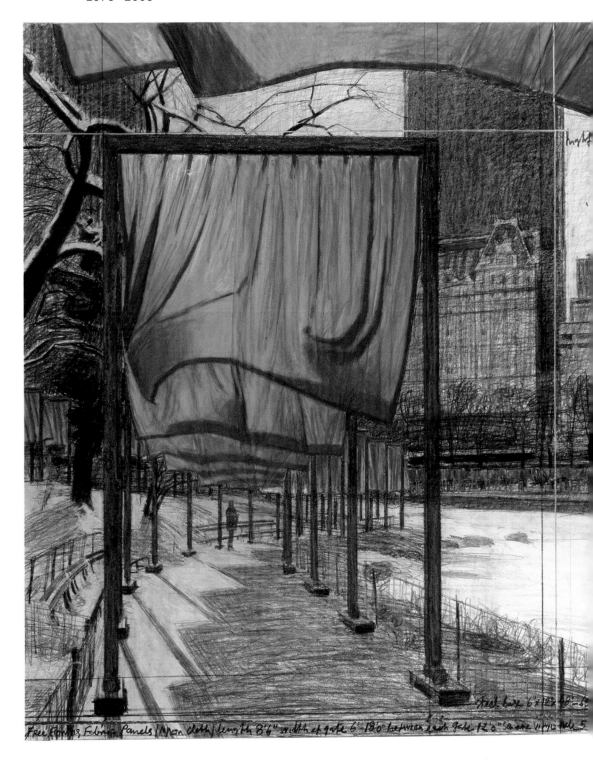

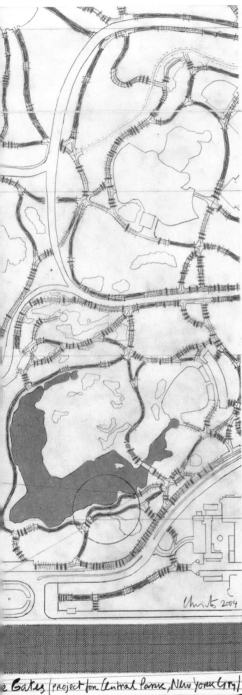

THE GATES
(Project for Central Park,
New York City), 2004
Collage; pencil, fabric,
wax crayon, charcoal,
enamel paint, pastel,
hand drawn map, tape,
and fabric sample
Two parts, 77.5 × 66.7 cm
and 77.5 × 30.5 cm
Photo: Wolfgang Volz

Collage, Bleistift, Stoff,
Wachskreide, Kohle,
Emailfarbe, von Hand
gezeichnete Karte, Klebe-
band und Stoffmuster
Zweiteilig, 77,5 × 66,7 cm
und 77,5 × 30,5 cm

THE GATES
(Project for Central Park,
New York City), 1998
Drawing; pencil, charcoal,
pastel, wax crayon, photo-
graph by Wolfgang Volz,
and aerial photograph
Two parts, 244 × 106.6 cm
and 244 × 38 cm
Photo: Wolfgang Volz

Zeichnung; Bleistift, Kohle,
Pastell und Wachskreide,
Fotografie von Wolfgang
Volz und Luftaufnahme
Zweiteilig, 244 × 106,6 cm
und 244 × 38 cm

THE GATES
(Project for Central Park,
New York City), 2001
Drawing; pencil, charcoal,
pastel, and wax crayon,
 35.2 × 38.7 cm
Photo: Wolfgang Volz

Bleistift, Kohle, Pastell und
Wachskreide, 35,2 × 38,7 cm

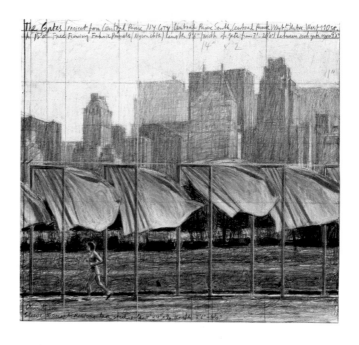

Free Flowing Fabric panels (Nylon cloth) suspended from top, width of gate 8'-20' height 15'0"
9'0" between each gate, Rectangular steel poles 42"x ⅛"

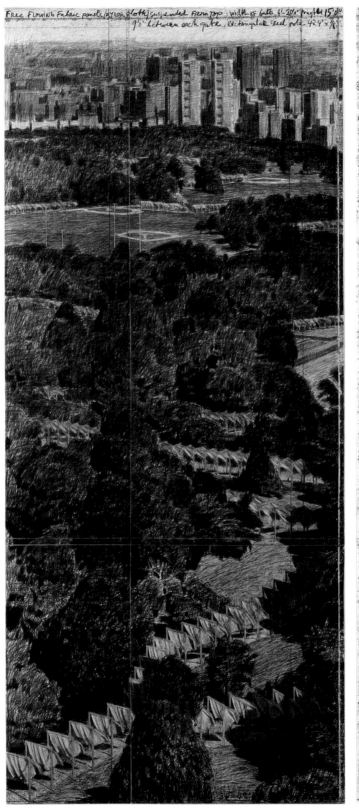

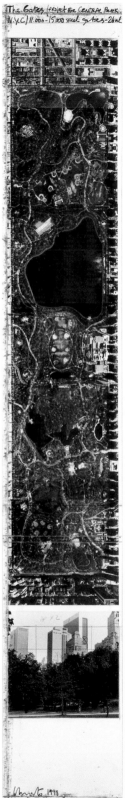

The Gates (project for CENTRAL PARK
N.Y.C) 11.000 - 15000 steel gates - 26mi

Christo 1998

THE GATES
Central Park, New York
City, 1979–2005

Central Park, New York
City, 1979–2005

The installation in Central Park was completed with the blooming of the 7,503 fabric panels on February 12, 2005. The 7,503 gates were 4.87 meters (16 feet) tall and varied in width from 1.68 to 5.48 meters (5 feet 6 inches to 18 feet) according to the 25 different widths of walkways, on 37 kilometers (23 miles) of walkways in Central Park. Free hanging saffron-colored fabric panels, suspended from the horizontal top part of the gates, came down to approximately 2.1 meters (7 feet) above the ground. The gates were spaced at 3.65 meter (12 foot) intervals, except where low branches extended above the walkways. *The Gates* and the fabric panels could be seen from far away through the leafless branches of the trees. The work of art remained for 16 days, then the gates were removed and the materials recycled.

The 12.7 cm (5 inch) square vertical and horizontal poles were extruded in 96.5 km (60 miles) of saffron-colored vinyl. The vertical poles were secured by 15,006 narrow steel base footings, 278 to 380 kilograms (613 to 837 pounds) each, positioned on the paved surfaces. No holes were made in the ground. The gates' components were fabricated, off-site, by seven manufacturers located on the East Coast of the USA. The weaving and sewing of the fabric panels was done in Germany.

In teams of eight, 600 workers wearing *The Gates* uniforms, were responsible for installing 100 gates per team. The monitoring and removal teams included an additional 300 uniformed workers.

Die Installationsarbeiten im Central Park wurden mit dem Erstrahlen von 7.503 Gewebebahnen am 12. Februar 2005 beendet. Die 7.503 Tore waren 4,87 Meter hoch, variierten in ihrer Breite entsprechend den 25 verschiedenen Breiten der Parkwege zwischen 1,68 und 5,48 Metern und standen auf 37 Kilometern Gehwegen im Central Park. Frei hängende safranfarbene Gewebebahnen schwebten von der oberen horizontalen Stange der Tore herab bis auf eine ungefähre Höhe von 2,1 Metern über dem Boden. Die Tore standen in Abständen von 3,65 Metern, außer dort, wo tiefe Äste über die Wege ragten. Die Tore und Gewebebahnen konnten von Weitem durch die blätterlosen Zweige der Bäume gesehen werden. Das Kunstwerk verblieb 16 Tage lang, dann wurden die Tore abgebaut und die Materialien recycelt.

Die quadratischen vertikalen und horizontalen Stangen mit einer Kantenlänge von 12,7 Zentimetern wurden aus safranfarbenem Vinyl in einer Gesamtlänge von 96,5 Kilometern extrudiert. Die senkrechten Stangen wurden durch 15.006 schmale Stahlsockelgewichte (278 bis 380 Kilogramm) gesichert, die auf den befestigten Wegen positioniert wurden. Es wurden keine Löcher in den Boden gebohrt. Die Komponenten der Tore wurden von sieben Herstellern an der amerikanischen Ostküste angefertigt. Die Stoffbahnen wurden in Deutschland gewebt und vernäht.

In Achterteams waren 600 Arbeiter in *The Gates*-Uniformen verantwortlich, jeweils 100 der Tore aufzubauen.

The monitors assisted the public and gave information. All workers were financially compensated and received breakfast and one hot meal a day. Professional security worked in the park after dark.

The Gates was entirely financed by Christo and Jeanne-Claude, as they have done for all their previous projects. The artists do not accept sponsorship or donations.

The grid pattern of the city blocks surrounding Central Park was reflected in the rectangular structure of the commanding saffron-colored poles while the serpentine design of the walkways and the organic forms of the bare branches of the trees were mirrored in the continuously changing rounded and sensual movements of the free flowing fabric panels in the wind.

The people of New York continued to use the park as usual. For those who walked through *The Gates*, following the walkways, the saffron-colored fabric was a golden ceiling creating warm shadows. When seen from the buildings surrounding Central Park, *The Gates* seemed like a golden river appearing and disappearing through the bare branches of the trees and highlighting the shape of the meandering footpaths.

Die Aufsichts- und die Abbaumannschaft umfassten zusätzlich 300 uniformierte Mitarbeiter.Aufsichtspersonen im Park waren den Besuchern behilflich und informierten über das Projekt. Alle Arbeiter wurden bezahlt und bekamen Frühstück und ein warmes Essen pro Tag. Nach Anbruch der Dunkelheit waren professionelle Sicherheitskräfte im Park präsent.

Wie alle vorangegnagen Projekte, wurde auch *The Gates* vollständig von Christo und Jeanne-Claude finanziert. Die Künstler akzeptieren keinerlei Sponsorengelder oder Spenden.

Die geometrische, gitterartige Anlage der den Central Park umgebenden Häuserblocks von Manhattan wurde durch die rechteckige Form der eindrucksvollen safranfarbenen Tore widergespiegelt, während die gewundenen Parkwege und die organischen Formen der kahlen Äste sich in den ständig wechselnden runden und sinnlichen Bewegungen der frei im Wind schwebenden Gewebebahnen wiederfanden.

Die New Yorker nutzten den Park weiter wie gewohnt. Für diejenigen, die durch *The Gates* gingen, den Parkwegen folgend, erschien der safranfarbene Stoff wie ein goldenes Dach, das warme Schatten warf. Der Blick von den Gebäuden rund um den Central Park ließ *The Gates* wie einen goldenen Fluss erscheinen, der immer wieder unter den nackten Ästen der Bäume verschwand und auftauchte und die Form der gewundenen Parkwege hervorhob.

THE FLOATING PIERS
(Project for Lake Iseo,
Italy), 2014
Collage; pencil, wax
crayon, enamel paint,
photograph by Wolfgang
Volz, map, fabric sample,
and tape, 43.2 × 55.9 cm
Photo: André Grossmann

Collage; Bleistift, Wachs-
kreide, Emailfarbe, Foto-
grafie von Wolfgang Volz,
Karte, Stoffmuster und
Klebeband, 43,2 × 55,9 cm

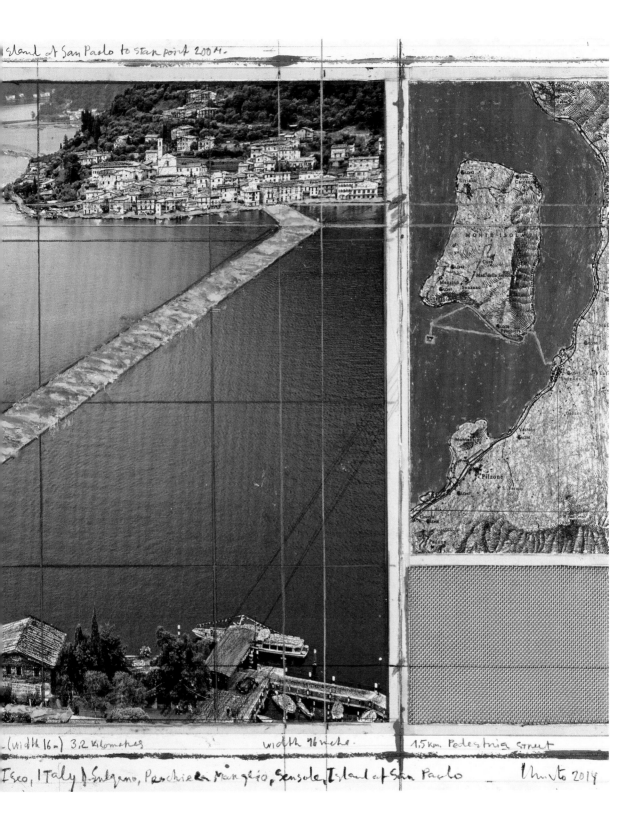

Island of San Paolo to start point 200 m.

(width 16 m) 3.2 kilometres width 16 metre. 1.5 km Pedestrian street

Iseo, Italy of Sulzano, Peschiera Maraglio, Sensole, Island of San Paolo _ Christo 2014

THE FLOATING PIERS
Lake Iseo, Italy,
2014–16

Lago Iseo, Italien,
2014–16

For sixteen days — June 18 through July 3, 2016—Italy's Lake Iseo was reimagined. 100,000 square meters (1 million square feet) of shimmering yellow fabric, carried by a modular floating dock system of 220,000 high-density polyethylene cubes, undulated with the movement of the waves as *The Floating Piers* rose just above the surface of the water.

Visitors were able to experience the work of art by walking on it from Sulzano to Monte Isola and to the island of San Paolo, which was framed by *The Floating Piers*. The mountains surrounding the lake offered a bird's-eye view of *The Floating Piers*, exposing unnoticed angles and altering perspectives. Lake Iseo is located 100 kilometers (62 miles) east of Milan and 200 kilometers (124 miles) west of Venice.

"Like all our projects, *The Floating Piers* was absolutely free and open to the public," said Christo. "There were no tickets, no openings, no reservations and no owners. The Floating Piers were an extension of the street and belonged to everyone."

A 3-kilometer-(1.9-mile)-long walkway was created as *The Floating Piers* extended across the water of Lake Iseo. The piers were 16 meters (52.5 feet) wide and approximately 35 centimeters (13.8 inches) high with sloping sides. The fabric continued along 2.5 kilometers (1.6 miles) of pedestrian streets in Sulzano and Peschiera Maraglio.

16 Tage lang – vom 18. Juni bis zum 3. Juli 2016 – wurde Italiens Iseosee mit neuem Leben erfüllt. 100.000 Quadratmeter schwimmendes gelbes Gewebe, getragen von einem modularen Docksystem aus 220.000 Schwimmwürfeln aus hoch verdichtetem Polyethylen, folgte dem Auf und Ab der Wellen. *The Floating Piers* bewegte sich so nur knapp über der Wasseroberfläche.

Die Besucher erlebten das Kunstwerk, indem sie auf den Stegen von Sulzano nach Monte Isola und zur Insel San Paolo spazierten, die von den *Floating Piers* eingerahmt wurde. Die Blicke von den Bergen rund um den See erlaubten, die *Floating Piers* aus der Vogelperspektive zu sehen; sie boten unerwartete Blickwinkel und wechselnde Perspektiven. Der Iseosee liegt 100 Kilometer östlich von Mailand und 200 Kilometer westlich von Venedig.

„Wie bei allen unseren Projekten war der Besuch von *The Floating Piers* vollkommen umsonst und offen für alle", so Christo. „Es gab keine Eintrittskarten, keine Eröffnungen, keine Reservierungen und keine Eigentümer. *The Floating Piers* war eine Verlängerung der Straße und die gehört jedem."

Indem sich die *Floating Piers* über das Wasser des Iseosees erstreckten, schufen sie einen drei Kilometer langen Gehweg. Die schwimmenden Stege waren 16 Meter breit, ragten etwa 35 Zentimeter aus dem See heraus und fielen zu den Seiten hin auf Wasserniveau ab. Der gelbe Stoff setzte sich auf den Gehwegen von Sulzano und Pesciera Maraglio fort.

"Those who experienced *The Floating Piers* felt like they were walking on water—or perhaps the back of a whale," said Christo. "The light and water transformed the bright yellow fabric to shades of red and gold throughout the sixteen days."

In the spring and summer of 2014, Christo, Vladimir Yavachev—Operations Director, Wolfgang Vol —Project Manager and Official Photographer, and Josy Kraft —Christo's Registrar, scouted the lakes of Northern Italy. Along with Project Director Germano Celant, they found Lake Iseo to be the most inspiring location. Since that time they worked alongside team members from around the world to realize *The Floating Piers*.

The Floating Piers was first conceived by Christo and Jeanne-Claude in 1970. It was Christo's first large-scale project since Christo and Jeanne-Claude realized *The Gates* in 2005, and since Jeanne-Claude passed away in 2009.

As with all of Christo and Jeanne-Claude's projects, *The Floating Piers* was funded entirely through the sale of Christo's original works of art. After the 16-day exhibition, all components were removed and industrially recycled.

„Diejenigen, die *The Floating Piers* erlebten, hatten das Gefühl, auf dem Wasser zu gehen oder auf dem Rücken eines Wals", so Christo. „An allen 16 Tagen verwandelten Licht und Wasser das leuchtend gelbe Gewebe in verschiedene Schattierungen von Rot und Gold."

Im Frühjahr und Sommer 2014 hatten Christo, Vladimir Yavachev (Technischer Leiter), Wolfgang Volz (Projektmanager und Exklusivfotograf) und Josy Kraft (Christos Registrar) die norditalienischen Seen besucht. Zusammen mit Projektdirektor Germano Celant wählten sie schließlich den Iseosee. Von diesem Moment an arbeiteten sie zusammen mit einem internationalen Team an der Realisierung von *The Floating Piers*.

The Floating Piers geht zurück auf eine Idee von Christo und Jeanne-Claude aus dem Jahre 1970. Es war Christos erstes Großprojekt, seit Christo und Jeanne-Claude zuletzt 2005 *The Gates* realisiert hatten, und außerdem das erste Projekt seit Jeanne-Claudes Tod 2009.

So wie bei allen Projekten von Christo und Jeanne-Claude wurde *The Floating Piers* ausschließlich mit dem Erlös aus dem Verkauf von Christos Originalkunstwerken finanziert. Nach 16 Tagen Ausstellungszeit wurden alle Bestandteile wieder entfernt und industriell recycled.

OVER THE RIVER
(Project for the Arkansas
River, State of Colorado),
1999
Drawing; pencil, pastel,
charcoal, wax crayon,
and topographic map
Two parts, 165 × 106.6 cm
and 165 × 38 cm
Photo: Wolfgang Volz

Zeichnung; Bleistift,
Pastell, Kohle, Wachs-
kreide und topografische
Karte
Zweiteilig, 165 × 106,6 cm
und 165 × 38 cm

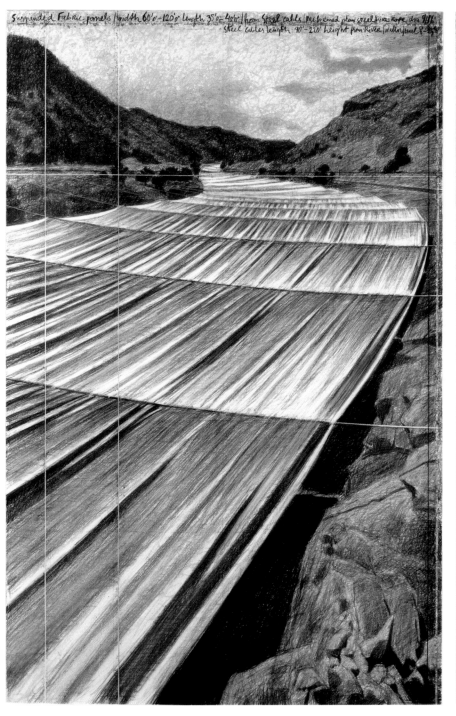

Suspended Fabric panels / width 60'0"-120'0" length 35'0"-40'0" / from Steel cables / each cmad plain steel wire rope dia 9/16"
- Steel cables length 90'-220' height from River / Water level 8-25ft

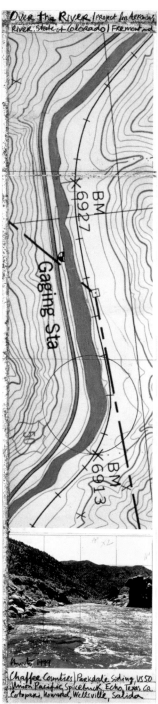

Over the River / project for Arkansas River, State of Colorado / Fremont and

BM 6927

Gaging Sta

BM 6913

Christo 1999

Chaffee Counties / Parkdale Siding, US 50
Union Pacific Spikebuck, Echo, Texas Cr.
Cotopaxi, Howard, Wellsville, Salida

OVER THE RIVER
(Project for the Arkansas
River, State of Colorado),
1999
Collage; pencil, pastel,
wax crayon, charcoal,
fabric, and topographic
map
Two parts, 30.5 × 77.5 cm
and 66.7 × 77.5 cm
Photo: Wolfgang Volz

Collage; Bleistift, Pastell,
Wachskreide, Kohle, Stoff
und topografische Karte
Zweiteilig, 30,5 × 77,5 cm
und 66,7 × 77,5 cm

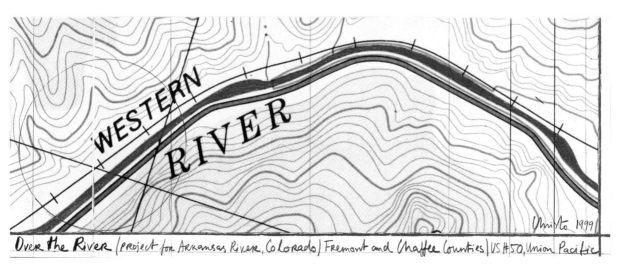

WESTERN RIVER

Christo 1999

Over the River (project for Arkansas River, Colorado) Fremont and Chaffee Counties / US #50, Union Pacific

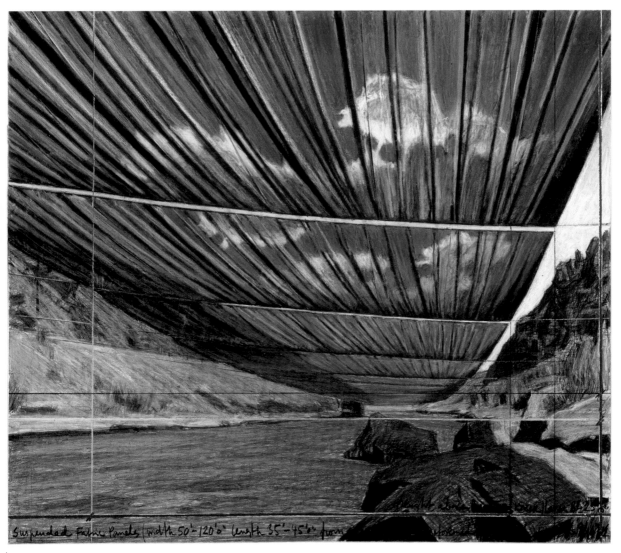

Suspended Fabric Panels (width 50'-120'0" length 35'-45'0" from

OVER THE RIVER
(Project for the Arkansas
River, State of Colorado),
1997
Drawing; pencil, pastel,
charcoal, photographs
by Wolfgang Volz, topo-
graphic map, wax crayon,
and tape
Two parts, 38 × 244 cm
and 106.6 × 244 cm
Photo: Wolfgang Volz

Zeichnung; Bleistift,
Pastell, Kohle, Fotogra-
fien von Wolfgang Volz,
topografische Karte,
Wachskreide und Klebe-
band
Zweiteilig, 38 × 244 cm
und 106,6 × 244 cm

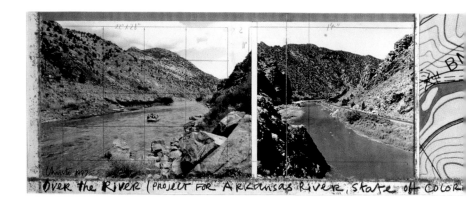

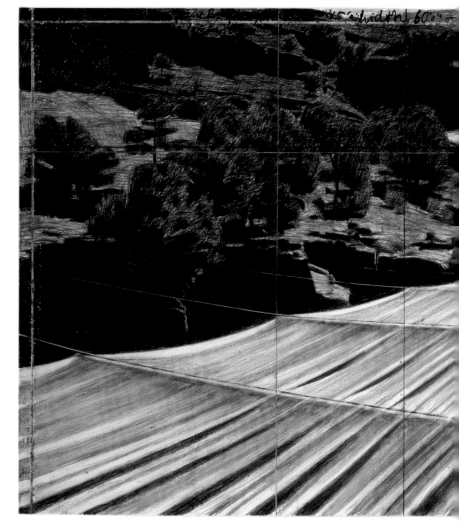

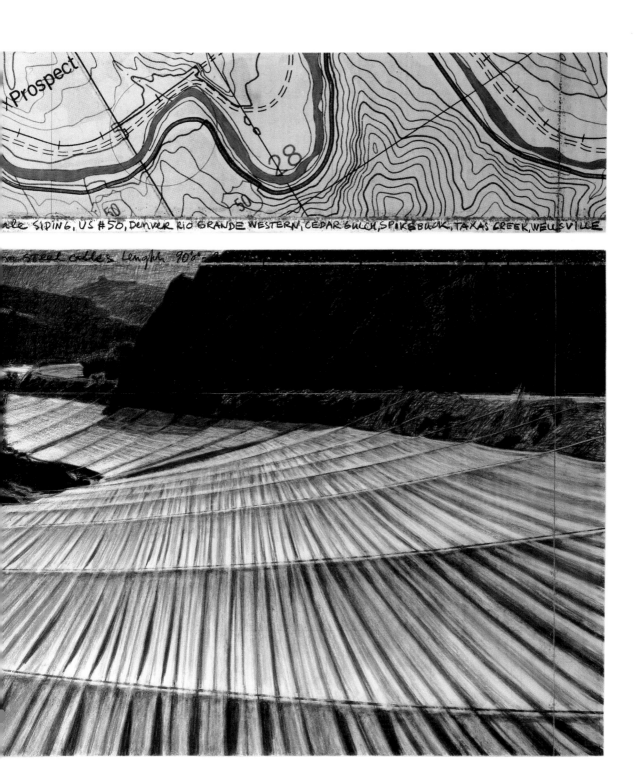

xProspect

ale SIDING, US #50, DENVER RIO GRANDE WESTERN, CEDAR GULCH, SPIKEBUCK, TAXAS CREEK, WELLSVILLE

in steel cables, Length, 90'0"

OVER THE RIVER
Project for the Arkansas
River, State of Colorado
Project not realized

Projekt für den Arkansas-
Fluss, Bundesstaat
Colorado
Nicht realisiertes Projekt

Christo and Jeanne-Claude's vision for *Over The River* was conceived in 1992 and included 9.5 kilometers (5.9 miles) of silvery, luminous fabric panels to be suspended clear of and high above the water in eight distinct areas along a 67.6-kilometer (42-mile) stretch of the Arkansas River between Cañon City and Salida in south-central Colorado.

In August 1992, 1993 and 1994, in search of a site for the project, Christo and Jeanne-Claude and their team traveled 22,530 kilometers (14,000 miles) in the Rocky Mountains in the United States. On those trips, the team prospected eighty-nine rivers, in seven states, and six possible locations were found. After visiting the six sites again in the summer of 1996, the Arkansas River in Colorado was selected.

Christo received all federal, state and local permits necessary to realize *Over The River* in 2011, when the US Department of the Interior announced its Record of Decision. This federal action was the final step of an Environmental Impact Statement (EIS), which is usually reserved for major infrastructures such as bridges, highways, dams and airports. The EIS for *Over The River*, the first ever completed for a work of art, began in the spring of 2009 and was prepared by the Bureau of Land Management, Royal Gorge Field Office, resulting in a 1,686 page comprehensive analysis.

Christo und Jeanne-Claudes Idee für *Over The River* entstand 1992 und sah vor, den Arkansas-Fluss im Bundesstaat Colorado zwischen Cañon City und Salida mit silber-glänzenden Stoffbahnen zu bedecken. Dabei sollte der Wasserlauf hoch über dem Flussbett auf einer Gesamtlänge von 67,6 Kilometern in acht Abschnitten von insgesamt 9,5 Kilometern überspannt werden.

Im August 1992, 1993 und 1994 reisten Christo und Jeanne-Claude mit ihrem Team auf der Suche nach einem geeigneten Fluss 22.530 Kilometer durch die Rocky Mountains in den Vereinigten Staaten. Während dieser Ausflüge begutachtete das Team 89 Flüsse in sieben Bundesstaaten, um schließlich sechs mögliche Standorte zu bestimmen. Nachdem sie die Gegenden im Sommer 1996 erneut besucht hatten, wurde der Arkansas-Fluss in Colorado für am geeignetsten befunden.

Im Jahr 2011 erhielt Christo mit einer Beschlusslage des US-Innenministeriums alle nötigen bundesstaatlichen, staatlichen und kommunalen Genehmigungen, um *Over The River* zu realisieren. Diese bundesstaatliche Verfügung war der letzte Schritt einer Umweltverträglichkeitsprüfung (UVP), die normalerweise großen Infrastrukturmaßnahmen wie dem Bau von Brücken, Autobahnen, Dämmen oder Flughäfen vorbehalten ist. Die UVP für *Over The River*, die erste, die jemals für ein Kunstwerk vorgenommen wurde, begann im Frühjahr 2009 und wurde vom Royal Gorge Field Office des US-Landes-

In 2012, a local group opposed to this temporary work of art filed lawsuits against Colorado State Parks in State Court and against the United States Federal Government, Bureau of Land Management, in U.S. Federal Court. In January 2017, after pursuing *Over The River, Project for the Arkansas River, State of Colorado* for 20 years and going through five years of legal arguments, Christo decided to no longer wait for the outcome and devote all of his energy, time and resources into the realization of *The Mastaba, Project for United Arab Emirates.*

verwaltungsamtes angefertigt. Sie mündete in einer umfassenden 1.686-seitigen Studie.

Im Jahr 2012 verklagte eine lokale Gruppe, die das zeitlich begrenzte Kunstwerk ablehnte, die Colorado State Parks auf Länderebene und die Regierung der USA auf Bundesebene. Im Januar 2017, nach 20 Jahren Ringen um *Over The River* und fünf Jahren rechtlicher Auseinandersetzungen, entschied sich Christo, nicht länger auf den Ausgang zu warten und stattdessen seine ganze Energie, Zeit und Ressourcen in die Realisierung von *The Mastaba, Projekt für die Vereinigten Arabischen Emirate* zu investieren.

The Mastaba
A Project for Abu Dhabi
Work in progress since 1977

OTTERLO MASTABA
(Project for the Kröller-
Müller Museum, Otterlo),
1973
Drawing; pencil, charcoal,
and crayon, 71 × 56 cm
Photo: Eeva-Inker

Zeichnung; Bleistift,
Kohle und Zeichenstift,
71 × 56 cm

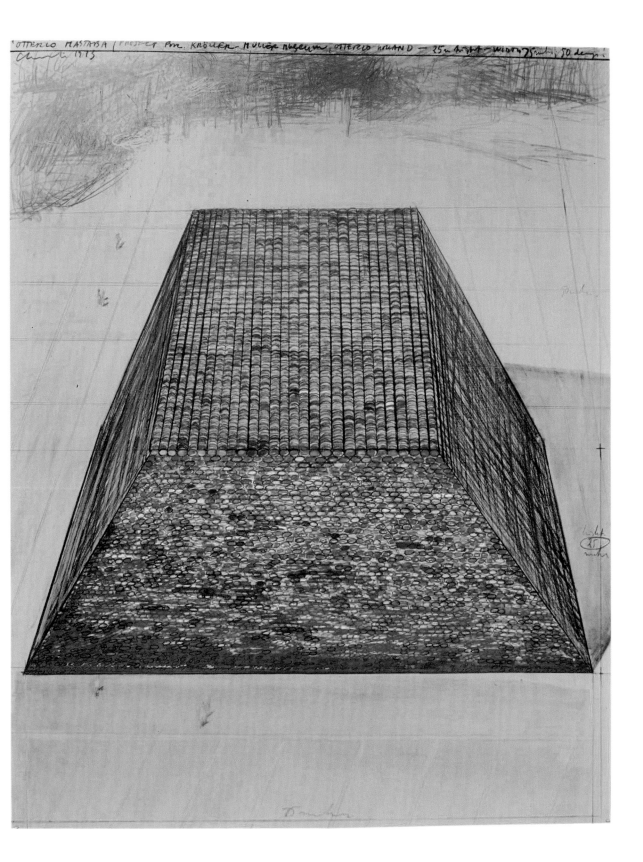

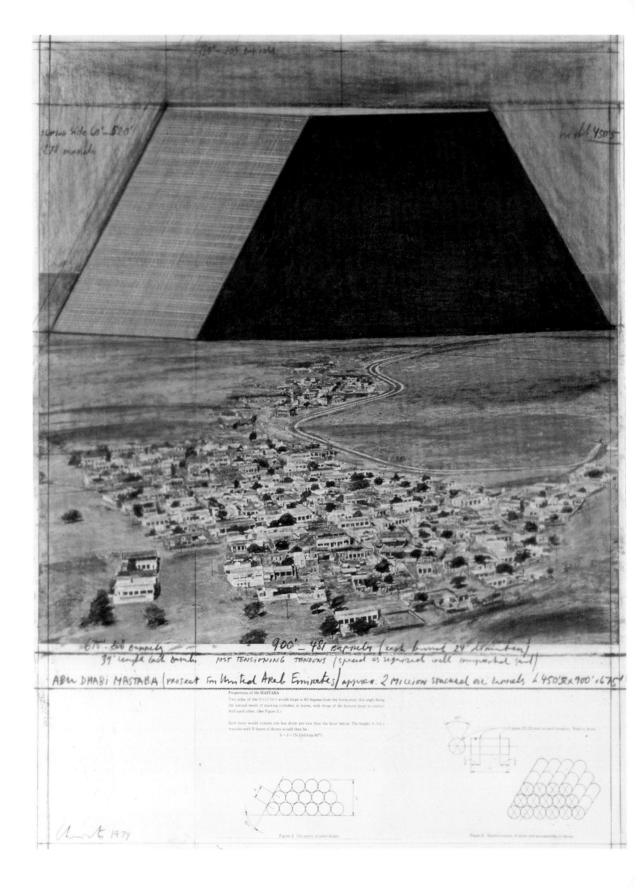

ABU DHABI MASTABA (project for United Arab Emirates) approx. 2 million stacked oil barrels h.450'8"x900'x675'

THE MASTABA OF
ABU DHABI
(Project for United Arab
Emirates), 1979
Collage; pencil, wax cray-
on, photostat from a
photograph, pastel, char-
coal, and technical data,
80 × 60.5 cm
Photo: Wolfgang Volz

Collage; Bleistift, Wachs-
kreide, Kopie einer Foto-
grafaie, Pastell, Kohle und
technische Angaben,
80 × 60,5 cm

THE MASTABA OF
ABU DHABI
(Project for United Arab
Emirates), 1978
Drawing; pencil, charcoal,
pastel, color pencil, and
map
Two parts, 38 × 244 cm
and 106.6 × 244 cm
Photo: André Grossman

Zeichnung; Bleistift, Kohle,
Pastell, Buntstift, und
Karte
Zweiteilig, 38 × 244 cm
und 106,6 × 244 cm

POST TENSIONING tendons (special as required) Top Width 126.8 meter (416 Feet) h. 150 M.
224 barrels 492 Ft.

Sloping side 60°

225 M. 300 meter (984 Ft) 523 barrels each barrel 61cm⌀
738 FT.

Christo 1979

THE MASTABA OF ABU DHABI (project for United Arab Emirates) 390.500 stacked oil Barrels

THE MASTABA OF
ABU DHABI
(Project for United Arab
Emirates), 1979
Drawing; pencil, charcoal,
pastel, wax crayon, and
map, 36 × 28 cm
Photo: André Grossman

Zeichnung; Bleistift,
Kohle, Pastell, Wachskrei-
de und Karte, 36 × 28 cm

THE MASTABA
(Project for United Arab
Emirates), 2008
Collage; pencil, wax cray-
on, pastel, charcoal, wash,
and tape, 35.3 × 39.4 cm
Photo: Wolfgang Volz

Collage; Bleistift, Wachs-
kreide, Pastell, Kohle,
Tusche und Klebeband,
35,3 × 39,4 cm

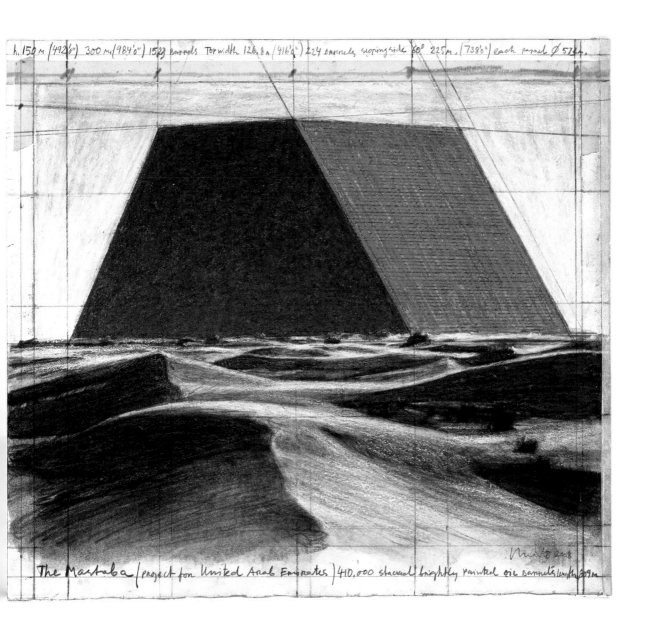

h. 150 m (492'0") 300 m (984'0") 1523 barrels Top width 126.8m (416'0") 224 barrels sloping side 60° 225m. (738'0") each barrel ⌀ 57cm.

The Mastaba (project for United Arab Emirates) 410,000 stacked brightly painted oil barrels length 300m

THE MASTABA
Project for United
Arab Emirates
Work in progress

Projekt für die Vereinigten
Arabischen Emirate
Arbeit in Vorbereitung

The Mastaba, a project for Abu Dhabi, was conceived in 1977.

It will be the largest sculpture in the world, made from 410,000 multi-colored barrels to form a mosaic of bright sparkling colors, echoing Islamic architecture. The mastaba is an ancient and familiar shape to the people of the region.

The Mastaba will be 150 meters (492 feet) high, 225 meters (738 feet) deep at the 60 degree slanted walls and 300 meters (984 feet) wide at the vertical walls. The top of *The Mastaba* will be a horizontal surface 126.8 meters (416 feet) wide and 225 meters (738 feet) deep.

The colors and the positioning of the 55-gallon steel barrels were selected by Christo and Jeanne-Claude in 1979, the year in which the artists visited the Emirate for the first time.

The proposed area is inland, in Al Gharbia (Western Region) approximately 160 kilometers (100 miles) south of the city of Abu Dhabi, near the oasis of Liwa.

In 2007 and 2008, Christo and Jeanne-Claude contracted professors of engineering from ETH Zürich (Swiss Federal Institute of Technology Zurich), University of Illinois at Urbana-Champaign in the US, Cambridge University in the UK and Hosei University in Tokyo, Japan, to prepare structural feasibility studies about *The Mastaba*. All four teams worked independently and did not know of each other.

The Mastaba, ein Projekt für Abu Dhabi, hat seinen Ursprung im Jahr 1977.

Es wird die größte Skulptur der Welt werden, bestehend aus 410.000 Fässern unterschiedlicher Farbe, die zusammen ein leuchtendes Mosaik formen, das an islamische Architektur erinnert. Die geometrische Form einer Mastaba ist der lokalen Bevölkerung gemeinhin vertraut.

The Mastaba wird 150 Meter hoch sein, 225 Meter tief an den um 60 Grad geneigten Wänden sowie 300 Meter breit an den vertikalen Wänden. Das Dach der Mastaba bildet eine horizontale Ebene mit einer Breite von 126,8 Metern und einer Tiefe von 225 Metern.

Die Farben und die genaue Position der Fässer, die ein Fassungsvermögen von je 208 Liter haben, wurde bereits 1979 von Christo und Jeanne-Claude bestimmt, das Jahr, in dem die beiden Künstler zum ersten Mal das Emirat besuchten.

Der vorgeschlagene Standort liegt im Landesinneren, in Al Gharbia (Western Region), etwa 160 Kilometer südlich der Stadt Abu Dhabi, nahe der Liwa-Oase.

In den Jahren 2007 und 2008 beauftragten Christo und Jeanne-Claude Professoren für Ingenieurwissenschaften der ETH Zürich, Schweiz, der Universität von Illinois in Urbana und Champaign in den USA, der Universität Cambridge in Großbritannien und der Hosei-Universität in Tokio, Japan, damit, Machbarkeitsstudien über die Mastaba zu erarbeiten. Jedes der vier Teams arbeitete unabhängig und ohne von den anderen zu wissen.

The artists then hired the German engineering firm, Schlaich Bergermann und Partner, in Stuttgart, to analyze these reports. The Hosei University concept was found to be the most technically sound and innovative. The entire substructure as well as the layer of barrels will be assembled flat on the ground. Ten elevation towers will make it possible to raise the entire structure on rails to its final position in about three to four days.

In 2012, Christo commissioned PricewaterhouseCoopers to conduct analyses on the social and economic benefits of *The Mastaba*.

Christo and Jeanne-Claude's relationship with Abu Dhabi goes back to 1979 when they first visited the Emirate. They have returned many times since, creating a longstanding friendship with the people of Abu Dhabi.

The Mastaba will be Christo and Jeanne-Claude's only permanent large-scale work.

Anschließend beauftragten die Künstler das Ingenieurbüro Schlaich Bergermann und Partner, Stuttgart, damit, die vorliegenden Studien zu evaluieren. Es stellte sich heraus, dass das Konzept der Hosei-Universität das technisch ausgereifteste und innovativste ist. Die gesamte Unterkonstruktion sowie die Ölfässer selbst werden demnach flach auf dem Boden vormontiert. Zehn Türme machen es anschließend möglich, die auf Gleisen ruhende Struktur innerhalb von drei oder vier Tagen in ihre finale Position zu heben.

Im Jahr 2012 beauftragte Christo PricewaterhouseCoopers damit, eine Studie über den sozialen und ökonomischen Nutzen von *The Mastaba* zu erstellen.

Christo und Jeanne-Claudes Beziehung zu Abu Dhabi reicht zurück bis ins Jahr 1979, als sie das Emirat erstmals besuchten. Seitdem sind sie viele Male zurückgekehrt und haben eine anhaltende Freundschaft zu den Menschen vor Ort aufgebaut.

The Mastaba wird Christo und Jeanne-Claudes einziges dauerhaftes Großprojekt werden.

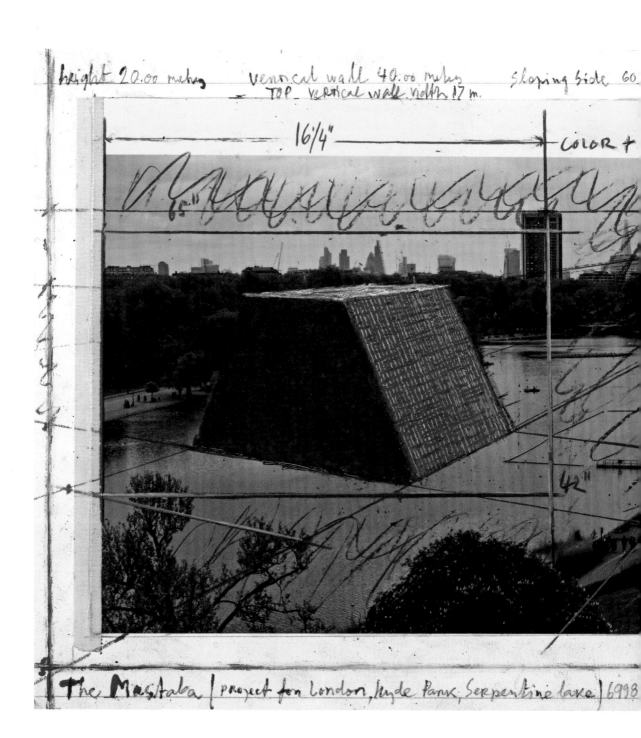

THE MASTABA
(Project for London, Hyde
Park, Serpentine Lake),
2017
Collage; pencil, wax
crayon, enamel paint,
color photograph by
Wolfgang Volz, tape
21.5 × 28 cm

Collage; Bleistift, Wachs-
kreide, Emailfarbe, Farb-
fotografie von Wolfgang
Volz, Klebeband
21,5 × 28 cm

THE MASTABA
London, Hyde Park,
Serpentine Lake, 2018

London, Hyde Park,
Serpentine-See, 2018

From June 18 to September 23, 2018, Christo and Jeanne- Claude's temporary sculpture, *The London Mastaba*, floated atop Hyde Park's Serpentine Lake in the center of London. The temporary sculpture, Christo's first major public outdoor work in the UK, coincided with an exhibition at the Serpentine Galleries detailing Christo and Jeanne-Claude's 60-year history of working with oil barrels.

The London Mastaba consisted of 7,506 horizontally stacked barrels on a floating platform in the Serpentine Lake. The sculpture's floating platform was made from interlocking high-density polyethylene cubes. On top of the platform, a steel scaffolding frame was constructed on which the barrels were attached.

Vom 18. Juni bis zum 23. September 2018 schwamm Christo und Jeanne-Claudes temporäre Skulptur *The London Mastaba* auf dem Serpentine-See im Londoner Hyde Park im Zentrum der Metropole.

Es handelte sich um das erste für den Außenraum konzipierte Kunstwerk, das Christo in Großbritannien realisieren konnte. Parallel dazu zeigten die Serpentine Galleries eine Ausstellung über die Entwicklung und 60-jährige Geschichte von Christo und Jeanne-Claudes Ölfässer-Projekten.

The London Mastaba bestand aus insgesamt 7 506 horizontal gestapelten Fässern, die mit Hilfe einer schwimmenden Plattform auf dem Serpentine-See schwammen. Die Plattform selbst bestand aus modularen Schwimmwürfeln aus hoch verdichtetem Polyethylen. Die Fässer waren im Inneren mit einem Gerüst verbunden, das auf der Plattform ruhte.

The massive sculpture, weighing a total of 600 metric tons (660 US tons), was anchored to the lakebed with 32 anchors. Its footprint covered approximately 1% of the total surface area of the lake.

As with all of Christo and Jeanne-Claude's projects, *The London Mastaba*, Serpentine Lake, Hyde Park, 2016–18 was funded entirely through the sale of Christo's original works of art. No public money is used for Christo's projects and he does not accept sponsorship.

Die Skulptur wog insgesamt 600 Tonnen und wurde durch 32 Anker auf dem Boden des Sees in Position gehalten. Die Grundfläche der Mastaba bedeckte ungefähr 1% der Oberfläche des Sees.

Wie bei allen Projekten von Christo und Jeanne-Claude wurde auch *The London Mastaba*, Serpentine Lake, Hyde Park, 2016–18 ausschließlich durch den Verkauf von Christos Originalkunstwerken finanziert. Christo akzeptiert keine Sponsorengelder oder Geld aus öffentlicher Hand.

The Mastaba, London Hyde Park
2018

L'Arc de Triomphe, Wrapped
2020

L'ARC DE TRIOMPHE,
WRAPPED
(Project for Paris, Place
de l'Etoile – Charles de
Gaulle), 2019
Collage; pencil, wax cray-
on, enamel paint, photo-
graph by Wolfgang Volz,
map, and tape,
43.2 × 55.9 cm
Photo: André Grossmann

Collage; Bleistift, Wachs-
kreide, Emailfarbe, Foto-
grafie von Wolfgang Volz,
Karte und Klebeband,
43,2 × 55,9 cm

ARC DE TRIOMPHE
WRAPPED
(Project for Paris), 1989
Lithograph with collage
of broadcloth, thread,
and city map, with addi-
tions of charcoal and
prismacolor, 71 × 55.5 cm

Lithografie mit Collage aus
Walkstoff, Garn und Stadt-
plan, mit Hinzufügungen
von Kohle und Prisma-
colorfarben, 71 × 55,5 cm
Ed. 109/150

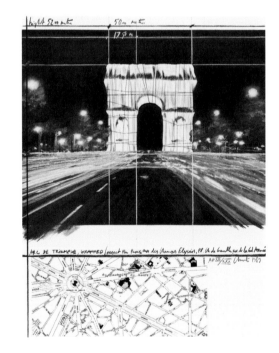

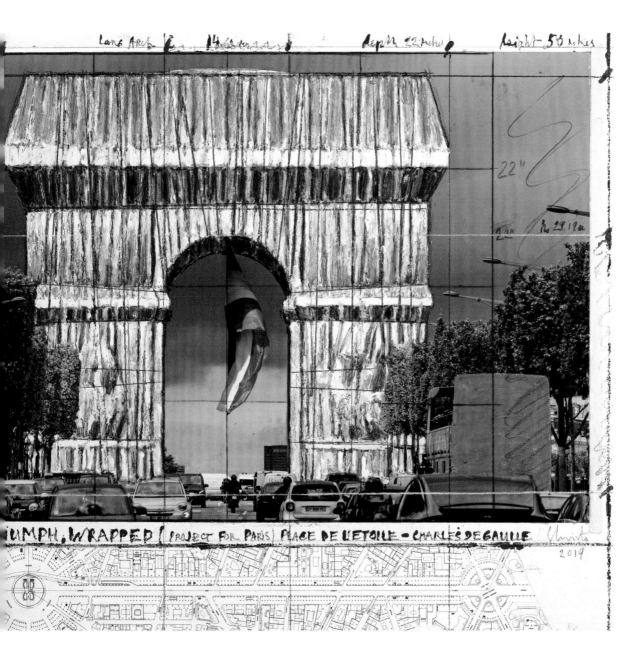

TRIUMPH, WRAPPED (PROJECT FOR PARIS) PLACE DE L'ETOILE – CHARLES DE GAULLE

2019

L'ARC DE TRIOMPHE,
WRAPPED
Project for Paris 2020

Projekt für Paris 2020

In 1961, Christo and Jeanne-Claude made their first proposal for wrapping a public building. Christo was living in a rented maid's room near the Arc de Triomphe. He completed several photomontages, including one in 1962 from a photograph of the Avenue Foch with the Arc de Triomphe wrapped, at night. There are also different works created in 1970 and 1989 showing different views of the wrapped monument.

This project remained in Christo and Jeanne-Claude's hearts, though they never applied for permission to realize it until 2018. In April 2019, permission was granted by the French government's Centre des Monuments Nationaux to realize *L'Arc de Triomphe, Wrapped*. The project will be on view for 16 days from September 19 to October 4, 2020.

1961 machten Christo und Jeanne-Claude erstmals den Vorschlag, ein öffentliches Gebäude zu verhüllen. Christo lebte damals in einem angemieteten Dienstmädchenzimmer in der Nähe des Triumphbogens. Er fertigte mehrere Fotomontagen zur Illustration seines Vorhabens, darunter 1962 auch eine Aufnahme der Avenue Foch mit einer Darstellung des verhüllten Triumphbogens bei Nacht. Weitere Arbeiten mit unterschiedlichen Ansichten des verhüllten Denkmals entstanden 1970 und 1989.

Das Projekt blieb stets in Christo und Jeanne-Claudes Herzen, doch erst im Jahr 2018 bemühte sich Christo offiziell um eine Genehmigung. Im April 2019 schließlich erteilte das Centre des Monuments Nationaux, die Verwaltungsbehörde der französischen Nationaldenkmäler, die Genehmigung zur Realisierung des *L'Arc de Triomphe, Wrapped*. Das Projekt wird vom 19. September bis 4. Oktober 2020 für sechzehn Tage zu sehen sein.

As a prelude to L'Arc de Triomphe, Wrapped, a major exhibition, presented at the Centre Georges Pompidou from March 18 to June 15, 2020, will retrace Christo and Jeanne-Claude's years in Paris from 1958 to 1964, as well as the story of *The Pont Neuf Wrapped*, Paris, 1975–85.

The Arc will be wrapped in 25,000 square meters (269,000 square feet) of bluish-silver-colored woven polypropylene fabric and 7,000 meters (23,000 feet) of red polypropylene rope.

The Arc de Triomphe de l'Étoile (Triumphal Arch of the Star) is one of the most iconic national monuments in France, located at the western end of the Champs-Élysées at the center of Place Charles de Gaulle. The Arc de Triomphe, built in the early 19th century, honors French soldiers who have given their lives since the French Revolution.

As Christo and Jeanne-Claude have always done for their previous projects, *L'Arc de Triomphe, Wrapped* will be entirely financed by Christo (through his CVJ Corporation) through the sale of his preparatory studies, drawings, collages, and scale models, earlier works of the 1950s and 1960s, and original lithographs on other subjects. The artist does not accept sponsorship of any kind.

Als Auftakt des Projekts präsentiert das Centre Georges Pompidou vom 18. März bis zum 15. Juni 2020 eine groß angelegte Ausstellung über Christo und Jeanne-Claudes Pariser Jahre von 1958 bis 1964 sowie die Dokumentationsausstellung zum Projekt *The Pont Neuf Wrapped*, Paris, 1975–85.

Der Triumphbogen wird mit 25.000 Quadratmetern silberfarbenem, blau schimmerndem Polypropylengewebe und 7.000 Metern rotem Polypropylenseil verhüllt.

Der Arc de Triomphe de l'Étoile ist eines der bekanntesten Monumente Frankreichs. Er befindet sich am westlichen Ende der Champs-Élysées im Zentrum des Place Charles de Gaulle. Erbaut Anfang des 19. Jahrhunderts, ehrt der Triumphbogen die französischen Soldaten, die seit der Französischen Revolution ihr Leben gelassen haben.

Wie bei allen Projekten von Christo und Jeanne-Claude wird auch der *L'Arc de Triomphe, Wrapped* ausschließlich durch den Verkauf von Christos Vorstudien, Zeichnungen, Collagen, Modellen, Originallithografien und frühen Werken aus den 1950er- und 1960er-Jahren finanziert. Christo akzeptiert keine Form der Sponsorenfinanzierung.

Matthias
Koddenberg

The Wrapping of the Reichstag as a Mirror of History

Die Reichstagsverhüllung als Spiegel der Geschichte

"In the *Wrapped Reichstag* each German
will mirror himself."[1]

„Im *Verhüllten Reichstag* wird sich jeder
Deutsche widerspiegeln."[1]

Willy Brandt

In 1995, the year in which Christo and Jeanne-Claude celebrated their greatest triumph to date, I celebrated my eleventh birthday. Back then I had little to do with art, if anything at all. That would change quickly. That summer, pictures of the *Wrapped Reichstag* flickered across the world's TV channels. I had no idea of the scope of this project at the time, or of the artists responsible for it. And these things didn't interest me. What I saw on television was fascinating, breathtaking—breathtakingly beautiful! When the Reichstag was wrapped in June 1995, art suddenly meant everything to me. At an age when my friends hung posters of *Take That* or the *Backstreet Boys* over their beds, I started filling my walls with photos of Christo and Jeanne-Claude's projects. A little later, with almost childlike naivety, I wrote a letter to a certain Christo and a certain Jeanne-Claude, New York City, USA. What did I want? An autograph. What did I get? A friendship that has grown steadily to this day. In the twenty-five years that have passed since then, Christo and Jeanne-Claude have become an inseparable part of my life, shaping my thoughts and actions.

1995, in jenem Jahr, in dem Christo und Jeanne-Claude ihren bis dato größten Triumph feierten, beging ich meinen elften Geburtstag. Mit Kunst hatte ich damals reichlich wenig zu tun, um nicht zu sagen: gar nichts. Das sollte sich schlagartig ändern. Über die TV-Kanäle dieser Welt flimmerten in jenem Sommer Bilder des *Verhüllten Reichstags*. Ich hatte damals weder eine Vorstellung von der Tragweite dieses Projekts, noch von den Künstlern, die dafür verantwortlich zeichneten. Es interessierte mich auch nicht. Was ich dort im Fernsehen sah, war für sich faszinierend, atemberaubend – atemberaubend schön! Als der Reichstag im Juni 1995 verhüllt wurde, bedeutete Kunst auf einmal mein Leben. In einem Alter, in dem meine Freunde sich Poster von *Take That* oder den *Backstreet Boys* über ihr Bett hängten, fing ich an, meine Wände mit Fotos von Christo und Jeanne-Claudes Projekten zu füllen. Mit fast kindlicher Naivität schrieb ich wenig später einen Brief an einen gewissen Mr. Christo und eine gewisse Ms. Jeanne-Claude, New York City, USA. Was ich wollte? Ein Autogramm. Was ich bekam? Eine Freundschaft, die bis heute stetig gewachsen ist. In den 25 Jahren, die seitdem vergangen sind, wurden Christo und Jeanne-Claude zu einem untrennbaren Teil meines Lebens, haben mein Denken und Handeln geprägt.

[1] Willy Brandt, quoted from *Christo und Jeanne-Claude: Dem Deutschen Volke. Verhüllter Reichstag 1971–1995*, DVD, EstWest Film & Video Production 2004.

[1] Willy Brandt, zitiert nach: Wolfram Hissen und Jörg Daniel Hissen, *Christo und Jeanne-Claude: Dem Deutschen Volke. Verhüllter Reichstag 1971–1995*, DVD, EstWest Film & Video Production 2004.

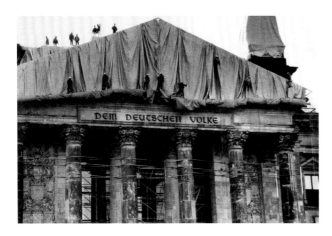

2 Christo, quoted from
P. K. "Verpacktes Denk-
mal, enthüllte Gedanken,"
Die Zeit (March 25, 1977).

3 Christo, quoted from
Henno Lohmeyer and
Felix Schmidt, *Eulen-
spiegel oder Revolutio-
när? Im Gespräch mit
dem Verhüllungskünstler
Christo*, Berlin 1993,
p. 13.

4 K. D., "Schindluder-
treiben mit der deutschen
Geschichte," *Deutsche
Wochenzeitung* (April 8,
1977).

5 Christo, quoted from
Lohmeyer and Schmidt
1993, pp. 30f.

When Jeanne-Claude died in November 2009, it was not so much the loss of one of the most important artists of the twentieth and twenty-first centuries that hurt; it was above all the person who was missing, the person to whom I owe so much. Jeanne-Claude and I were forty-nine years apart, almost half a century. Her spirit, her esprit, and her acumen were that of a teenager. To this day, it is impossible to speak of Christo in the singular.

In response to my letter, I received a parcel filled with postcards, books, and catalogs. For the first time, I learned of the decades of struggle that preceded the realization of the Reichstag project. The project had occupied Christo and Jeanne-Claude for almost a quarter century. There were countless negotiations, meetings, failures, and three rejections before, in February 1994, the German parliament voted on the project in a seventy-minute debate and finally approved its realization by 292 votes to 223. Until then, the project had existed only as an idea in the minds of two artists, as a fixed idea that had a strong impact on their lives, to which they sacrificed their money, time, and energy. Some call it madness, megalomania, or waste. Christo calls it passion.

Als Jeanne-Claude im November 2009 starb, war es weniger der Verlust einer der bedeutendsten Künstlerinnen des 20. und 21. Jahrhunderts, der schmerzte, es ist vor allem der Mensch, der fehlt, der Mensch, dem ich so viel zu verdanken habe. Jeanne-Claude und mich trennten 49 Jahre – fast ein halbes Jahrhundert. Ihr Geist, ihr Esprit, ihr Scharfsinn war der einer Jugendlichen. Bis heute ist es unmöglich, von Christo im Singular zu sprechen.

Als Antwort auf meinen Brief erhielt ich damals ein Paket, gefüllt mit Postkarten, Büchern und Katalogen. Es war auch das erste Mal, das ich vom jahrzehntelangen Kampf erfuhr, der der Realisierung des Reichstagsprojekts vorangegangen war. Nahezu ein Vierteljahrhundert lang hatte das Vorhaben Christo und Jeanne-Claude beschäftigt. Unzählige Verhandlungen, Treffen, Fehlschläge und drei Absagen hatte es gebraucht, bis im Februar 1994 das deutsche Parlament in einer 70-minütigen Debatte über das Projekt abstimmte und schließlich mit 292 zu 223 Stimmen die Zustimmung zur Realisierung gab. Bis zu diesem Zeitpunkt existierte das Projekt lediglich als Vorstellung im Kopf zweier Künstler, als fixe Idee, die ihr Leben bestimmte, der sie ihr Geld, ihre Zeit und ihre Energie opferten. Manche nennen das Irrsinn, Größenwahnsinn oder Verschwendung. Christo nennt es Leidenschaft.

Since his flight from the communist regime in Bulgaria, Christo has had a special, very personal relationship to the East-West conflict. As a refugee and a stateless person, he lived for years in fear of imprisonment, deportation, and extradition. For Christo, Berlin has always been a symbol of his own situation, as a divided city in which East and West collided not only figuratively but also concretely. At the beginning of the 1970s, Christo and Jeanne-Claude developed their idea for wrapping the Reichstag building from this idea. In 1977, Christo said, "Although I had never seen Berlin before this project, I have always known that this city is a vivid example of the division between East and West, that it is a microcosm of political and social states, not only symbolically, but in a very real way. There is no other city in the world that is in such a situation, and it is because of this situation that I chose it for my project."[2]

Christo once described his work as a "poke at society,"[3] not to hurt it, but to wake it up. The pain caused by the Reichstag project could be clearly felt in the agitated comments of the feuilletons. In the German press, Christo was insulted as an "art charlatan" and "artist clown." His project was said to "abuse German history."[4] Christo himself was aware of the importance of his endeavor from the very beginning: "An extraordinary history is connected with this building. The hope, the expectation of being the first democratic parliament in Germany, the problems after World War I, the rise of Hitler, the fire said to be set by the Nazis, the end of World War II, the trauma of the Cold War—all these different historical phases and dimensions are recalled by the project. That's why I'm clinging to it, because it's so rich, open to so many interpretations."[5]

Seit seiner Flucht vor dem kommunistischen Regime in Bulgarien hatte Christo eine besondere, ganz persönliche Beziehung zum Ost-West-Konflikt. Als Flüchtling und Staatenloser lebte er jahrelang in der Angst vor Inhaftierung, Abschiebung und Auslieferung. Berlin als geteilte Stadt, in der Ost und West nicht nur bildlich, sondern ganz konkret aufeinanderprallten, war für Christo seit jeher Symbol seiner eigenen Situation. Anfang der 1970er-Jahre entwickelten Christo und Jeanne-Claude aus dieser Position heraus ihre Idee zur Verhüllung des Reichstagsgebäudes. „Ich habe", so Christo 1977, „obwohl ich Berlin vor diesem Projekt nie gesehen hatte, immer gewußt, daß diese Stadt das lebendige Beispiel der Trennung zwischen Ost und West ist, daß es ein Mikrokosmos der politischen und sozialen Zustände ist, und das nicht nur symbolisch, sondern ganz real. Es gibt keine andere Stadt in der Welt, die sich in einer solchen Situation befindet, und wegen eben dieser Situation habe ich sie für mein Projekt ausgesucht."[2]

Als ein „Pieken der Gesellschaft"[3] hat Christo seine Arbeit einmal bezeichnet, nicht, um sie zu verletzten, sondern um sie aufzuwecken. Beim Reichstagsprojekt war der Schmerz in den aufgeregten Kommentaren der Feuilletons deutlich zu spüren. Als „Kunstscharlatan" und „Künstler-Clown" wurde Christo in der deutschen Presse beschimpft. Sein Projekt treibe „Schindluderspiele mit der deutschen Geschichte".[4] Christo selbst war sich der Bedeutung seines Projekts von Beginn an bewusst: „Eine außerordentliche Geschichte verbindet sich mit diesem Gebäude. Die Hoffnung, die Erwartung, das erste demokratische Parlament in Deutschland zu sein, die Probleme nach dem Ersten Weltkrieg, der Aufstieg des Herrn Hitler, der offenbar von den Nazis gelegte Brand, das Ende des Zweiten Weltkriegs, das Trauma des Kalten Krieges – alle diese unterschiedlichen geschichtlichen Phasen und Dimensionen werden durch das

2 Christo, zitiert nach: P. K. „Verpacktes Denkmal, enthüllte Gedanken", Die Zeit (25. März 1977).

3 Christo, zitiert nach: Henno Lohmeyer und Felix Schmidt, Eulenspiegel oder Revolutionär? Im Gespräch mit dem Verhüllungskünstler Christo, Berlin 1993, S. 13.

4 K. D., „Schindludertreiben mit der deutschen Geschichte", Deutsche Wochenzeitung (8. April, 1977).

6 For all of the project-related data referred to below, see: *Christo and Jeanne-Claude: Wrapped Reichstag, Berlin, 1971–95*, Cologne 1996.

7 Karl Carstens, in "Frage des Wertes? Pro und contra Christo: Brandt und Carstens zur Reichstags-Verhüllung," *Der Abend* (June 14, 1977).

8 Christo, quoted from Peter Hans Göpfert, "Christo," *Die Welt* (March 16, 1977).

5 Christo, zitiert nach: Lohmeyer und Schmidt 1993, S. 30f.

6 Für sämtliche im Folgenden erwähnten projektbezogenen Daten siehe: *Christo and Jeanne-Claude: Wrapped Reichstag, Berlin, 1971–95*, Köln 1996.

7 Karl Carstens, in: „Frage des Wertes? Pro und contra Christo: Brandt und Carstens zur Reichstags-Verhüllung", *Der Abend* (14. Juni 1977).

8 Christo, zitiert nach: Peter Hans Göpfert, „Christo", *Die Welt* (16. März 1977).

In 1976, Christo visited West Berlin for the first time [6] to personally inspect the Reichstag building and to attend his first meetings with the decision-makers. It quickly became apparent that the President of the Bundestag, as the hostess of the Reichstag, was the one who was authorized to decide on Christo and Jeanne-Claude's project. Although incumbent Annemarie Renger was open to the project, she asked Christo to wait for the Bundestag elections in November. Her successor, Karl Carstens, to whom Christo first presented the project in January 1977, finally rejected it, although surveys showed that a majority of West Germans were positive about the project. In the newspaper *Der Abend*, Carstens explained his decision. The discussions about the project had shown "that the majority of our fellow citizens would not understand it if the Reichstag building with its special significance and symbolic character for the continuing unity of the German nation were made the object of a controversial artistic experiment." [7] For Christo and Jeanne-Claude, the rejection was a bitter setback. And yet today the refusal itself is part of the work of art. Even if Christo does not create the problems his projects cause, they are in a sense what constitute the core of his art. "If I have fun with the problems," Christo said in 1977 in an interview with *Die Welt* newspaper, "then I also enjoy the risk, the challenge, the impact." [8]

This has little to do with the modern notion of the artist sitting alone and withdrawn in his studio all day long. Christo and Jeanne-Claude's projects obey other laws; they had long since crossed the boundaries within which art usually operates. For fifty years, the two worked with great effort and tenacity outside the normal art world. Back in 1995, I wasn't aware of this; today I'm all the more amazed by it. This deviation from the norm, this crossing of boundaries, is what angers most people who are confronted with Christo

Projekt in Erinnerung gerufen. Deshalb hänge ich daran, weil es so reichhaltig ist, so viele Interpretationen zuläßt." [5]

1976 besuchte Christo erstmals Westberlin, [6] um das Reichstagsgebäude persönlich zu inspizieren und erste Treffen mit Entscheidungsträgern wahrzunehmen. Schnell stellte sich heraus, dass die Bundestagspräsidentin als Hausherrin des Reichstages die Entscheidungsgewalt über Christo und Jeanne-Claudes Projekt hatte. Obwohl Amtsinhaberin Annemarie Renger dem Projekt offen gegenüber stand, bat sie Christo, die Bundestagswahlen im November abzuwarten. Ihr Nachfolger Karl Carstens, dem Christo das Projekt im Januar 1977 erstmals vorstellte, lehnte das Vorhaben schließlich ab, obwohl Umfragen zeigten, dass eine Mehrheit der Westdeutschen dem Projekt gegenüber positiv eingestellt waren. In der Zeitung *Der Abend* begründete Carstens seine Entscheidung. Die Diskussionen um das Projekt hätten gezeigt, „daß ein Großteil unserer Mitbürger es nicht verstehen würde, wenn gerade das Reichstagsgebäude mit seiner besonderen Bedeutung und seinem Symbolcharakter für die fortbestehende Einheit der deutschen Nation zum Gegenstand eines umstrittenen künstlerischen Experiments gemacht würde". [7]

Für Christo und Jeanne-Claude war die Absage ein herber Rückschlag. Und doch ist sie heute selbst Teil des Kunstwerks. Auch wenn Christo die Probleme, die seine Projekte verursachen, nicht herbeizwingt, so sind sie in gewisser Weise doch das, was den Kern seiner Kunst ausmacht. „Wenn ich Spaß an den Problemen habe", so Christo 1977 in einem Interview mit der Welt, „dann freue ich mich auch am Risiko, an der Herausforderung, dem Aufprall." [8]

Mit der modernen Vorstellung vom Künstler, der den Tag über allein und zurückgezogen in seinem Atelier sitzt, hat das wenig zu tun. Christo und Jeanne-Claudes Projekte gehorchen anderen Ge-

"If I have fun with the problems, then I also enjoy the risk, the challenge, the impact."
„Wenn ich Spaß an den Problemen habe, dann freue ich mich auch am Risiko, an der Herausforderung, dem Aufprall."

Christo

9 Christo, quoted from *Die Zeit* (March 25, 1977).

10 Christo, quoted from: Michael Martens, *Ist Kunst unsterblich? Ein Gespräch zur Person und über die Zeit mit Christo und Jeanne-Claude, Winsen/Luhe and Weimar*, pp. 37–39.

9 Christo, zitiert nach: *Die Zeit* (25. März 1977).

and Jeanne-Claude's work: "Wonderful! But not in my front yard, please."

The Reichstag project was perhaps Christo and Jeanne-Claude's boldest attempt to break out of the narrow circle of the museum world in which they had previously moved with their wrapped buildings. To make a parliament a truly public building, the building of an entire people, an entire nation, had been the artists' aim from the very outset. With Christo's very first proposal for wrapping a public building in 1961, the accompanying text states that the edifice to be wrapped should, if possible, be a "parliament building or prison." "Earlier," Christo said in 1977 in a contribution to *Die Zeit*, "I packaged museums, buildings within the sphere of art. The Reichstag is a political building, and it has taught me about the interconnections between art and politics. [...] It is not the Reichstag, but the back and forth of its packaging that has set in motion a discussion about the significance of the building and its place in Berlin, in Germany, and in history." [9]

The discussions surrounding the Reichstag project not only revolved around the historical significance of the building, but also around the intrepid naivety of two artists who came out of nowhere to a seemingly intact world, who wanted to disrupt it for a brief moment and created a work of art that could neither be explained rationally nor used commercially. Christo and Jeanne-Claude's projects, which usually last no longer than two weeks, serve no purpose in our capitalist society or in politics. A politician who gets involved with their ideas has basically already lost the battle. If she/he rejects the project, she/he is regarded as being inimical to art; if she/he approves of it, she/he runs the risk of turning her own voters against her/him. Perhaps the greatest merit of Christo and Jeanne-Claude's art is what it teaches us. Their projects are lessons, and do not only engage with what

setzen; sie haben die Grenzen, in denen Kunst für gewöhnlich agiert, längst überschritten. Fünfzig Jahre lang haben die beiden mit großer Anstrengung und Hartnäckigkeit außerhalb des normalen Kunstbetriebs gearbeitet. Damals, 1995, war mir das nicht bewusst, heute staune ich darüber umso mehr. Diese Abweichung von der Norm, diese Grenzüberschreitung ist es, was die meisten Leute, die mit Christo und Jeanne-Claudes Arbeiten konfrontiert werden, erzürnt: „Wunderbar! Aber bitte nicht in meinem Vorgarten."

Das Reichstagsprojekt war vielleicht Christo und Jeanne-Claudes kühnster Versuch, aus dem engen Kreis der Museumswelt, in dem sie sich bis dahin mit ihren verhüllten Gebäuden bewegt hatten, auszubrechen. Ein Parlament als wahrhaft öffentliches Gebäude, als Gebäude eines ganzen Volks, einer ganzen Nation zu verhüllen, war von Beginn an der Wunsch der Künstler gewesen. Bereits bei Christos erstem Vorschlag zur Verhüllung eines öffentlichen Gebäudes heißt es 1961 im Begleittext, das zu verhüllende Bauwerk solle nach Möglichkeit ein „Parlamentsgebäude oder Gefängnis" sein. „Früher", so sagte Christo 1977 in einem Beitrag für *Die Zeit*, „verpackte ich Museen, also Gebäude innerhalb der Kunstsphäre. Der Reichstag ist ein politisches Gebäude, und es hat mich die Verflechtungen von Kunst und Politik gelehrt. [...] Es ist ja nicht der Reichstag, sondern das Hin und Her der Entscheidung seiner Verpackung, das eine Diskussion über die Bedeutung des Gebäudes und seinen Platz in Berlin, in Deutschland und in der Geschichte in Gang gesetzt hat." [9]

Die Diskussionen rund um das Reichstagsprojekt gründeten nicht nur auf der historischen Bedeutung des Gebäudes, es war auch die unerschrockene Naivität zweier Künstler, die aus dem Nichts in eine scheinbar heile Welt einbrachen, diese für einen kurzen Augenblick störten und ein

Christo and Jeanne-Claude in
conversation with Willy Brandt
New York 1981

Christo und Jeanne-Claude im
Gespräch mit Willy Brandt
New York 1981

art is. They probably reveal more about politics, about a country's social and economic conditions, than any statistics, any survey, or any history book. Our capitalist thought mechanisms require art to be eternal. Christo and Jeanne-Claude do not and do not want to comply with this demand: "It is part of our aesthetic decision to challenge the alleged immortality of art through the temporary, limited duration of our works. The questions we ask are questions about art's claim to eternity. [...] Our art does not remain, is not meant to remain. That's what constitutes its quality. [...] It doesn't exist because a mayor, a minister, or a president wants it to, but because the artist wants it to exist. There is no justification for it—the work is absolutely irrational, not accountable to anyone, and as a result it reaches a dimension of freedom that can only arise under such conditions, with no motivation, no reason, no justification for its existence except that it is a work of art." [10]

Christo and Jeanne-Claude's art always aims at this philosophical dimension by disrupting our customary view of things for a short time, removing familiar objects from our gaze, alienating them and thereby questioning them. If their projects had the claim to eternity that we generally demand from art, they would become a given. But Christo and Jeanne-Claude's

Kunstwerk errichten wollten, das weder rational zu erklären noch kommerziell zu nutzen war. In unserer kapitalistischen Gesellschaft oder der Politik sind Christo und Jeanne-Claudes Projekte, die meist nicht viel länger als zwei Wochen existieren, ohne Sinn. Und tatsächlich sind sie das auch. Der Politiker, der sich auf ihre Ideen einlässt, hat im Grunde schon verloren. Lehnt sie/er das Projekt ab, gilt sie/er als kunstfeindlich, befürwortet sie/er es, so läuft sie/er Gefahr, die eigenen Wähler gegen sich aufzubringen. Es ist vielleicht das, was uns Christo und Jeanne-Claudes Kunst lehrt, ihr größter Verdienst. Ihre Projekte sind Lehrstücke, nicht nur über die Frage, was Kunst ist. Sie verraten vermutlich mehr über Politik, über soziale und ökonomische Zustände eines Landes als jede Statistik, jede Umfrage, jedes Geschichtsbuch. Unsere kapitalistischen Denkmechanismen fordern von der Kunst die Ewigkeit. Eine Forderung, der Christo und Jeanne-Claude nicht nachkommen und nicht nachkommen wollen: „Es ist ein Teil unserer ästhetischen Entscheidung, die angebliche Unsterblichkeit der Kunst durch die zeitweilige, begrenzte Dauer unserer Arbeiten herauszufordern. Die Fragen, die wir damit stellen, sind Fragen nach dem Ewigkeitsanspruch der Kunst. […] Unsere Kunst bleibt nicht, soll nicht bleiben. Das macht ihre Qualität aus. […]

11 Petra Kipphoff, "Verpackt den Reichstag," *Die Zeit* (November 25, 1977).

12 Willy Brandt, in *Der Abend* (June 14, 1977).
13 Christo, quoted from André Müller, "Es wird umwerfend sein," *Die Zeit* (June 2, 1995).

10 Christo, zitiert nach: Michael Martens, *Ist Kunst unsterblich? Ein Gespräch zur Person und über die Zeit mit Christo und Jeanne-Claude*, Winsen/Luhe und Weimar 1999, S. 37–39.

11 Petra Kipphoff, „Verpackt den Reichstag!", *Die Zeit* (25. November 1977).

12 Willy Brandt, in: *Der Abend* (14. Juni 1977).

projects are not a modern Disneyland, which for a few euros leads us into a colorful fairytale world and enables us to escape from everyday life. On the contrary, their art breaks into our everyday life, disturbs it, confuses it, is sometimes annoying and uncomfortable.

The day after Carsten's rejection, Christo proved that he is not one to shy away from conflict. Instead of ending their project, Christo and Jeanne-Claude announced that they wanted to continue working on it. "Never before in the history of the Federal Republic of Germany," wrote Petra Kipphoff in *Die Zeit*, "has such a large number of politicians, from Willy Brandt to Kurt Biedenkopf, thought about an art project, been compelled to think about an art project. [...] A symbol is a symbol, an emblem. If you do not engage with it, but only fearfully protect it from adverse influences, it becomes a relic, a souvenir. And what remains in the end is only a vestige, the remnant of a symbol, the ashes of reality. Is this a sensible way to deal with history?" [11]

In fact, in the ensuing years Willy Brandt became a vehement supporter of the project and justified his support with the same stance. As he stated in 1977, he did not consider "a controversy about the Christo project to be necessarily detrimental to the symbolic value of the Reichstag. On the contrary, such a discussion would [...] be helpful in reminding us of the symbolic value of this building. The German Reichstag building cannot be separated from the highlights of German history, but it is also associated with events that burden us. I think it's dangerous to avoid discussing this part of our history." [12]

In order to advance their project, Christo and Jeanne-Claude decided the following year to set up a board of trustees made up of around a dozen renowned representatives from a wide range of professions, including art historians, scientists, business people, and lawyers. Many advocates

Sie existiert nicht, weil ein Bürgermeister, ein Minister oder ein Präsident sie gerne hätte, sondern weil der Künstler sie gerne haben möchte. Es gibt auch keine Rechtfertigung für sie – die Arbeit ist absolut irrational, niemandem verantwortlich, wodurch sie eine Dimension der Freiheit erreicht, die nur unter solchen Bedingungen entstehen kann, ohne eine Motivation, ohne einen Grund, ohne eine Daseinsberechtigung außer der einen, daß es sich um ein Kunstwerk handelt." [10]

Christo und Jeanne-Claudes Kunst zielt immer auf diese philosophische Dimension, indem sie für eine kurze Zeit unsere gewohnte Sicht auf die Dinge stört, vertraute Gegenstände unserem Blick entzieht, sie verfremdet und dadurch infrage stellt. Würden ihre Projekte den Anspruch auf Ewigkeit für sich beanspruchen, den wir gemeinhin von der Kunst fordern – sie würden zu etwas Selbstverständlichem werden. Doch Christo und Jeanne-Claudes Projekte sind kein modernes Disneyland, das uns für ein paar Euro in eine bunte Märchenwelt entführt und dem Alltag entfliehen lässt. Ganz im Gegenteil. Ihre Kunst bricht in unseren Alltag ein, stört ihn, bringt ihn durcheinander, ist mitunter lästig und unbequem.

Dass Christo nur zu gerne den Finger in die Wunde legt, bewies er am Tag nach Carstens Absage. Statt ihr Vorhaben zu beerdigen, verkündeten Christo und Jeanne-Claude, weiter an dem Projekt arbeiten zu wollen. „Noch nie", schrieb Petra Kipphoff damals in der *Zeit*, „hat sich, von Willy Brandt bis Kurt Biedenkopf, in der Geschichte der Bundesrepublik eine so große Anzahl von Politikern auf das Nachdenken über ein Kunstprojekt eingelassen, einlassen müssen. [...] Ein Symbol ist ein Sinnbild, ein Wahrzeichen. Wenn man damit nicht mehr umgeht, sondern es nur noch ängstlich vor Zugluft schützt, wird es zur Reliquie, zum Andenken. Und was schließlich bleibt, ist ein Relikt, das Überbleibsel eines Sinnbilds,

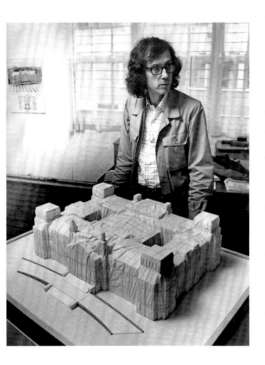

die Asche der Realität. Ist das ein sinnvoller Umgang mit Geschichte?"[11]

Tatsächlich wurde Brandt in den folgenden Jahren zu einem vehementen Verfechter des Projekts und begründete seine Unterstützung aus der gleichen Haltung heraus. Er halte, gab er schon 1977 zu Protokoll, „eine Kontroverse um das Christo-Projekt nicht unbedingt für abträglich für den Symbolwert des Reichstages. Im Gegenteil: Eine solche Diskussion würde […] hilfreich sein, uns den Symbolwert dieses Gebäudes zu vergegenwärtigen. Das Gebäude des Deutschen Reichstages ist nicht zu trennen von Höhepunkten der Deutschen Geschichte; es ist aber auch mit Vorgängen verbunden, die uns belasten. Ich halte es für gefährlich, einer Diskussion um diesen Teil unserer Geschichte auszuweichen."[12]

Um ihr Projekt voranzutreiben, entschlossen sich Christo und Jeanne-Claude im folgenden Jahr, ein Kuratorium zu gründen, das mit rund einem Dutzend namhafter Repräsentanten unterschiedlichster Profession besetzt werden sollte – Kunsthistoriker, Wissenschaftler, Geschäftsleute, Juristen. Schnell fanden sich viele Fürsprecher, die sich bereit erklärten, ehrenamtlich und öffentlich für das Reichstagsprojekt zu kämpfen, darunter etwa Gerd Bucerius, Arend Oetker, Michael und Christl Otto sowie Otto und Winnie Wolff von Amerongen. Letztere schafften es kurz darauf, den früheren Bundespräsidenten Walter Scheel als Fürsprecher zu gewinnen. Scheel bemühte sich in der Folge bei Carstens Nachfolger, Bundestagspräsident Richard Stücklen, um eine Genehmigung. Im Dezember 1980 dann gab Stücklen bekannt, dass er nicht von der Entscheidung seines Vorgängers abweichen werde. Das Projekt war damit zum zweiten Mal abgelehnt worden. Dass Christo und Jeanne-Claude ihr Vorhaben dennoch nicht aufgaben, lag auch und abermals an Willy Brandt, der die Künstler im darauffolgenden Jahr in New York

Christo with the very first scale model for *Wrapped Reichstag*, London 1977
Photo: Jorge Lewinski

Christo mit dem ersten maßstabsgetreuen Modell zum Projekt *Wrapped Reichstag*, London 1977

were quickly found who agreed to fight for the Reichstag project in an honorary and public capacity, among them Gerd Bucerius, Arend Oetker, Michael and Christl Otto, as well as Otto and Winnie Wolff von Amerongen. Shortly afterwards, the latter managed to win over the former Federal President Walter Scheel as an advocate. Scheel subsequently sought approval from Carsten's successor, Bundestag President Richard Stücklen. In December 1980, Stücklen announced that he would not deviate from the decision of his predecessor. This was the second time that the project had been rejected. The fact that Christo and Jeanne-Claude did not abandon their project was again due to Willy Brandt, who visited the artists in New York the following year and encouraged them to pursue their idea further. Brandt gave them valuable advice: The artists should seek allies in the two major parties, the SPD and the CDU, since the approval of one party would automatically mean rejection by the other.

In September 1985, Christo and Jeanne-Claude completed their project *The Pont Neuf Wrapped* in Paris after ten years of preparation. The successful realization kindled their hopes of implementing the Reichstag project, as the monumental character and political implications of the project were not dissimilar to those of the Reichstag. Shortly thereafter, their Berlin project was given new impetus by businessman Roland Specker, who with his association *Berliner für den Reichstag* collected 70,000 signatures for the Reichstag project. In June 1987, Specker handed the list over to the new President of the Bundestag, Philipp Jenninger, who, however, refused to receive the artists personally and rejected the project for the third time.

This time, Christo and Jeanne-Claude's reaction was more defiant than combative. Frustrated by the resistance of German politics, Christo stopped making drawings

besuchte und sie ermutigte, ihre Idee weiter zu verfolgen. Dabei gab Brandt den entscheidenden Rat: Die Künstler sollten Verbündete in den beiden großen Parteien suchen, der SPD und der CDU, da die Zustimmung einer Partei automatisch die Ablehnung der anderen zur Folge haben würde.

Im September 1985 vollendeten Christo und Jeanne-Claude in Paris nach zehn Jahren Vorbereitung ihr Projekt *The Pont Neuf Wrapped*. Mit der erfolgreichen Realisierung war auch ihre Hoffnung verbunden, dem Reichstagsprojekt neuen Aufschwung zu verleihen, schließlich war das Vorhaben hinsichtlich des monumentalen Charakters und der politischen Implikationen dem Reichstagsprojekt nicht unähnlich. Einen neuen Impuls erhielt ihr Berliner Vorhaben kurz darauf durch den Geschäftsmann Roland Specker, der mit seinem Verein *Berliner für den Reichstag* 70 000 Unterschriften zugunsten des Reichstagsprojekts sammelte. Im Juni 1987 übergab Specker die Liste an den neuen Bundestagspräsidenten Philipp Jenninger, der sich jedoch weigerte, die Künstler persönlich zu empfangen und das Projekt zum dritten Mal ablehnte.

Christo und Jeanne-Claudes Reaktion fiel dieses Mal eher trotzig denn kämpferisch aus. Frustriert von den Widerständen der deutschen Politik, hörte Christo auf, Zeichnungen vom *Verhüllten Reichstag* anzufertigen, bis sich kurz darauf die politische Situation ein weiteres Mal grundlegend wandelte. Seit August 1961 hatte die Berliner Mauer die Stadt nicht nur physisch auf brutale Weise geteilt. Das sollte sich im November 1989 schlagartig ändern. Das schwankende Regime konnte den Freiheitsdrang und die Flucht seiner Bürger nicht länger aufhalten und hob die Ausreisebeschränkungen in den Westen auf. Innerhalb weniger Tage fiel die Mauer, die so lange als unüberwindbar gegolten hatte, in sich zusammen. Deutschland steuerte auf die lang erhoffte Wieder-

of the *Wrapped Reichstag* until, a short time later, the political situation changed fundamentally once again. Since August of 1961, the Berlin Wall had divided the city not only physically but also brutally. This would change abruptly in November 1989. The unstable regime was no longer able to stifle its citizens' desire for freedom and flight, and lifted the restrictions on their departure to the West. Within a few days the Wall, long considered insurmountable, collapsed. Germany was heading towards long-awaited reunification; the Reichstag not only became the scene of numerous rallies, but in the course of the discussion about the future seat of government was now also in the public eye as a potential parliament building. "Before 1989," Christo said later in an interview, "the Reichstag was a mausoleum. Nobody believed they would see the end of the Cold War during their lifetime. If we had realized the project at that time, it would inevitably have been linked to the division of Germany. [...] Today, the wrapping is a symbol of a new beginning." [13]

Almost overnight, not only Berlin and the Reichstag building, but also Christo and Jeanne-Claude's project awakened from their slumber. In December 1991, Rita Süssmuth, who had been elected President of the German Bundestag in 1988, provided the decisive impetus for the revival of the project. In a passionate appeal, Süssmuth wrote to Christo and Jeanne-Claude, inviting the artists to a meeting to discuss the possibility of realizing the project together. At that time, the Reichstag building was already slated as the future seat of parliament and the necessary refurbishment was in the planning phase. It was clear to all concerned that only a limited period of time remained for the implementation of the project. In order to achieve the broadest possible consensus, Süssmuth urged—as Brandt had done previously— that the project be promoted in public and parliament

vereinigung zu; der Reichstag wurde nicht nur zum Schauplatz zahlreicher Kundgebungen, sondern geriet im Zuge der Diskussion um den zukünftigen Regierungssitz auch als potenzielles Parlamentsgebäude in den Fokus der öffentlichen Aufmerksamkeit. „Vor 1989", so Christo später in einem Interview, „war der Reichstag ein Mausoleum. Niemand glaubte, daß er noch zu Lebzeiten das Ende des Kalten Krieges erleben würde. Hätten wir das Projekt damals verwirklicht, hätte es unausweichlich im Zusammenhang mit der deutschen Teilung gestanden. [...] Heute ist die Verhüllung ein Symbol für den Neubeginn." [13]

Quasi über Nacht wurden nicht nur Berlin und das Reichstagsgebäude, sondern auch Christo und Jeanne-Claudes Projekt aus dem Dornröschenschlaf geholt. Den entscheidenden Impuls für die Wiederbelebung des Vorhabens lieferte schließlich im Dezember 1991 Rita Süssmuth, die 1988 zur Präsidentin des Deutschen Bundestags gewählt worden war. In einem flammenden Appell schrieb Süssmuth damals an Christo und Jeanne-Claude und bat die Künstler zu einem Treffen, um gemeinsam die Möglichkeit der Realisierung des Projekts zu erörtern. Das Reichstagsgebäude war zu diesem Zeitpunkt bereits als zukünftiger Sitz des Parlaments vorgesehen und die dazu nötigen Umbauarbeiten in Planung. Allen Beteiligten war klar, dass für eine Umsetzung des Vorhabens nur noch eine begrenzte Zeitspanne blieb. Um eine möglichst breite Zustimmung zu erreichen, drängte Süssmuth – wie es zuvor schon Brandt getan hatte – darauf, in der Öffentlichkeit und im Parlament über alle Parteigrenzen hinweg für das Projekt um Zustimmung zu werben. Süssmuth stellte klar, dass sie eine Entscheidung nicht alleine treffen könne, sondern das Parlament als legitime Vertretung des Volkes über das Reichstagsprojekt abzustimmen habe. Die folgenden Monate entwickelten sich für Christo und

13 Christo, zitiert nach: André Müller, „Es wird umwerfend sein!", *Die Zeit* (2. Juni 1995).

14 Jeanne-Claude, quoted from Lohmeyer and Schmidt 1993, p. 60.

15 Christo, ibid., p. 33.

14 Jeanne-Claude, zitiert nach: Lohmeyer und Schmidt 1993, S. 60.

15 Christo, zitiert nach: ebd., S. 33.

across all party lines. Süssmuth made it plain that she could not take the decision alone, but that the parliament, as the legitimate representative of the people, had to vote on the Reichstag project. The following months developed into a true tour de force for Christo and Jeanne-Claude. Between April 1993 and February 1994, they visited a total of 352 members of parliament, to whom they put forward their arguments for the project in individual discussions.

At this time, Christo and Jeanne-Claude decided to officially appear as artists on an equal footing. For three decades, Jeanne-Claude had played the socially imposed role of Christo's wife and right hand, before in 1994, to the dismay of a narrow-minded art scene, both declared that from now on there was only Christo and Jeanne-Claude. I didn't find out about this until later. For me, Christo never existed without Jeanne-Claude. It never mattered to me who had the idea for a project. Why should it have? Christo and Jeanne-Claude were not conceptual artists and never were. What counted was the fulfillment of their ideas, not theoretical intellectual games. Christo and Jeanne-Claude's art is an art of the real. They were doers, not thinkers. "Any idiot can have a good idea," Jeanne-Claude once said. "Which do you prefer—a sexual act or a book about it?" [14] But the prelude to a project by Christo and Jeanne-Claude was anything but sensual. When Christo and Jeanne-Claude talked about the problems, the hurdles, and the arguments about the Reichstag project, they did so with a smile on their faces that left journalists distraught. "It's a dramatic work," Christo said in an interview shortly before the project was carried out, "that reaches down into the depths of emotion. It is very gratifying for me that my project has provoked such discussions." [15]

The parliamentary debate of February 25, 1994, in which the German Bundestag

Jeanne-Claude zu einer wahren Tour de Force. Zwischen April 1993 und Februar 1994 besuchten sie insgesamt 352 Abgeordnete, denen sie in Einzelgesprächen ihre Argumente für das Projekt erläuterten.

Zu dieser Zeit entschieden sich Christo und Jeanne-Claude, nun auch offiziell als gleichberechtigte Künstler aufzutreten. Drei Jahrzehnte lang hatte Jeanne-Claude die ihr gesellschaftlich aufoktroyierte Rolle als Christos Ehefrau und rechte Hand gespielt, bevor beide 1994, zum Entsetzen einer bornierten Kunstszene, erklärten, ab sofort gebe es nur noch Christo und Jeanne-Claude. Auch das erfuhr ich erst später. Für mich gab es nie einen Christo ohne eine Jeanne-Claude. Für mich spielte es nie eine Rolle, wer die Idee zu einem Projekt hatte. Warum auch? Christo und Jeanne-Claude sind keine Konzeptkünstler, sind es nie gewesen. Ihnen kommt es auf die Realisierung ihrer Ideen an, nicht auf ein rein theoretisches Gedankenspiel. Christo und Jeanne-Claudes Kunst ist eine Kunst des Realen. Sie sind Macher, keine Denker. „Jeder Idiot kann eine gute Idee haben", pflegte Jeanne-Claude zu sagen. „Was ist Ihnen lieber – ein Geschlechtsakt oder ein Buch darüber?" [14] Dabei ist das Vorspiel bei Christo und Jeanne-Claude alles andere als sinnlich. Zumindest in der Vorstellung Außenstehender. Wenn Christo und Jeanne-Claude von den Problemen, den Hürden, den Auseinandersetzungen um das Reichstagsprojekt erzählten, dann taten sie das mit einer Freude, mit einem Lächeln auf den Lippen, das jeden Journalisten verstört zurückließ. „Es ist ein dramatisches Werk", so Christo kurz vor der Realisierung in einem Interview, „das in die Tiefe der Gefühle hinabreicht. Es ist für mich sehr erfreulich, daß mein Vorhaben solche Diskussionen provoziert hat." [15]

Die Parlamentsdebatte vom 25. Februar 1994, in der der Deutsche Bundestag über die Realisierung des *Verhüllten Reichstags* abstimmte, bildete den

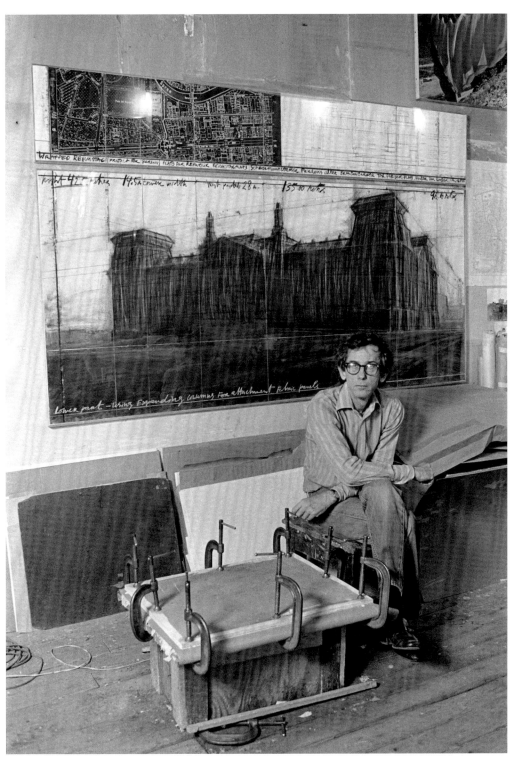

Christo in his studio with
a preparatory drawing
for *Wrapped Reichstag*,
New York 1984
Photo: Wolfgang Volz

Christo in seinem Atelier
mit einer Zeichnung zum
Projekt *Wrapped Reichs-
tag*, New York, 1984

voted on the realization of *Wrapped Reichstag*, was the temporary high point in the then twenty-year history of the project. Once again, the arguments of the proponents and opponents were presented dramatically. It was the first time in history that a democratically elected parliament voted on a work of art. The irony is immense: The country's political elite was discussing a work of art that did not even exist yet, was worried about its reputation, about being reelected, while the world was wracked by war, economic crisis, and unemployment. Christo and Jeanne-Claude's projects are not political, have no political message. At the same time, their political explosiveness could not be greater. Because (and this must always be borne in mind) never before had an artist ventured so far into the public realm, into public space, as Christo and Jeanne-Claude. If Christo had only drawn a picture of the *Wrapped Reichstag* and nothing more, nobody would have had a problem with it. But Christo and Jeanne-Claude were not satisfied. They went beyond the notion of limited and extremely specialized art, and radically questioned this idea. With their projects they intervened in real structures, real spaces, and real landscapes. Christo and Jeanne-Claude did not want to create a work of art about the Reichstag. The building, the city, the history—everything belonged to the project and was part of the artwork.

In their speeches, opponents of the project repeatedly emphasized the inviolability of the dignity of the building: "[...] because the Reichstag is not just any building, we should not experiment with it right now. [...] State symbols, symbols in general, should unite people, bring people together. Wrapping the Reichstag would, however, not unite people it would polarize them. Too many people would not be able to understand and accept it. [...] I therefore ask you all to bear in mind that the trust of too many fellow citizens in the dignity

vorläufigen Höhepunkt in der damals über 20-jährigen Geschichte des Projekts. Hier wurden noch einmal auf dramatische Weise die Argumente der Befürworter und Gegner vor Augen geführt. Es war das erste Mal in der Geschichte überhaupt, dass ein demokratisch gewähltes Parlament über ein Kunstwerk abstimmte. Man muss sich einmal die Ironie dieser Szene vor Augen führen: Da diskutiert die politische Elite des Landes über ein Kunstwerk, das es noch gar nicht gibt, fürchtet um ihren Ruf, um die Wiederwahl, während in der Welt Krieg, Wirtschaftskrise und Arbeitslosigkeit regieren. Christo und Jeanne-Claudes Projekte sind nicht politisch, sie haben keine politische Botschaft. Zugleich könnte ihre politische Brisanz größer nicht sein. Denn, und das muss man immer bedenken, noch nie haben sich Künstler mit ihren Arbeiten so weit in die Öffentlichkeit, in den öffentlichen Raum gewagt wie Christo und Jeanne-Claude. Hätte Christo es dabei belassen, nur ein Bild des *Verhüllten Reichstags* zu zeichnen, hätte wohl niemand ein Problem damit gehabt. Christo und Jeanne-Claude aber reichte das nicht. Sie gehen über die begrenzte und extrem spezialisierte Vorstellung von Kunst hinaus, stellen sie radikal infrage. Mit ihren Projekten greifen sie in reale Strukturen, reale Räume und reale Landschaften ein. Christo und Jeanne-Claude wollten kein Kunstwerk „über" den Reichstag schaffen. Das Gebäude, die Stadt, die Geschichte – alles gehörte zum Projekt und war Teil des Kunstwerks.

In ihren Reden betonten die Gegner des Projekts immer wieder die Unantastbarkeit der Würde des Gebäudes: „[…] weil der Reichstag eben nicht irgendein Gebäude ist, sollten wir mit ihm gerade keine Experimente veranstalten. […] Staatliche Symbole, Symbole überhaupt, sollen einen, sie sollen zusammenführen. Eine Verhüllung des Reichstages […] würde aber nicht einen, nicht zusammenführen, sie würde polarisieren. […] Des-

of our democratic history and culture could be damaged." Wolfgang Schäuble, who gave the leading speech against the project at the time while Helmut Kohl demonstratively played with his red voting card, drove the pathos so far that many of the opponents demonstratively voted for the wrapping in the end. It should not remain unmentioned that Schäuble later publicly revised his opinion on the Reichstag project—a gesture that is all too rare among politicians. When Christo was honored for his life's work by the Konrad Adenauer Foundation in March 2019, the organizers invited Schäuble to be the keynote speaker, not without a certain irony. The wrapping of the Reichstag, Schäuble said in his speech, "appeared to me to be outrageous. The place where the attempt to establish democracy in Germany had literally gone up in flames did not seem to me to be a suitable playground for an art project. I saw the dignity of the symbolic parliament building threatened and the experimental aspect of the project seemed inappropriate for the Reichstag building, which is not just any building. My rejection was a mistake. And it was not the euphoric reaction of the five million visitors that disabused me. I was impressed by the powerfully eloquent reactions in the press [...], but in the end this was not decisive either. It was not even the enthusiastic reactions abroad, which made it clear that we, the newly reunited Germany, had not been thought to have so much artistic joy and lightness, that were the overriding factor. [...] What really convinced and persuaded me in the end was the aesthetic impression their work left behind. It was also an incredible aesthetic pleasure." [16]

Apart from all the historical and political implications, the pros and cons, the discussions, arguments, and struggles over the wrapping of the Reichstag, one thing should never be forgotten: Christo and Jeanne-Claude's projects are breathtak-

halb bitte ich Sie alle: Bedenken Sie die Gefahr, daß das Vertrauen zu vieler Mitbürger in die Würde unserer demokratischen Geschichte und Kultur Schaden nehmen könnte." Wolfgang Schäuble, der damals die führende Rede gegen das Projekt hielt, während Helmut Kohl demonstrativ mit seiner roten Stimmkarte spielte, trieb den Pathos so weit, dass viele der Projektgegner am Ende demonstrativ für die Verhüllung stimmten. Es soll nicht unerwähnt bleiben, dass Schäuble seine Meinung über das Reichstagsprojekt später öffentlich revidierte – eine für Politiker allzu seltene Geste. Als Christo im März 2019 von der Konrad-Adenauer-Stiftung für sein Lebenswerk geehrt wurde, luden die Organisatoren – nicht ohne eine gewisse Ironie – Schäuble als Laudator ein. Die Reichstagsverhüllung, so Schäuble in seiner Rede, „erschien mir wie ein Frevel. Der Ort, an dem der Versuch, in Deutschland eine Demokratie zu errichten, buchstäblich in Flammen aufgegangen war, schien mir keine geeignete Spielwiese für ein Kunstprojekt. Also sah ich die Würde des symbolträchtigen Parlamentsgebäudes bedroht und das Experimentelle des Projekts schien mir unpassend für das Reichstagsgebäude, das eben kein Haus wie jedes andere ist. Meine Ablehnung war ein Irrtum. Und eines Besseren belehrt, haben mich gar nicht in erster Linie die euphorische Reaktion der fünf Millionen Besucher […]. Auch die wortgewaltigen Reaktionen in der Presse […] haben mich beeindruckt, aber letztlich war es nicht ausschlaggebend. Nicht einmal die begeisternden Reaktionen im Ausland, aus denen deutlich herauszulesen war, dass man uns, dem gerade wiedervereinten Deutschland, so viel Kunstfreude und Leichtigkeit gar nicht zugetraut hätte. […] Aber was mich am Ende wirklich überzeugt und umgestimmt hat, war der ästhetische Eindruck, den Ihr Werk hinterließ. Es war auch ein unglaubliches ästhetisches Vergnügen." [16]

16 Wolfgang Schäuble, speech on the occasion of *Homage to Christo*, Konrad Adenauer Foundation, March 27, 2019.

16 Wolfgang Schäuble, Rede anlässlich der *Hommage für Christo*, Konrad Adenauer Stiftung, 27. März 2019.

17 Christo, quoted from Lohmeyer and Schmidt 1993, p. 41f.

18 Christo, quoted from Lohmeyer und Schmidt 1993, p. 33.

17 Christo, zitiert nach: Lohmeyer und Schmidt 1993, Seite 41f.

18 Christo, zitiert nach: ebd., S. 32.

ingly beautiful in the end. Admittedly, this is not a particularly scientific expression; on the contrary it is deeply subjective and scorned. And yet it was precisely this aspect that touched people the most. This is what moved Wolfgang Schäuble and this is what moved me. Christo and Jeanne-Claude's projects have no purpose and at the same time, they have one. They force people to think; they awaken feelings in people. Throughout our lives we are busy justifying our actions. All these considerations are wiped away by Christo and Jeanne-Claude's projects. They are an expression of unhindered, poetic creativity, of total freedom, without a trace of justification. "Many critics of my works find the irrationality, the absurdity of my projects maddening. That's exactly why I make them. They force us to think, but they also have an edifying, uplifting effect, beyond all morality and justification of our existence." [17]

Artists, in their tendency to renounce everyday life, have always been condemned to be helpless romantics. They cannot get away from the aspiration to oppose the ordinary with the extraordinary. This is perhaps particularly true of Christo and Jeanne-Claude. The extraordinary can be expressed in the political realm—then art runs the risk of crossing the threshold of propaganda. Or the extraordinary, as in the case of Christo and Jeanne-Claude, can be expressed in the aesthetic realm.

When the Reichstag was wrapped in the summer of 1995, Berlin was flooded with tourists for two weeks. They did not all come because of the past, they came to pay homage to the present and future, for which the *Wrapped Reichstag* had become a symbol. "That's exactly why this project has to be realized: because it appeals to the energetic young generation, and that's the future," Christo had said before the realization. [18] How right he would be. For the first time since the fall of the Wall, six years earlier, the city did not

Neben all den historischen und politischen Implikationen, dem Für und Wider, den Diskussionen, Auseinandersetzungen und Kämpfen um die Reichstagsverhüllung sollte man eines nie vergessen – die Projekte von Christo und Jeanne-Claude sind am Ende vor allem das: atemberaubend schön. Das ist zugegebenermaßen kein besonders wissenschaftlicher Begriff; er ist im Gegenteil zutiefst subjektiv und reichlich verpönt. Und doch ist es das, was die Menschen am meisten berührt. So erging es Wolfgang Schäuble und so erging es mir. Christo und Jeanne-Claudes Projekte sind ohne Zweck – und gleichzeitig sind sie es nicht. Sie zwingen die Menschen zum Nachdenken; sie wecken in ihnen Gefühle. Unser ganzes Leben lang sind wir damit beschäftigt, unser Tun zu rechtfertigen. Alle diese Überlegungen werden von Christo und Jeanne-Claudes Projekten weggewischt. Sie sind Ausdruck einer ungehinderten, poetischen Kreativität, einer totalen Freiheit, ohne eine Spur von Rechtfertigung. „Viele Kritiker meiner Werke finden die Irrationalität, die Absurdität meiner Projekte zum Verrücktwerden. Das genau ist der Grund, warum ich sie mache. Sie zwingen zum Nachdenken, sie haben aber auch eine erbauende, erhebende Wirkung, jenseits aller Moralität und Rechtfertigung unserer Existenz." [17]

Künstler, in ihrer Neigung, dem Alltagstrott zu entsagen, sind seit jeher dazu verdammt, hilflose Romantiker zu sein. Sie kommen vom Anspruch, dem Gewöhnlichen das Außergewöhnliche entgegenzusetzen, nicht los. Auf Christo und Jeanne-Claude trifft das vielleicht in besonderem Maße zu. Dieses Außergewöhnliche kann sich im Politischen zeigen – dann läuft die Kunst Gefahr, die Schwelle zur Propaganda zu überschreiten. Oder das Außergewöhnliche zeigt sich, wie bei Christo und Jeanne-Claude, im Ästhetischen.

Als der Reichstag im Sommer 1995 verhüllt wurde, war Berlin zwei Wochen lang von Touristen überschwemmt. Sie alle

focus on a symbol of the old, but on a symbol of the new. With their project, Christo and Jeanne-Claude accomplished what no architect or urban planner in the German capital had ever achieved before: the streets of Berlin suddenly burst into life; the project transcended the space, unfolding its effect far beyond the building. Virtually all of Berlin was a construction site at the time, but no new building had the power to become an emblem of the transformation of the city. The *Wrapped Reichstag* changed everything. Berlin once again became a vibrant cosmopolitan city, and if the *Wrapped Reichstag* was not the creator of the new Berlin, it became the symbol of the opening of the city that Berlin had long and eagerly awaited.

kamen nicht wegen der Vergangenheit, sie waren gekommen, um der Gegenwart und Zukunft zu huldigen, für die der *Verhüllte Reichstag* zum Symbol geworden war. „Das ist genau der Punkt, warum dieses Projekt verwirklicht werden muss: weil es an die tatkräftige junge Generation appelliert, und das ist die Zukunft", hatte Christo noch vor der Realisierung gesagt. [18] Wie Recht er behalten sollte. Zum ersten Mal seit dem Fall der Mauer sechs Jahre zuvor fokussierte sich die Stadt nicht auf ein Symbol des Alten, sondern auf ein Symbol des Neuen. Christo und Jeanne-Claude vollbrachten mit ihrem Projekt, was zuvor kein Architekt oder Stadtplaner in der deutschen Hauptstadt geschafft hatte: Die Straßen von Berlin barsten plötzlich nur so vor Leben, das Projekt überwand den Raum und entfaltete seine Wirkung weit über das Gebäude hinaus. Ganz Berlin war damals bereits eine große Baustelle, doch kein Neubau hatte die Kraft, zum Wahrzeichen für die Veränderung der Stadt zu werden. Der *Verhüllte Reichstag* änderte alles. Berlin nahm wieder seinen Platz als lebendige Weltstadt ein, und war der *Verhüllte Reichstag* auch nicht der Schöpfer des neuen Berlin, so wurde er doch zum Sinnbild für die Öffnung der Stadt, auf die Berlin so sehnsüchtig gewartet hatte.

Pp. 138/139
Christo and Jeanne-Claude in front of the *Wrapped Reichstag*, Berlin 1995
Photo: Wolfgang Volz

S. 138/139
Christo und Jeanne-Claude vor dem *Wrapped Reichstag*, Berlin 1995

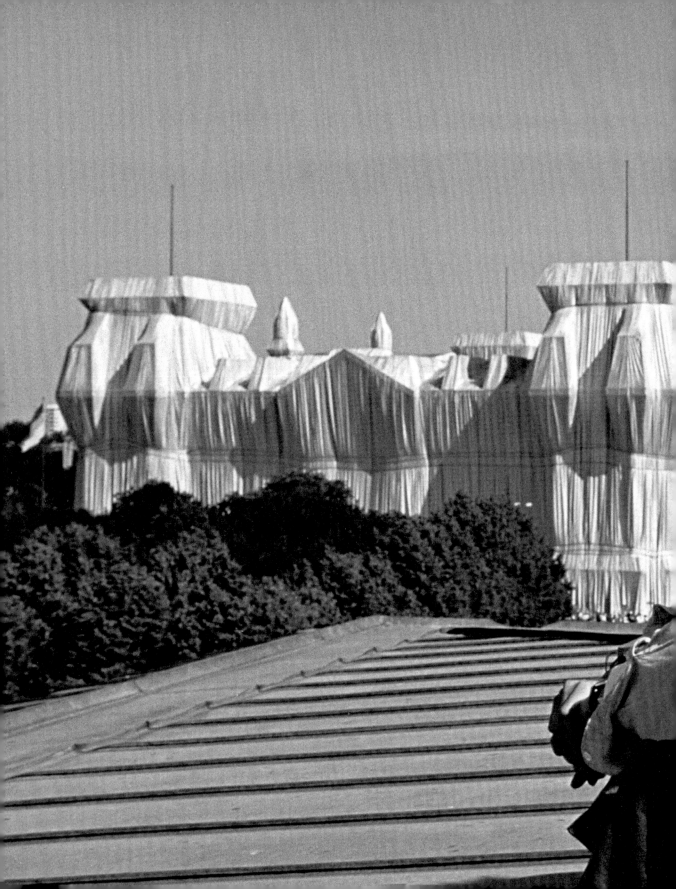

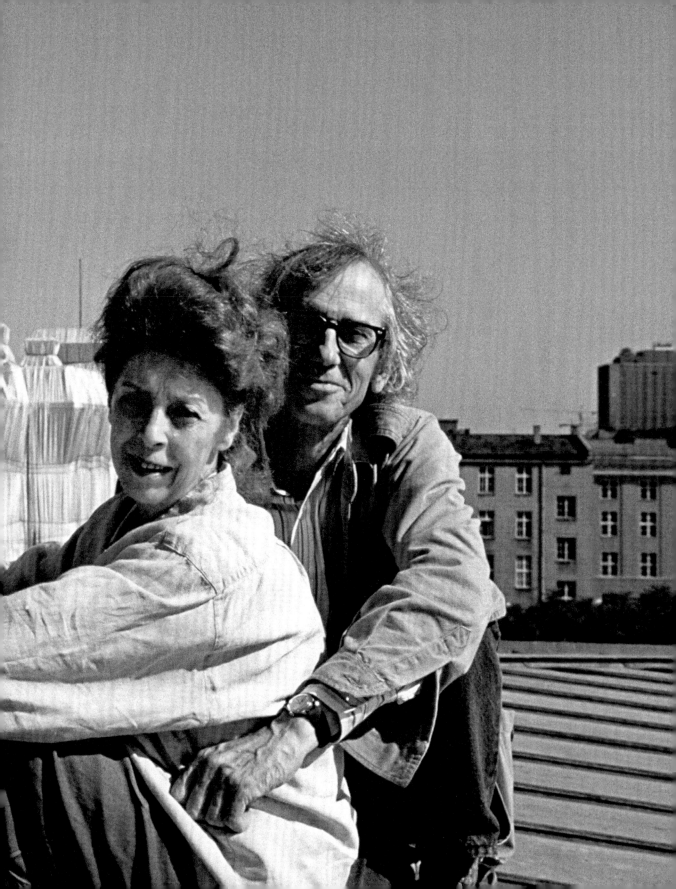

Ingrid and Thomas
Jochheim in con-
versation with
Friedhelm Hütte

Ingrid und Thomas
Jochheim im Gespräch
mit Friedhelm Hütte

From Christo
with Love …

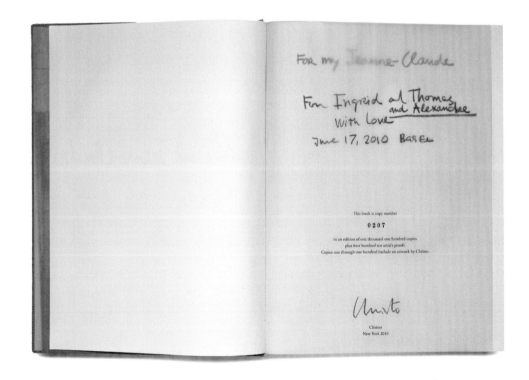

Friedhelm Hütte: When did you start to build up your collection?

Ingrid Jochheim: We moved forty years ago. We were looking for art for the walls of our new house and decided to use lithographs from the Vienna School of Fantastic Realism. We brought them to a picture framer, where we chose the most amazing frames. A friendship developed, also to her husband, a young artist who was just embarking on a career …

Thomas Jochheim: … and who was a master student in Ernst Fuchs' class.

IJ: From then on, we spent a great deal of time together and learned a lot from Wolfgang Nocke—that's the name of this artist, who still lives and works in Recklinghausen. We visited museums, studios, and galleries, learning a great deal about references to art history. So it became more and more exciting for us.

TJ: And then Wolf Vostell installed the sculpture *La Tortuga* in front of the music theater in Marl. It's a reversed steam locomotive with tender.

FH: A real locomotive?

TJ: Yes! We met Vostell, who invited us to his studio on Käuzchensteig in Berlin. There we became familiar with his ideas and works, learned a lot about the Fluxus movement, and started buying works by Vostell.

FH: So things were already moving in the direction of today's collection.

TJ: That's right. More sculptures and paintings were added, so that today we own about fifty works by Vostell. Among the older renowned German artists, he is the only one represented in our collection. Of course we also have works by younger German artists, but thirty-five years ago we discovered a completely different tendency through a Belgian gallery owner.

IJ: A work by Niki de Saint Phalle, that we bought from this gallerist at Art Cologne …

IJ: Which led us to the Nouveaux Réalistes. At the same time, we looked

Friedhelm Hütte: Wann haben Sie damit begonnen, Ihre Sammlung aufzubauen?

Ingrid Jochheim: Vor vierzig Jahren sind wir umgezogen. Für die Wände unseres neuen Hauses suchten wir Kunst und haben uns damals für Lithografien der Wiener Schule entschieden. Die brachten wir zu einer Bilderrahmerin, bei der wir uns die fantastischsten Rahmen aussuchten. Daraus ist eine Freundschaft entstanden, auch zu ihrem Mann, der sich als junger Künstler gerade niedergelassen hatte …

Thomas Jochheim: … und Meisterschüler bei Ernst Fuchs war.

IJ: Von da an verbrachten wir viel Zeit miteinander und haben von Wolfgang Nocke, so heißt dieser Künstler, der übrigens immer noch in Recklinghausen lebt und arbeitet, viel gelernt. Wir haben Museen besucht, Ateliers, Galerien, wir haben viel über die Bezüge zur Kunstgeschichte gelernt. Und so wurde es immer spannender für uns.

TJ: Und dann hat Wolf Vostell in Marl vor dem Musiktheater die Skulptur *La Tortuga* aufgestellt. Das ist eine umgedrehte Dampflokomotive mit Tender.

FH: Eine echte Lokomotive?

TJ: Ja! Dabei haben wir Vostell kennengelernt, der uns nach Berlin in sein Studio Am Käuzchensteig eingeladen hat. Dort wurden wir mit seinen Ideen und Arbeiten vertraut, haben viel über die Fluxus-Bewegung gelernt und die ersten Arbeiten von Vostell gekauft.

FH: Das ging dann schon in die heutige Richtung der Sammlung.

TJ: Richtig. Es kamen weitere Skulpturen und noch mehr Bilder dazu, so dass wir heute an die fünfzig Arbeiten von Vostell besitzen. Das ist unter den älteren renommierten deutschen Künstlern auch der einzige in unserer Sammlung. Natürlich haben wir auch jüngere deutsche Künstler, aber vor fünfunddreißig Jahren sind wir durch einen belgischen Galeristen

Christo and Jeanne-Claude: 75
Cologne 2010
Ex. 207/1000
Photo: Mathias Schormann

Christo and Jeanne-Claude: 75
Köln 2010
Ex. 207/1000

across the pond and found American Pop Art very exciting.

FH: As a second part of the collection?

IJ: Yes, as a second general area. And that's how we arrived at Christo. Right after the wrapping of the Reichstag in Berlin in 1995, we met Christo and Jeanne-Claude personally. A short time later, we flew to New York and visited them in their studio.

TJ: Christo and Jeanne-Claude got together in a similarly unusual way as we did. I proposed marriage to my wife four hours after we met, although she was engaged and a wedding date had already been set. Christo and Jeanne-Claude were no different: Jeanne-Claude had married someone else although she had already fallen in love with Christo. But right after the honeymoon she separated from her husband and moved in with Christo.

FH: It's unusual for a married couple to work together artistically. How did you get to know their respective roles?

IJ: We found the distribution of roles ideal. They developed the idea, the plan for a project, together. Jeanne-Claude then worked on the implementation and execution, while Christo created drawings that illustrated and conveyed the project. The drawings were exclusively by Christo, but the entire project was always a collaborative effort between Christo and Jeanne-Claude. They made all the decisions jointly. But there were intensive discussions from time to time.

TJ: Christo still travels a lot. Since Jeanne-Claude's death in 2009, his nephew Vladimir Yavachev has always been at his side and Christo can rely on him completely. Jonathan Henery, a nephew of Jeanne-Claude, continues to work in the New York office with Christo and his team, on the basis of complete trust. Thus, it has been optimally ensured that the work and projects can continue.

FH: Jeanne-Claude was the project manager, so to speak.

auf eine ganz andere Richtung gestoßen.

IJ: Eine Arbeit von Niki de Saint Phalle, die wir bei diesem Galeristen auf der Art Cologne gekauft haben …

IJ: Das hat uns zu den Nouveaux Réalistes geführt. Zur gleichen Zeit haben wir über den großen Teich geschaut und fanden die amerikanische Pop Art sehr spannend.

FH: Als den zweiten Teil der Sammlung?

IJ: Ja, als zweites Gebiet. So sind wir auch auf Christo gekommen. Direkt nach der Verhüllung des Reichstags in Berlin 1995 haben wir Christo und Jeanne-Claude persönlich kennengelernt. Kurze Zeit darauf sind wir nach New York geflogen und konnten beide in ihrem Studio besuchen.

TJ: Christo und Jeanne-Claude haben sich auf ähnlich außergewöhnliche Weise kennengelernt wie wir. Ich habe meiner Frau vier Stunden nach dem ersten Treffen einen Heiratsantrag gemacht, obwohl sie verlobt war und bereits ein Hochzeitstermin feststand. Das war bei Christo und Jeanne-Claude nicht viel anders: Jeanne-Claude hatte geheiratet, obwohl sie sich bereits in Christo verliebt hatte. Sie trennte sich dann von ihrem Mann nach den Flitterwochen, um zu Christo zu ziehen.

FH: Es ist recht ungewöhnlich, dass ein Ehepaar auch künstlerisch zusammenarbeitet. Wie haben Sie denn die Rollenverteilung der beiden kennengelernt?

IJ: Die Rollenverteilung fanden wir ideal. Die Idee und der Plan für ein Projekt wurden gemeinsam entwickelt. An der Umsetzung und Durchführung hat dann Jeanne-Claude gearbeitet. Christo schuf Zeichnungen, die das Projekt veranschaulichten und vermittelten. Die Zeichnungen sind ausschließlich von Christo, aber das gesamte Projekt war immer eine gemeinschaftliche Arbeit von Christo und Jeanne-Claude. Alle Entscheidungen trafen sie gemeinsam. Es gab aber auch mitunter intensive Diskussionen.

IJ: She was involved in everything. She coined the beautiful term "the Christo working family." This is a group of people from all over the world. But when a project is finally realized, everyone comes together, and everyone has his or her own specific task to work on. One member of this team is Wolfgang Volz, who was there from the beginning. His photographs of the locations are the basis for Christo's drawings and the only authorized photos of the projects—the art historian Werner Spies once called him "the eye of Christo and Jeanne-Claude." Volz was the project manager not only for the *Wrapped Reichstag*, but also for other projects.

FH: So it's a team of specialists?

IJ: Exactly, of professionals. Christo and Jeanne-Claude are as loyal as can be. Once they have experienced good, reliable cooperation with someone, they work with them again and again.

FH: Including special crafts enterprises and manufacturers from Germany, if I'm not mistaken?

IJ: That's correct. Since the wrapping of the Reichstag, all the fabric they have used has come from the same producer. A German company from Emsdetten. Another example is the climbing group. They came from Berlin.

TJ: Or the Berlin-based engineering office, which was responsible for *The Floating Piers* for Lago d'Iseo in Italy, for instance. They are now working on the Arc de Triomphe project and hopefully will also collaborate on the Mastaba in Abu Dhabi, if there is a permit.

FH: What is special about your collection is that you live with the artworks. The works in other collections of the same size are often stored by fine art logistics or are outsourced to different museums as loans.

TJ: We also have a small warehouse, but our works are primarily distributed between our two sites in Recklinghausen and Berlin.

TJ: Christo reist immer noch viel. An seiner Seite ist seit Jeanne-Claudes Tod 2009 immer sein Neffe Vladimir Yavachev, auf den er sich völlig verlassen kann. Im New Yorker Büro arbeitet nach wie vor Jonathan Henery, ein Neffe von Jeanne-Claude, sehr vertrauensvoll für ihn und das Team. So ist für die Weiterführung der Arbeit und Projekte bestens gesorgt.

FH: Jeanne-Claude war also sozusagen die Projektmanagerin.

IJ: Sie war in alles involviert. Sie hat diesen schönen Begriff von der „Christo-Working-Family" geprägt. Das ist eine Gruppe von Menschen aus der ganzen Welt. Wenn ein Projekt schließlich realisiert wird, dann kommen alle zusammen. Da hat dann jeder seinen eigenen Bereich, an dem er arbeitet. Dazu gehört auch Wolfgang Volz, der von Anfang an dabei war. Seine Fotos der Locations sind die Grundlage für Christos Zeichnungen und auch die einzig autorisierten Aufnahmen der Projekte – der Kunsthistoriker Werner Spies nannte ihn einmal „das Auge von Christo und Jeanne-Claude". Volz war nicht nur für den Reichstag, sondern auch bei weiteren Projekten der Projektleiter.

FH: Es ist also ein Team von Spezialisten?

IJ: Genau, von Fachleuten. Christo und Jeanne-Claude sind da treu wie Gold. Wenn sie einmal die Erfahrung einer guten, verlässlichen Zusammenarbeit mit jemandem gemacht haben, dann finden diese Menschen immer wieder zusammen.

FH: Darunter sind auch spezielle Handwerksbetriebe und Hersteller aus Deutschland, oder?

IJ: Ja, das stimmt. Seit der Verhüllung des Reichstages sind alle Stoffe vom gleichen Produzenten. Das ist ein deutscher Betrieb aus Emsdetten. Oder nehmen wir die Klettergruppe – die kam aus Berlin.

TJ: Oder das Berliner Ingenieurbüro, das unter anderem für *The Floating Piers* im Lago d'Iseo in Italien verantwortlich

FH: Does each artwork have a specific spot? Or do you sometimes move works, hang them in a different place?

IJ: This happens very rarely now. Many of the works have been with us for a long time and we have added to our collection again and again, until at some point we had the feeling that the artworks were like our children. This was the case in Recklinghausen a little earlier than here in Berlin. Now we wouldn't want to be without them anymore; we really need them close to us. It would be very difficult to remove anything.

FH: You told us what it was like when you first flew to New York to meet Christo and Jeanne-Claude. What special impressions do you remember?

TJ: Actually, we had an appointment in New York with our gallerists Linda and Guy Pieters, who had already worked with Christo and Jeanne-Claude for a long time and are still close friends with Christo today. But, shortly before they were supposed to leave for New York, they discovered that their passports had been stolen in a burglary two days before. They wrote to Jeanne-Claude and told her that the Jochheims would come instead. At first, Jeanne-Claude had reservations. "We don't even know them yet," she said. "Why don't you come together with them next time?" But in the end we were welcome, and from the very first meeting a close friendship arose that has lasted until today.

IJ: When people visited Christo and Jeanne-Claude, there was a particularly beautiful ritual: they were received on the first floor, in their showroom. They sat together comfortably, and usually a few more visitors were invited, but never more than eight people. Christo is happy when you like his bloody marys, which he mixes himself in expert fashion. He talks about his projects and his art, and shows his latest works, which he always presents himself. So you are very close to the thoughts and

war. Sie übernehmen jetzt auch die Arbeiten am Arc de Triomphe und hoffentlich auch die Mastaba in Abu Dhabi, wenn es eine Genehmigung dafür geben sollte.

FH: Das Besondere an Ihrer Sammlung ist, dass Sie mit den Kunstwerken leben – wenn man an andere Sammlungen gleichen Umfangs denkt, die ihre Werke oft in Kunstspeditionen aufbewahren oder an verschiedene Museen als Leihgaben ausgelagert haben.

TJ: Wir haben auch ein kleines Lager, aber in erster Linie sind unsere Arbeiten auf die beiden Standorte in Recklinghausen und Berlin verteilt.

FH: Hat jedes Kunstwerk seinen bestimmten Platz? Oder hängen Sie manchmal etwas um?

IJ: Das passiert jetzt eher selten. Vieles ist schon lange bei uns und wir haben unsere Sammlung auch immer wieder ergänzt, bis irgendwann das Gefühl da war, mit den Kunstwerken so etwas wie liebe Kinder um sich zu haben. Das war in Recklinghausen etwas früher als hier in Berlin der Fall. Man möchte sie dann nicht mehr missen, wir brauchen sie regelrecht in unserer Nähe. Da wäre es sehr schwer, etwas heraus zu nehmen.

FH: Sie haben erzählt, wie es war, als Sie zum ersten Mal nach New York geflogen sind, um Christo und Jeanne-Claude zu treffen. Was waren die besonderen Eindrücke?

TJ: Eigentlich waren wir in New York mit unseren Galeristen Linda und Guy Pieters, die seit langem mit Christo und Jeanne-Claude zusammengearbeitet hatten und bis heute eng mit ihm befreundet sind und noch immer zusammenarbeiten, verabredet. Nun stellten sie aber kurz vor der Abreise fest, dass bei einem Einbruch zwei Tage vorher auch ihre Pässe gestohlen worden waren. Das mussten sie nun Jeanne-Claude mitteilen und schrieben ihr, dass aber die Jochheims kommen würden. Es war Jeanne-Claude zunächst nicht recht: „Die kennen wir noch gar nicht.

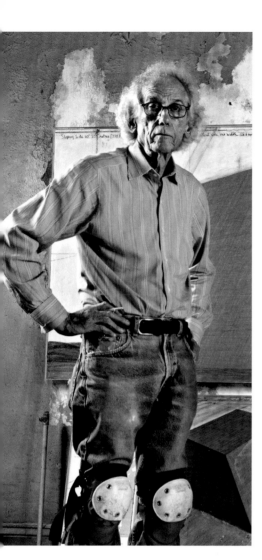

Kommt doch das nächste Mal gemeinsam." Schließlich waren wir aber doch willkommen und aus der ersten Begegnung entstand eine bis heute andauernde enge Freundschaft.

IJ: Wenn man Christo und Jeanne-Claude besuchte, gab es ein besonders schönes Ritual: Man wird in der ersten Etage, in ihrem Showroom, empfangen. Dort sitzt man gemütlich zusammen, meistens werden noch ein paar Besucher dazu eingeladen, nie mehr als acht Personen. Christo freut sich, wenn man seine Bloody Marys mag. Die mixt er selber und das macht er ganz wunderbar. Es wird über Projekte und Kunst geplaudert, Christo zeigt seine neuesten Arbeiten, die er immer selbst präsentiert. So ist man sehr nah an den Gedanken und dem Geschehen. Das ist das Ritual, das man immer bei einem Besuch bei Christo erlebt.

TJ: Man kommt auch nicht viel weiter als in den ersten Stock. Bei einem Besuch fragten wir, ob wir sein Atelier im fünften Stock des Hauses sehen dürfen. Ich hatte gelesen, dass Willy Brandt schon dort gewesen sei. Christo hat uns dann mitgenommen.

IJ: Oben ist es ganz spannend, alles ganz „rough". In das Haus sind Christo und Jeanne-Claude im Jahr 1964 eingezogen. Und die obere Etage sieht fast so aus wie zu dieser Zeit. Auf die unverputzten Wände pinnt Christo seine Blätter und zeichnet dort auch. Es ist alles sehr geordnet – und er ist da ganz allein!

FH: Ohne Assistent?

IJ: Immer ohne Assistenten. Er hat uns erzählt, dass er seine Arbeiten selbst einrahmt. Und es gibt tatsächlich keinen Stuhl in dem ganzen Studio. Christo steht den ganzen Tag ...

TJ: ... oder kniet ...

IJ: ... oder kniet! Er hat Knieschützer, wenn er auf dem Boden arbeitet.

FH: Das sind wirklich interessante Einblicke, die Sie da in den Werkprozess haben. Das Besondere an Ihrem Christo-

Christo at his studio,
New York 2012
Photo: Wolfgang Volz

Christo in seinem Studio,
New York 2012

the events. You always experience this same ritual when you visit Christo.

TJ: You don't get much further than the first floor. During a visit, we asked if we could see his studio on the fifth story of the building. I had read that Willy Brandt had been there. Christo took us there.

IJ: It's very exciting upstairs. Everything is very rough. Christo and Jeanne-Claude moved to the house in 1964. And the top floor looks almost like it did back then. Christo pins his sheets of paper on the unplastered walls and also draws there. Everything is very orderly—and he's all alone!

FH: Without an assistant?

IJ: Always without assistants. He told us he also frames his works himself. And there's no chair in the entire studio. Christo stands all day …

TJ: … or kneels …

IJ: … or kneels! He wears kneepads when he's working on the floor.

FH: You have gained very interesting insights into the work process. The special thing about your Christo collection is that you have purchased at least one original from each project.

IJ: From every project he has realized, there is at least one unique specimen in our collection. Because we have always been fascinated by the life and work of Christo and Jeanne-Claude.

TJ: You can see that now in the project in Paris. Our earliest work from this project is from 1989. The wrapping of the Arc de Triomphe is not a new idea, but an old one that can only be implemented now.

IJ: We also have works from the Mastaba for Abu Dhabi from the 1970s, when they sketched this idea for the first time. Then there was an interruption because of the Gulf wars. It wasn't until the early 2000s that they resumed the project. So twenty or even thirty years can pass between the first work on a project and its realization.

Konvolut ist, dass es Ihnen gelungen ist, von jedem Projekt mindestens ein Original zu erwerben.

IJ: Von jedem Projekt, das er realisiert hat, befindet sich in unserer Sammlung mindestens ein Unikat. Weil uns das Leben und Wirken von Christo und Jeanne-Claude immer absolut fasziniert hat.

TJ: Das sieht man auch jetzt an dem Projekt in Paris. Unsere erste Arbeit dazu ist aus dem Jahr 1989. Die Verhüllung des Arc de Triomphe ist keine neue Idee, sondern eine „alte", die erst jetzt realisiert werden kann.

IJ: Von der Mastaba für Abu Dhabi haben wir auch schon Arbeiten aus den 1970er-Jahren, als sie diese Idee zum ersten Mal skizzierten. Dann gab es eine Pause wegen der Kriege am Golf. Erst Anfang der 2000er-Jahre haben sie das Projekt wieder aufgenommen. So kann es sein, dass zwischen der ersten Arbeit an einem Projekt und der Realisierung zwanzig oder sogar dreißig Jahre verstreichen können.

FH: Gibt es denn Projekte, die noch nicht realisiert worden sind? Die Mastaba ist das eine, aber gibt es noch andere, die noch nicht realisiert wurden?

IJ: *Over The River, Project for Colorado*. Das wurde ab 1992 geplant, aber 2017 letztendlich eingestellt.

IJ: Eigentlich hat Christo ja gesagt, er würde nichts mehr einpacken. Aber der *Arc de Triomphe* ist ein Projekt aus dem Jahr 1962 und es ist natürlich ganz besonders, es jetzt realisieren zu können – der Triumphbogen wird 2020 tatsächlich verhüllt. *The Floating Piers*, die Christo 2016 am Lago d'Iseo in Italien realisiert hat, waren schon an zwei anderen Orten geplant, in Japan und andernorts … es gab offizielle Anfragen und viele Gespräche, aber letztlich keine Genehmigungen. Insgesamt haben Christo und Jeanne-Claude 47 Projekte geplant. Davon sind bisher 23 realisiert worden.

FH: Are there any other projects that haven't been implemented yet? Besides the Mastaba?

IJ: *Over The River, a project for Colorado*. It was devised starting in 1992, but was discontinued in 2017.

IJ: At some point Christo said he wouldn't wrap anything anymore. But the Arc de Triomphe project dates back to 1962 so it is very special to be able to realize it now. At long last, the Arc de Triomphe will be packaged in 2020. *The Floating Piers*, which Christo realized in 2016 at Lago d'Iseo in Italy, were already planned for two other locations, in Japan and elsewhere … there were official requests and many discussions, but ultimately no permits. Christo and Jeanne-Claude have planned a total of 47 projects. Of these, 23 have been realized to date.

TJ: There were a number of buildings he wanted to package: Cologne Cathedral, then several large buildings in New York …

IJ: Now the Arc de Triomphe project shows that some things are still possible if you pursue your goals unwaveringly and never give up …

FH: Are there any new ideas or plans? But perhaps this is a secret …

TJ: Not as far as we know, not at the moment.

IJ: Christo is still working hard on the Mastaba. When this project is realized, it will be the only one that is not temporary. It is intended to be permanent. So the Mastaba would be the crowning achievement of a life's work, intended for eternity, and the largest sculpture of all.

FH: The landscape or urban planning conditions play an important role. How are the locations selected? Rivers, lakes, and buildings? Did you every talk about this with the artist couple? What gets the ball rolling?

IJ: In terms of the Reichstag project, we know what it was. Mike Cullen, an American who moved to Berlin fifty years ago and still lives there today, sent them a

TJ: Es gab etliche Bauten, die er einpacken wollte: den Kölner Dom, dann in New York mehrere große Gebäude …

IJ: Jetzt zeigt der *Arc de Triomphe*, dass manches immer noch möglich ist, wenn man Ziele hartnäckig verfolgt und niemals aufgibt …

FH: Gibt es neue Ideen, Planungen? Vielleicht ist das aber auch geheim …

TJ: Nein, soviel wir wissen, im Moment nicht.

IJ: Christo arbeitet immer noch mit Nachdruck an der Mastaba. Wenn dieses Projekt realisiert wird, ist es das einzige, das nicht temporär, sondern dauerhaft wäre. Die Mastaba wäre somit die Krönung eines Lebenswerks, für die Ewigkeit gedacht, und die größte Skulptur überhaupt.

FH: Eine wichtige Rolle spielen die landschaftlichen oder städtebaulichen Gegebenheiten. Wie werden die Orte ausgewählt? Flüsse, Seen oder auch Gebäude …? Haben Sie darüber einmal mit dem Künstlerpaar gesprochen? Was hat letztlich den Ausschlag gegeben?

IJ: Beim Reichstag wissen wir das. Das war Mike Cullen, ein Amerikaner, der heute noch in Berlin lebt, und vor fünfzig Jahren hierhergezogen ist. Der schickte ihnen eine Postkarte vom Reichstag und schlug vor, das Gebäude zu verpacken. Christo und Jeanne-Claude hatten schon länger die Idee der Verhüllung eines großen öffentlichen Gebäudes, am liebsten eines Parlaments. Das hat sie sofort fasziniert.

TJ: Und die Nähe zur Berliner Mauer.

IJ: Für *The Floating Piers* haben sie sich lange umgesehen und überlegt, welcher Schauplatz der richtige ist. Ausschlaggebend für den Lago d'Iseo waren die beiden in der Mitte des Sees liegenden Inseln. Bei dem nicht realisierten Projekt *Over The River* wissen wir, dass sie viele Flusskilometer abgefahren und abgelaufen sind, insgesamt an 89 Flüssen. Sie sind Perfektionisten, die weder Arbeit

postcard from the Reichstag suggesting that they wrap the building. Christo and Jeanne-Claude had long had the idea of covering a large public building, preferably a parliament building. They were immediately fascinated by this prospect.

TJ: And the proximity to the Berlin Wall.

IJ: For *The Floating Piers*, they looked around for a long time in search of the right setting. The decisive factor for Lago d'Iseo was the two islands in the middle of the lake. With the unrealized *Over The River* project, we know that they sailed and walked down many miles of river, along a total of eighty-nine different rivers. They are perfectionists and spare neither work nor time when it comes to their projects.

FH: In the end everything is dismantled, recycled, and the old state is restored.

IJ: We heard that Mercedes Benz wanted to buy some of the fabric used for the Reichstag project and use it for the interiors of a special car series. Which would have meant that Christo and Jeanne-Claude could have sold part of it, and this would have cut recycling costs. But this was out of the question. They pay for everything themselves. Christo and Jeanne-Claude have always felt that if someone contributes money for a project, then they also have a say in it. They didn't want to be talked into something. These are our projects. They are completely useless. They are created because we want them to be created and want to see them realized. That's the reason.

FH: Self-financing is their motto ...

IJ: Christo always pays for the space, rents it. He rented the Reichstag, he rented Central Park ...

FH: He rents it?

IJ: Yes, he rents it. He pays for being allowed to use a space, an area, or whatever it is. They're very careful about that. In Central Park, the technology for the gates was honed for a long time so that no anchors had to be driven into the ground. The project was then of course recycled

noch Zeit scheuen, wenn es um ihre Projekte geht.

FH: Zum Schluss wird alles wieder abgebaut, recycled, und der alte Zustand wiederhergestellt.

IJ: Über das Reichstagsprojekt haben wir gehört, dass Mercedes Benz einen Teil des dort verwendeten Stoffs übernehmen wollte, um daraus die Innenausstattung einer besonderen Serie zu fertigen. Das hätte bedeutet, einen Teil des Materials verkaufen zu können und Recyclingkosten zu sparen. Doch das kam überhaupt nicht infrage. Sie zahlen alles selbst. Christo und Jeanne-Claude haben immer die Meinung vertreten, wenn jemand Geld gibt, dann ist es auch legitim, dass er einen Anspruch hat. Sie wollten sich aber in gar nichts reinreden lassen. „Das sind unsere Projekte, sie sind völlig nutzlos, sie entstehen, weil wir es möchten, und weil wir sie realisiert sehen möchten." Das ist die Begründung.

FH: Die Finanzierung, also Selbstfinanzierung, ist hier ein gutes Stichwort ...

IJ: Christo bezahlt immer für die Flächen, er mietet sie. Er hat den Reichstag gemietet, er hat den Central Park gemietet ...

FH: Er mietet?

IJ: Ja, er mietet, er bezahlt dafür, dass er diesen Raum, die Fläche oder was immer es ist, bespielen darf. Dabei sind sie sehr sorgsam. Im Central Park wurde lange an der Technik für die Tore gefeilt, damit zum Beispiel keine Verankerungen in den Boden getrieben werden mussten. Das Projekt wurde danach selbstverständlich recycled und der Park wieder in dem Zustand zurückgegeben, wie man ihn vorgefunden hatte.

FH: Damit ist auch gewährleistet, dass die Projekte nur in den Zeichnungen und in den Fotografien weiterleben.

IJ: Ja, das fanden wir schon immer so faszinierend.

FH: Vielleicht noch etwas zu „Christo und Berlin"?

and the park returned to its original state.

FH: This also ensures that the projects only live on in the drawings and photographs.

IJ: Yes. We've always found this fascinating.

FH: Perhaps you could say something more about Christo and Berlin?

IJ: Christo and Jeanne-Claude always enjoyed coming to Berlin. They were here long after the opening of the wall, when the Reichstag was wrapped. He has good friends and collectors here. Christo has always felt that Berlin is an open city.

TJ: Rita Süssmuth was very important for him, because she pushed through the Reichstag project so decisively in the end.

IJ: Now Christo and Jeanne-Claude's documentation of the Reichstag project can be seen at the Reichstag itself, as they always wished, thanks to Lars Windhorst's purchase and permanent loan. And Christo really likes coming to Berlin.

FH: One last question: Does Christo also make free drawings? Anything like that?

IJ: No. Perhaps in the beginning. Today all drawings relate to his projects. And when Christo signs books or catalogs, he only signs his name, without adding a drawing as many artists do. But with us, there's also always an "in love."

IJ: Christo und Jeanne-Claude sind immer gerne nach Berlin gekommen. Vor der Maueröffnung schon, und dann waren sie gleich nach dem Fall der Mauer lange hier, als der Reichstag verhüllt wurde. Er hat hier gute Freunde und Sammler. Christo empfand Berlin immer als eine offene Stadt.

TJ: Rita Süssmuth war für ihn sehr wichtig, weil sie das Reichstagsprojekt so maßgeblich am Ende durchgeboxt hat.

IJ: Jetzt ist durch den Ankauf und die Dauerleihgabe von Lars Windhorst auch Christo und Jeanne-Claudes Dokumentation über das Reichstagsprojekt vor Ort im Reichstag selbst zu sehen, so wie sie es sich immer gewünscht haben. Und er kommt wirklich gerne nach Berlin.

FH: Eine letzte Frage: Macht Christo auch freie Zeichnungen? Gibt es etwas in der Art?

IJ: Nein. Hat er vielleicht ganz zu Anfang mal gemacht. Heute haben alle Zeichnungen mit seinen Projekten zu tun. Auch wenn Christo Bücher oder Kataloge signiert, dann nur mit seinem Namen, nicht mit einer zusätzlichen Zeichnung wie andere Künstler das tun. Allerdings ist bei uns immer ein „In Love ..." dabei.

Christo in his studio with
preparatory collages
for *Wrapped Reichstag*,
New York 1984
Photo: Sanjiro Minamikawa

Christo in seinem Atelier
mit Collagen zum Projekt
Wrapped Reichstag,
New York, 1984

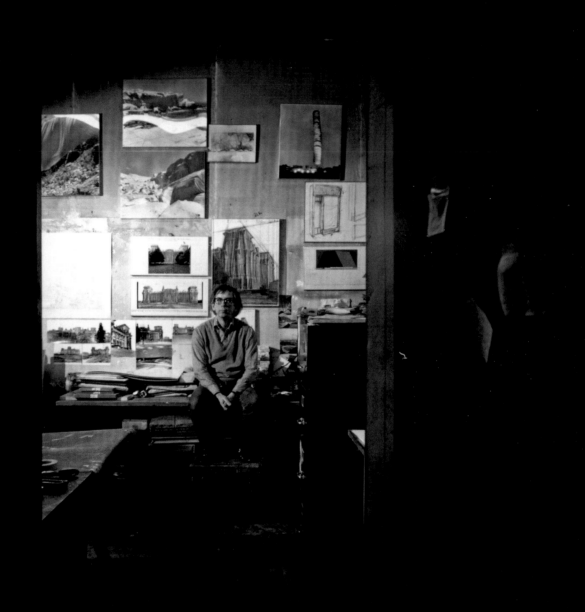

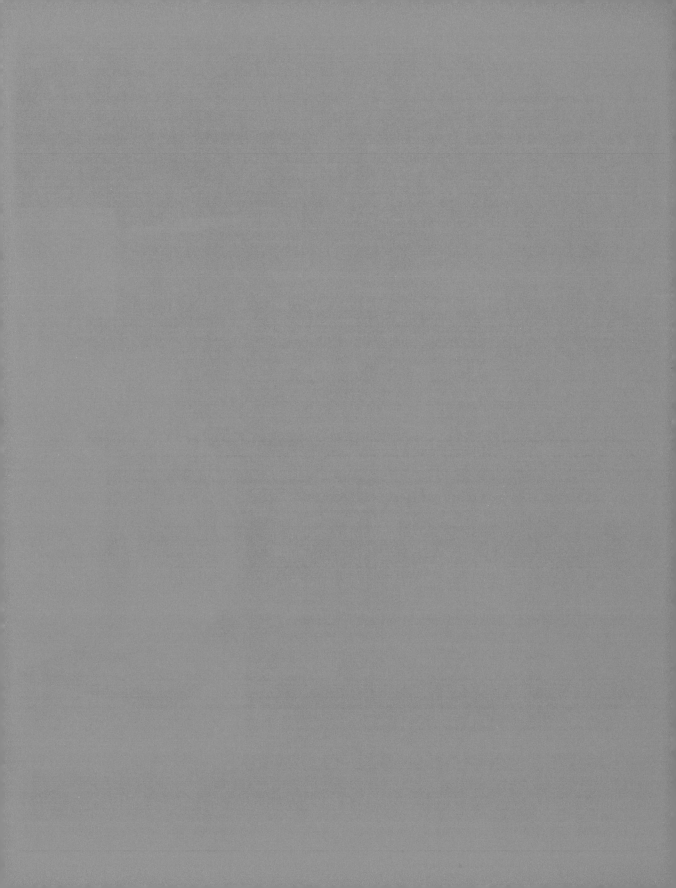

Biography
Biografie

Christo (born 1935 in Gabrovo, Bulgaria) and his late wife Jeanne-Claude (born 1935 in Casablanca, Morocco, died 2009, New York City, USA) have created some of the most visually breathtaking works of the twentieth and twenty-first centuries. The artists began their collaboration in 1961.

Their large-scale projects include *Wrapped Coast*, Little Bay, Australia, 1968–69; *Valley Curtain*, Rifle, Colorado, 1970–72; *Running Fence*, Sonoma and Marin Counties, California, 1972–76; *Surrounded Islands*, Biscayne Bay, Florida, 1980–83; *The Pont Neuf Wrapped*, Paris, 1975–85; *The Umbrellas*, Japan–USA, 1984–91; *Wrapped Reichstag*, Berlin, 1971–95; *Wrapped Trees*, Riehen, Switzerland, 1997–98; *The Gates*, Central Park, New York City, 1979–2005; and *The Floating Piers*, Lake Iseo, Italy, 2014–16.

Their work is represented in museums and galleries throughout the world including the Guggenheim and Metropolitan museums in New York, Tate Modern in London, and the Centre Pompidou in Paris.

Christo (1935 in Gabrovo, Bulgarien, geboren) und seine verstorbene Frau Jeanne-Claude (1935 Casablanca, Marokko – 2009, New York City, USA) haben eines der visuell atemberaubendsten künstlerischen Gesamtwerke des 20. und 21. Jahrhunderts geschaffen. Die Künstler haben ihre Zusammenarbeit 1961 begonnen.

Ihre groß angelegten Projekte umfassen *Wrapped Coast*, Little Bay, Australien, 1968–69; *Valley Curtain*, Rifle, Colorado, 1970–72; *Running Fence*, Sonoma und Marin Counties, Kalifornien, 1972–76; *Surrounded Islands*, Biscayne Bay, Florida, 1980–83; *The Pont Neuf Wrapped*, Paris, 1975–85; *The Umbrellas*, Japan–USA, 1984–91; *Wrapped Reichstag*, Berlin, 1971–95; *Wrapped Trees*, Riehen, Schweiz, 1997–98; *The Gates*, Central Park, New York City, 1979–2005; und *The Floating Piers*, Lago d'Iseo, Italien, 2014–16.

Ihr Werk wird in Museen und Galerien weltweit gezeigt, unter anderen im Guggenheim und Metropolitan Museum in New York, der Tate in London und im Centre Pompidou in Paris.

Christo and Jeanne-Claude at the studio
New York 2004
Photo: Wolfgang Volz

Christo und Jeanne-Claude im Studio
New York 2004

PP./S. 160/161

Christo and Jeanne-Claude at the studio
New York 1976
Photo: Fred W. McDarrah/Getty Images

Christo und Jeanne-Claude im Studio
New York 1976

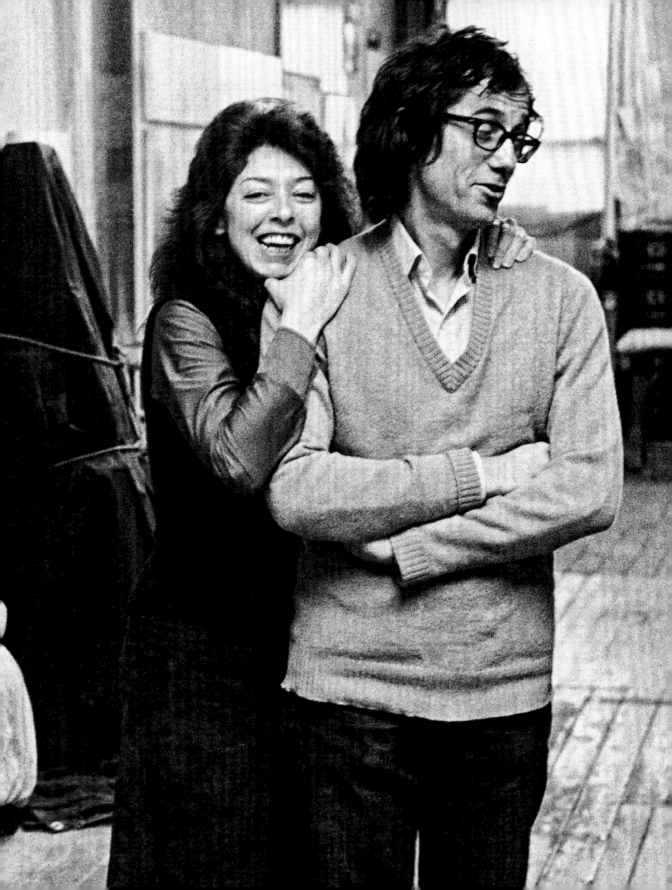

List of Works Exhibited
Liste der ausgestellten Werke

WRAPPED MAGAZINE, 1963
Magazines, polyethylene, twine, mounted on
burlap-covered board / Zeitschriften, Polyethylen,
Schnur, montiert auf mit Sackleinen bespannter
Holzplatte
63 × 22 cm

WRAPPED APPLIQUÉS, 1963
Appliqués, polyethylene, twine, mounted on painted
board / Applikationen, Polyethylen, Schnur, montiert
auf bemalter Holzplatte
46 × 24 cm

INTERVIEW, 1963
Magazin cover, silkscreen, photograph by
Jeanne-Claude / Magazincover, Siebdruck,
Fotografie von Jeanne-Claude
32 × 21 cm

ORANGE STORE FRONT, 1965
Pencil, wood, fabric, staples, enamel paint,
galvanized metal / Bleistift, Holz, Stoff, Metall-
klammern, Emailfarbe, verzinktes Metall
82 × 67 cm

LOOK MAGAZINE EMPAQUETÉ, 1965
Look magazine wrapped in transparent polyethylene
with cord, on black wooden support / Look-Magazin
über Schaumstoff, verpackt in Polyethylene und
Schnur, auf Holzträger
56 × 45.6 × 8.2 cm
Ed. 31/100

WRAPPED MAGAZINES (in four parts), 1967
Magazines, polyethylene, twine, rope; fabric,
polyethylene, twine / Zeitschriften, Polyethylen,
Schnur, Seil; Stoff, Polyethylen, Schnur
4 parts, 4-teilig, 45 × 30 × 22, 33 × 26 × 15,
33 × 27 × 17.36 × 29 × 18 cm

THREE WRAPPED TREES (Project for the Fondation
Marguerite et Aimé Maeght, St. Paul de Vence,
France), 1967
Drawing; pencil, wax crayon, charcoal, wash on
paper / Zeichnung; Bleistift, Wachsmalstift, Kohle,
Tusche auf Papier
71 × 55 cm

CORRIDOR STORE FRONT PROJECT, 1968
Two-part screenprint with hinges, to be opened.
Front print die-cut, mounted on acetate; rear print
mounted on cardboard / Zweiteiliger Siebdruck mit
Scharnieren zum Öffnen. Vorderer Druck gestanzt,
auf Acetatplatte befestigt; hinterer Druck auf Karton
gezogen
70 x 55 cm
Ex. 33/100

Fig. 1
WRAPPED WOMAN (Project for the Institute of
Contemporary Art, Philadelphia), 1968, 1997
Lithograph with collage of polyethylene and twine,
with pencil additions / Lithografie mit Collage,
Polyethylen, Schnur, Bleistift
56 × 1 cm
Ed. XXVIII/XXX

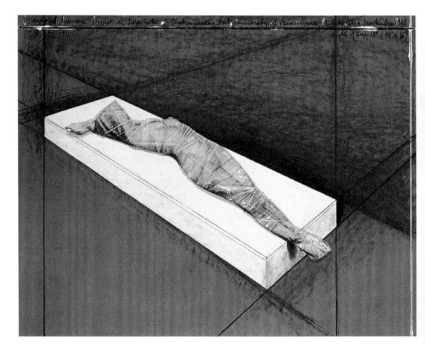

1

P./S. 41
WRAPPED COAST (Project for Little Bay New South Wales, Australia), 1969
Drawing; pencil, wax crayon, ball point pen, topographic map/Zeichnung; Bleistift, Wachsmalkreide, Kugelschreiber, Landkarte
71 × 56 cm

P./S. 45
VALLEY CURTAIN (Project for Colorado, USA), 1971
Collage; fabric, photostat, pencil, color pencil, surveyor's map/Collage; Stoff, Fotokopie, Bleistift, Buntstift, Übersichtskarte
71 × 56 cm

MONSCHAU PROJECT, 1971
"Do-it-yourself catalog" for the Monschau project. Cardboard box with signed postal sticker, postcard, ball of twine, plastic souvenir model, four photographs, a piece of polypropylene fabric used for the wrapping, and information material/„Do-it-yourself-Katalog" für das Monschau-Projekt. Kartonschachtel mit signiertem Postaufkleber, Postkarte, Kordel, Souveniermodell aus Plastik, vier Fotografien, ein Stück Polypropylenstoff, der für die Verhüllung verwendet wurde und Informationsmaterial
Box, 16.5 x 23 x 16.5 cm
Ed. 150 copies

PP./S. 46/47
VALLEY CURTAIN (Project for Colorado, USA), 1971
Drawing; pencil, wax crayon, charcoal on paper/Zeichnung; Bleistift, Wachsmalkreide, Kohle auf Papier
93 × 154 cm

TEN MILLION OIL DRUMS WALL (Project for the Suez Canal), 1972
Silkscreen/Siebdruck
70.7 × 55.5 cm
Ed. 45/70

P./S. 101
OTTERLO MASTABA (Project for the Kröller-Müller Museum, Otterlo, The Netherlands), 1973
Drawing; pencil, charcoal, crayon/Zeichnung; Bleistift, Kohle, Farbstift
71 × 56 cm

PP./S. 50/51
RUNNING FENCE (Project for Sonoma and Marin Counties), 1975
Drawing; pencil, charcoal, colored pencil, ball point pen, photographs, map on paper/Zeichnung; Bleistift, Kohle, Buntstift, Kugelschreiber, Fotografien, Landkarte auf Papier
Two parts/2-teilig, 35.5 × 244, 106.6 × 244 cm

P./S. 103
THE MASTABA OF ABU DHABI (Project for United Arab Emirates), 1978
Drawing; pencil, charcoal, pastel, color pencil, map/Zeichnung; Bleistift, Kohle, Pastell, Buntstift, Landkarte
Two parts/2-teilig, 38 × 244, 106.6 × 244 cm

P./S. 102
THE MASTABA OF ABU DHABI (Project for United Arab Emirates), 1979
Collage; pencil, wax crayon, photostat from a photograph, pastel, charcoal, technical data/Collage; Bleistift, Wachsmalstift, Kopie einer Fotografie, Pastell, Kohle, Datenblatt
80 × 60.5 cm

P./S. 104
THE MASTABA OF ABU DHABI (Project for United Arab Emirates), 1979
Drawing; pencil, charcoal, pastel, wax crayon, map/Zeichnung; Bleistift, Kohle, Wachskreide, Landkarte
36 × 28 cm

P./S. 61
THE PONT NEUF WRAPPED (Project for Paris, France), 1980
Collage; pencil, fabric, twine, pastel, wax crayon, technical data, aerial photograph/Collage; Bleistift, Stoff, Bindfaden, Pastell, Wachsmalstift, technische Angaben, Luftaufnahme
Two parts/2-teilig, 71 × 28, 71 × 56 cm

P./S. 55
SURROUNDED ISLANDS (Project for Biscayne Bay, Greater Miami, Florida, USA), 1983
Collage; pencil, fabric, pastel, charcoal, wax crayon, enamel paint, photostat/Collage; Bleistift, Stoff, Pastell, Kohle, Wachsmalstift, Emailfarbe, Fotokopie
Two parts/2-teilig, 71 × 56, 71 × 28 cm

Fig. 2
LOWER MANHATTAN WRAPPED BUILDING (Project for 2 Broadway, New York), 1984
Lithograph with collage of fabric, twine, and thread/Lithografie mit Collage aus Stoff, Schnur und Draht
71 × 56 cm
Ed. 60/110

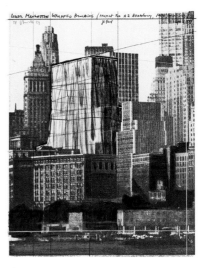

THE MASTABA (Project for Kunstverein Köln), 1986
Photograph mounted on rag paper, with silkscreen
and collotype/Fotografie auf Bütten, mit Siebdruck
und Lichtdruck
Print/Druck, 87.5 × 71 cm
Oil drum/Tonne, 37 cm Durchmesser/59 cm hoch
Ed. 5/200

MASTABA (Project for Kunstverein Köln), 1986/87
Oil drum, lacquered/Öltonne, lackiert
Diameter/Durchmesser 38 x 58.5 cm
Ed. 200 + 50 A.P.

5,600 CUBICMETER PACKAGE (documenta IV,
Kassel), 1967–68, 1986
Silkscreen and collotype, with collage of three photo-
graphs, transparent polyethylene, and thread,
with felt marker additions. One photograph shows
Joseph Beuys helping with the installation of
Christo's work during documenta IV. / Siebdruck
und Lichtdruck, mit Collage aus drei Fotografien,
transparentem Polyethylen und Garn, mit Filz-
marker-Hinzufügungen.
Part of the portfolio *For Joseph Beuys*, with works by
30 artists / Teil des Portfolios *Für Joseph Beuys*, mit
Arbeiten von 30 Künstlern
80 × 60 cm
Ed. 90/90

Fig. 3
WRAPPED TREES (Project for the Avenue des
Champs-Elysées, Paris), 1987
Lithograph with collage of transparent polyethylene,
thread, and staples, with felt marker additions/
Lithografie mit Collage aus transparentem Polyethy-
len, Garn und Büroklammern, mit Filzmarker-Hinzu-
fügungen
71 × 56.5 cm
Ed. 169/200

PP./S. 70/71
WRAPPED REICHSTAG (Project for Berlin), 1987
Drawing; pencil, charcoal, wax crayon and map/
Zeichnung; Bleistift, Kohle, Wachskreide und Stadt-
plan
Two parts/2-teilig, 38 × 165, 106.6 × 165 cm

P./S. 65
THE UMBRELLAS (Joint Project for Japan and
USA), 1988
Drawing; pencil, charcoal, wax crayon, pastel,
enamel paint, map/Zeichnung; Bleistift, Kohle,
Wachsmalstift, Pastell, Emailfarbe, Karte
Two parts/2-teilig, 165 × 38, 165 × 106.6 cm

Fig. 4
PACKAGE ON A "HUNT" (Project for Goslar), 1988
Photograph mounted on rag paper, with color
screenprint, collotype, and collage of a photograph
and a blueprint/Fotografie, montiert auf Bütten, mit
Farbsiebdruck, Lichtdruck und Collage einer
Fotografie und einer Blaupause
80 × 70 cm
Ed. 25/100

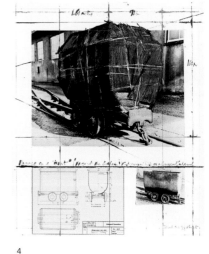

4

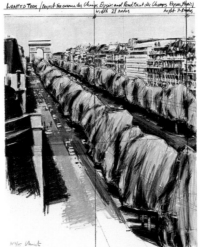

3

Fig. 5
THE PONTE SANT'ANGELO, WRAPPED (Project for Rome), 1989
Lithograph with collage of broadcloth, thread, offset print, and city map, with additions of charcoal and prismacolor/Lithografie mit Collage aus Walkstoff, Garn, Offsetdruck und Stadtplan, mit Hinzufügungen von Kohle und Prismacolorfarben
71 × 55.5 cm
Ed. 110/150

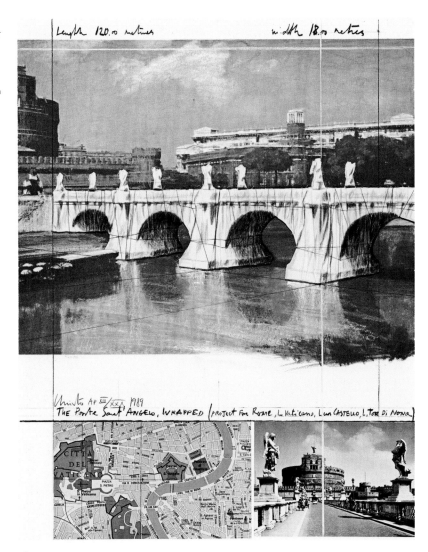

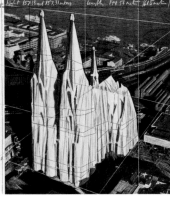

7

P./S. 110
ARC DE TRIOMPHE, WRAPPED (Project for
Paris), 1989
Lithograph with collage of broadcloth, thread, and
city map, with additions of charcoal and prismacolor /
Lithografie mit Collage aus Walkstoff, Garn und
Stadtplan, mit Hinzufügungen von Kohle und Prisma-
colorfarben
71 × 55.5 cm
Ed. 109/150

WRAPPED BUILDING (Project for 1 Times Square,
Allied Chemical Tower, New York), 1991
Lithograph with collage of fabric, thread, transparent
polyethylene, staples, photograph, map (chine collé),
and masking tape, with charcoal and color additions /
Lithografie mit Collage aus Stoff, Draht, transparen-
tem Polyethylen, Heftklammern, Fotografie,
Landkarte (Chine collé) und Abdeckklebeband, mit
Kohle- und Farbhinzufügungen
100 × 63.5 cm
Ed. 37/125

WRAPPED BUILDING (Project for 1 Times Square,
Allied Chemical Tower, New York), 1991
Lithograph with collage of fabric, thread, transparent
polyethylene, staples, photograph, map (chine collé),
and masking tape, with charcoal and color additions /
Lithografie mit Collage aus Stoff, Draht, transparen-
tem Polyethylen, Heftklammern, Fotografie,
Landkarte (Chine collé) und Abdeckklebeband, mit
Kohle- und Farbhinzufügungen
100 × 63.5 cm
Ed. 37/125

Fig. 7
MEIN KÖLNER DOM, WRAPPED (Project for
Cologne), 1992
Lithograph with collage of fabric, twine, staples, and
map, with charcoal, pencil and color pencil additions /
Lithografie mit Collage aus Stoff, Faden,
Heftklammern und Landkarte, mit Kohle-, Blei- und
Farbstift-Hinzufügungen
56 × 71 cm
Ed. 69/110

WRAPPED FLOORS AND COVERED WINDOWS
(Project for Museum Würth, Künzelsau, Germany),
1995
Lithograph with collage of cloth, brown wrapping
paper, and latex paint / Lithografie mit Collage aus
Stoff, braunem Einpackpapier und Latexfarbe
77.5 × 66.5 cm
Ed. 19/20 H.C.

PP./S. 96/97
OVER THE RIVER (Project for the Arkansas River,
Colorado, USA), 1997
Drawing; pencil, pastel, charcoal, photographs by
Wolfgang Volz, topographic map, wax crayon, tape /
Zeichnung; Bleistift, Pastell, Kohle, Fotografien von
Wolfgang Volz, topographische Karte, Wachs-
malstift, Klebeband
Two-parts / 2-teilig, 38 × 244, 106.6 × 244 cm

PP./S. 74/75
WRAPPED TREES (Project for Fondation Beyeler
and Berower Park, Switzerland), 1998
Collage; pencil, enamel paint, photograph by
Wolfgang Volz, wax crayon, topographic map, fabric
sample, tape / Collage; Bleistift, Emailfarbe,
Fotografie von Wolfgang Volz, Wachskreide,
topografische Karte, Stoffmuster, Klebeband
21.5 × 28 cm

P./S. 85
THE GATES (Project for Central Park, New York
City, USA), 1998
Drawing; pencil, charcoal, pastel, wax crayon,
photograph by Wolfgang Volz, aerial photograph /
Zeichnung; Bleistift, Kohle, Pastell, Wachsmalstift,
Fotografie von Wolfgang Volz, Luftaufnahme
Two parts / 2-teilig, 244 × 106.6, 244 × 38 cm

P./S. 79
THE WALL (Project for 13,600 oil barrels, Gasometer
Oberhausen, Germany), 1999
Collage; pencil, enamel paint, photograph by
Wolfgang Volz, wax crayon, technical data, tape /
Collage; Bleistift, Emailfarbe, Fotografie von
Wolfgang Volz, Wachsmalstift, technische Daten,
Klebeband
35.5 × 28 cm

P./S. 93
OVER THE RIVER (Project for the Arkansas River,
Colorado, USA), 1999
Drawing; pencil, pastel, charcoal, wax crayon,
topographic map / Zeichnung; Bleistift, Pastell,
Kohle, Wachskreide, topografische Karte
165 × 106.6, 165 × 38 cm

P./S. 95
OVER THE RIVER (Project for the Arkansas River,
Colorado, USA), 1999
Collage; pencil, pastel, wax crayon, charcoal, fabric,
topographic map / Collage; Bleistift, Pastell,
Wachskreide, Kohle, Stoff, topografische Karte
Two parts / 2-teilig, 30.5 × 77.5, 66.7 × 77.5 cm

WRAPPED BOTTLE AND CANS, 1958–2001
Collage; graphite, chalk, and pastel on card /
Collage; Bleistift, Kreide und Pastell auf Karton
20.3 x 20.3 cm

P./S. 84
THE GATES (Project for Central Park, New York
City, USA), 2001
Drawing; pencil, charcoal, pastel, wax crayon/
Zeichnung; Bleistift, Kohle, Pastell, Wachsmalstift
35.2 × 38.7 cm

P./S. 80/81
THE GATES (Project for Central Park, New York
City, USA), 2004
Collage; pencil, fabric, wax crayon, charcoal, enamel
paint, pastel, hand drawn map, tape, fabric sample/
Collage; Bleistift, Stoff, Wachsmalstift, Kohle,
Emailfarbe, Pastell, von Hand gezeichnete Karte,
Klebeband, Stoffmuster
Two parts/2-teilig, 77.5 × 66.7, 77.5 × 30.5 cm

P./S. 107
THE MASTABA OF ABU DHABI (Project for United
Arab Emirates), 1979
Collage; pencil, wax crayon, pastel, charcoal, wash
and tape/Collage; Bleistift, Wachskreide, Pastell,
Kohle, Tusche und Klebeband
35.3 × 39.4 cm

CHRISTO & JEANNE-CLAUDE 75 (Project for
Jewelry on Jeanne-Claude's Hand), 2010
Book with original pigment/silkscreen print/
Buch mit Original-Pigment-/Siebdruck
44 × 33 cm
Taschen Verlag 2010
Ed. 75/100

Fig. 8
THE PONTE SANT'ANGELO, WRAPPED (Project
for Rome), 2011
Screenprint with collage of fabric and twine, with
felt pen and pencil additions, and semi-transparent
polyester-foil with masking tape/Siebdruck mit
Collage aus Stoff und Schnur, mit Filzstift- und Blei-
stifthinzufügungen und semitransparenter Polyester-
folie mit Abklebeband
63.5 × 72 cm
Ed. 90/160

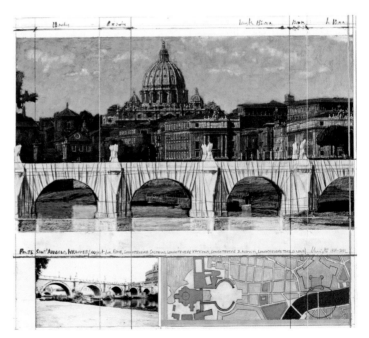

8

Fig. 9
WRAPPED VOLKSWAGEN (Project for 1961
Volkswagen Beetle Saloon), 2013
Screenprint with collage of fabric, transparent poly-
ethylene and twine, with felt pen and pencil addi-
tions, and photos with masking tape/Siebdruck mit
Collage aus Stoff, transparentem Polyethylen und
Schnur, mit Hinzufügungen von Filz- und Bleistift, und
Fotografien mit Abklebeband
56 × 71 cm
Ed. 1/160

PP./S. 88/89
THE FLOATING PIERS (Project for Lago d'Iseo,
Italy), 2014
Collage; pencil, wax crayon, enamel paint,
photograph by Wolfgang Volz, map, fabric sample,
tape/Collage; Bleistift, Wachsmalkreide, Emailfarbe,
Fotografie von Wolfgang Volz, Karte, Stoffmuster,
Klebeband
43.2 × 55.9 cm

WRAPPED BILD-ZEITUNG (13.8.1961), Mauerbau,
2014
Newspaper, plastic, rope/Zeitung, Plastik, Seil
27 × 50 cm

WRAPPED BOOK, 2017
Projectbook, wrapped, on/Projektbuch, verpackt,
über The Floating Piers
30 × 30 × 8 cm
Ed. 20/20

PP./S. 110/111
THE MASTABA (Project for London, Hyde Park,
Serpentine Lake), 2017
Collage; pencil, wax crayon, enamel paint, color
photograph by Wolfgang Volz, tape/Collage;
Bleistift, Wachskreide, Emailfarbe, Farbfotografie
von Wolfgang Volz, Klebeband
21.5 × 28 cm

P./S. 114/115
L'ARC DE TRIOMPHE, WRAPPED (Project for Paris,
Place de l'Étoile—Charles de Gaulle), 2019
Collage; wax crayon, enamel paint, photograph by
Wolfgang Volz, map, tape/Collage; Wachskreide,
Emailfarbe, Fotografie von Wolfgang Volz, Stadtplan,
Klebeband
43.1 × 55.9 cm

WOLFGANG VOLZ

REICHSTAG, 1995
Photograph/Fotografie
260 × 100 cm
AP 1/2

CHRISTO & JEANNE-CLAUDE IN THE DESERT,
2014
Photograph/Fotografie
30 × 42 cm
AP 8/15

Untitled/Ohne Titel, undated/nicht datiert
Photograph/Fotografie
Portfolio with 18 sheets/Mappe mit 18 Blättern
Each/Je 60 × 73 cm
Ed. 9/13

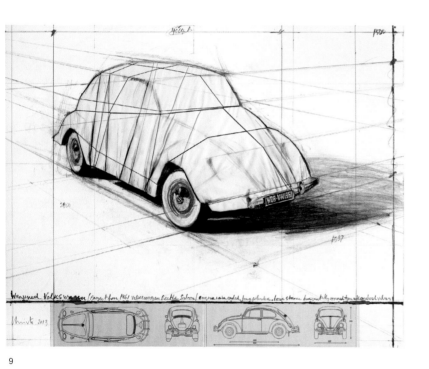

Wrapped Volkswagen (Project for 1961 Volkswagen Beetle Saloon) one air cooled four cylinder, rear engine, horizontally opposed type, with oyerhead valves

Christo 2013

9

Thanks
Dank

Fabienne Alexopoulos, Burke Barrett, Nathalie Baudy, Katharina Behling,
Meryem Berker, Cornelia Bertram, Eva Castringius, Kathrin Conrad, Bahadar Dorani,
Druckservice Schellenberg, Hayat Ebert, Sascha Engel, Michela Filippini, Ingeborg Fries,
Mirko Frohne, Lydia Fuchs, Viktória Gere, Markus Giese, Lorenza Giovanelli,
Angelika Golembiewski, Olaf Hartmann, Lorenza Giovanelli, Jacqueline Hermann,
Gero Heschl, Hilde Homburger, Ingrid & Thomas Jochheim, Zahirat Juseinov,
Bettina Kabot, Amrei Kahl, Stefan Kessel, Jörg Klambt, Elisabeth Klotz, Knab GmbH,
Matthias Koddenberg, Oliver Koerner von Gustorf, Kofler + Kompanie, Veronika Kranzpiller,
Birte Kreft, Lambert und Lambert, Cornelia Laufer, Andreas Mantyk, Irina Marschall,
Daniela Mewes, Oliver Mewes, Claude Mollinari, Annekathrin Müller, Steffen Lang,
Serdar Özdemir, Doro Petersen, Denny Pöhle, Tahir Qasim, Svenja Gräfin v. Reichenbach,
Aurelia Rist, Peter Rode, Julia Rosenbaum, RT Ausstellungstechnik Berlin,
Bettina Ruhrberg, Mike Schärfke, Kathrin Schmidt, Claudia Schmidt-Matthiesen,
Mathias Schormann, Bruno Spath, Marie Splawski, Studio Christo, Senad Suljic,
Angelika Thill, Frank Tornow, Sadaf Vasaei, Wolfgang Volz, Dean Weiß, Vladimir Yavachev,
Steffen Zarutzki

Colophon
Impressum

This book is published in conjunction with the exhibition / Diese Publikation erscheint anlässlich der Ausstellung
Christo and Jeanne-Claude: Projects 1963 – 2020. Ingrid & Thomas Jochheim Collection

PalaisPopulaire, Berlin
21.3. – 17.8.2020

PalaisPopulaire
Unter den Linden 5, 10117 Berlin
db-palaispopulaire.de
db-palaispopulaire.com

Head / Leitung
Svenja Gräfin v. Reichenbach

Deputy / Stellvertretende Leitung
Sara Bernshausen

Catalog / Katalog

Editor / Herausgeber
Deutsche Bank AG

Concept / Konzept
Friedhelm Hütte

Project management / Projektmanagement
Sara Bernshausen

Editorial management
Thill Verlagsbüro, Cologne / Köln

Translation from German to English /
Übersetzung aus dem Deutschen ins Englische
Burke Barrett (pp. / S. 4 – 7, 120 – 149),
Michael Scuffil (pp. / S. 14 – 29)

Graphic design / Grafische Gestaltung
faible Graphic Design, Fabienne Alexopoulos

Typeface / Schrift
Deutsche Bank Display, Deutsche Bank Text,
Arnhem

Paper / Papier
Cover Maxi Offset, 350 g/m²
LuxoArt Samt, 135 g/m²

This publication is partially based on / Diese Publikation beruht in Teilen auf *Christo & Jeanne-Claude. Photographs by Wolfgang Volz. Works from the Ingrid and Thomas Jochheim Collection*, exh. cat. / Ausst.-Kat. Mönchehaus Museum, Goslar (Distanz Verlag, Berlin), 2018.

Project management / Projektmanagement
Kerber Verlag, Lydia Fuchs

Production / Herstellung
Kerber Verlag, Jens Bartneck

Please find more information on Deutsche Bank's art program at db.com/art and db-artmag.com /
Informationen über das Kunstprogramm der Deutschen Bank finden Sie unter deutsche-bank.de/kunst und db-artmag.de

Printed and published by / Gesamtherstellung:
Kerber Verlag, Bielefeld
Windelsbleicher Straße 166 – 170, 33659 Bielefeld
Germany
Tel. +49 (0) 5 21 / 9 50 08-10
Fax +49 (0) 5 21 / 9 50 08-88
info@kerberverlag.com
kerberverlag.com

Kerber publications are distributed worldwide /
KERBER Publikationen werden weltweit vertrieben:

ACC Art Books
Sandy Lane
Old Martlesham
Woodbridge, IP12 4SD, UK
+44 1394 38 99 50
+44 1394 38 99 99 (F)
accartbooks.com

Artbook | D.A.P.
75 Broad Street, Suite 630
New York, NY 10004, USA
+1 212 627 19 99
+1 212 627 94 84 (F)
artbook.com

AVA Verlagsauslieferung
Scheidegger
Obere Bahnhofstraße 10A
8910 Affoltern am Albis, Switzerland
+41 44 762 42 41
+41 44 762 42 49 (F)
avainfo@ava.ch

KNV Zeitfracht
Verlagsauslieferung
kerber-verlag@knv-zeitfracht.de

The Deutsche Nationalbibliothek lists this publication in the Deutsche Nationalbibliografie: dnb.de. /
Die Deutsche Nationalbibliothek verzeichnet diese Publikation in der Deutschen Nationalbibliografie: dnb.de.

ISBN 978-3-7356-0649-5
www.kerberverlag.com

ISBN 978-3-942294-34-8
PalaisPopulaire

Printed in Germany

PalaisPopulaire
Art, Culture & Sports
by Deutsche Bank